The Art of the ?

The Art of the Storyboard

Storyboarding for Film, TV, and Animation

John Hart

Focal Press

Boston Oxford Auckland Johannesburg Melbourne New Delhi

Focal Press is an imprint of Butterworth–Heinemann.

Copyright © 1999 by John Hart

Butterworth–Heinemann

 A member of the Reed Elsevier group

 Recognizing the importance of preserving what has been written, Butterworth–Heinemann prints its books on acid-free paper whenever possible.

 Butterworth–Heinemann supports the efforts of American Forests and the Global ReLeaf program in its campaign for the betterment of trees, forests, and our environment.

Library of Congress Cataloging-in-Publication Data
Hart, John, 1940–
 The art of the storyboard : storyboarding for film, TV, and
animation / John Hart.
 p. cm.
 Includes bibliographical references.
 ISBN 0-240-80329-9 (alk. paper)
 1. Motion pictures—Production and direction. 2. Storyboards.
I. Title.
PN1995.9.P7H42 1998
741.5'8—dc21 98-36549
 CIP

British Library Cataloguing-in-Publication Data
A catalogue record for this book is available from the British Library.

The publisher offers special discounts on bulk orders of this book.
For information, please contact:
Manager of Special Sales
Butterworth-Heinemann
225 Wildwood Avenue
Woburn, MA 01801-2041
Tel: 781-904-2500
Fax: 781-904-2620
For information on all Butterworth-Heinemann publications
available, contact our World Wide Web home page at:
http://www.bh.com

10 9 8 7

Printed in the United States of America

To John Hoar, Ph.D., whose indispensable editorial skills in dealing with this multifaceted text, ongoing criticism, and never-failing support made this book possible.

Contents

Acknowledgments ix
Introduction xi

1 The Storyboard's Beginnings:
 A Short History of Animation 1

2 The Storyboard Artist: A Team Player 6

3 Drawing the Basic Storyboard:
 The Story Concept Is What Counts 27

4 How the Storyboard Meets the Needs
 of Each Member of the Production Team 57

5 Actually Drawing the Components of the Storyboard 67

6 More Drawing Techniques:
 Drawing the Moving Action Figure in the Storyboard 93

7 Giving Order and Increased Reality to the Visuals
 within the Storyboard, by Using Perspective
 and Receding Planes 117

8 Depth of Field and Manipulating Light 135

9 Perspective and Depth of Field:
 Designing and Composing the Frame 159

10 The Shot, Part I: The Shot's Function
 as Part of the Narrative Flow 167

11 The Shot, Part II: The Visual Language of Cinema 184

Appendix A A Word about Cartoons,
 Commercials, and Multimedia 205

Appendix B Interviews 211

 Bibliography 219

Acknowledgments

I would like to acknowledge the following individuals: Herb Fogelson, Ron Massaro, Jim McKinney, Herme Shore, Tim Weaver, my sister Mary Graham, and my late friend, Lanny Foster—writer par excellence.

A particular mention goes to my editors at Focal Press, Marie E. Lee, Terri Jadick, and Jodie Allen for their encouragement and support.

All artwork was rendered by John Hart, unless otherwise noted in the text.

Introduction

In saying that you want to be a storyboard artist, you're saying that you want to be the person who illustrates all the individual frames that make up the shots in a shooting script either for commercials, industrials films/multimedia, animated feature films, or animation used in commercials, industrials, or educational films. All these genres use storyboards in one form or another.

To be a storyboard artist you must have a good grasp of interpreting other people's thoughts. Your drawing talents must be developed thoroughly in both rendering live-action images realistically and in interpreting images as called for in animated films or videos. You must be comfortable expressing yourself clearly and creatively to your audience.

You will be part of what is referred to as the preproduction team. You will work with producers, production designers, directors of photography, and special effects teams. Most of your storyboard work, however, will be with the director, whose vision of the project will inform the entire production team.

The Art of the Storyboard seeks to help you in the following ways:

- To summarize the history and development of the storyboard and clarify its adaptation and function as a viable visual tool for the creative team that produces live action feature-length films, animation films and cartoons, commercials, multimedia/industrial films and videos, and documentaries.
- To provide basic exercises and illustrations in order to develop the drawing/drafting/design skills essential to realizing an artist's style, a style that will satisfy the needs of directors working in any of the aforementioned fields of creative endeavor.
- To serve as a standard text or a supplementary text for established art or film studies at the secondary or college level or in film schools.
- To help the student of storyboarding or film techniques whose time or funds restrict participation in organized classes to be better prepared for future art challenges.
- To increase the appreciation of the storyboard as a preproduction tool for producers, directors, cinematographers, art directors, and the like in any media, who perhaps aren't as familiar with its processes and purposes.

Stills from historically important films—from silent to sound—will be used throughout the text to illustrate their inherent design qualities and "stopped action" (actually parts of a storyboard, called *shots* or

stills from "key frames"). Each of the chosen renderings of movie or animated stills from close to 200 entertainment projects will serve three basic functions:

1. To place the film in its historical context in the evolution of twentieth century film styles, particularly those nominated for or winning Academy Awards for Best Picture, Best Cinematography, Best Production Design/Art Direction, or Best Special Effects.
2. To illuminate for the student of film each film's unique compositional qualities; that is, its use of framing in the context of its realization in reproducing a three-dimensional reality on the screen.
3. To delineate the dynamic placement of figures, use of camera angles (the point of view of a character often dictates camera angles used), and in particular, the director of photography's (or cinematographer's) "painting with light," thus creating striking visuals composed of light and shade (chiaroscuro).

The stills or shots that have been analyzed and interpreted here serve as singular illustrated frames that makeup the visual narrative that becomes the sequential action of the storyboard. These "key frames," when filmed as individual shots (projected on a screen at 24 frames per second), induce a "persistence of vision" on the human retina, thus creating a "cinematic motion" in the viewer's perception.

The basic drawing techniques illustrated in this book are applicable to any work the storyboard artist will do either in feature films, animation, commercials, or in computer-generated applications. But something this book will emphasize over and over is that, while it helps to draw well, it's the story concept that counts, and even rudimentary drawing techniques can convey the narrative flow of a given production.

1

The Storyboard's Beginnings: A Short History of Animation

When I was studying art in high school, I thought that the greatest place to get a job as an artist would be at Walt Disney Studios in Burbank, California. Having seen *Snow White and the Seven Dwarfs, Fantasia, Dumbo, Bambi, Song of the South,* and so forth, I imagined myself sitting at an artist's drawing board, helping to design and execute even more of the magically visual imagery for which Disney, along with his conceptual artists and animators, had become justly famous.

Although my career went off in quite a different direction (an eventual master's degree in Portrait Painting and a long teaching career in commercial art and photography), I wonder what would have happened if I had applied and actually been accepted.

What I didn't realize at the time was that I might have been put to work simply coloring the thousands of cels (acetate sheets) that make up a finished cartoon or full-length animated feature. I didn't think about the multitude of other jobs a trained artist could do at an animation studio—jobs like story and storyboard development, character design, animation drawing, action analysis and timing, camera and editing, special effects, puppet animation, and computer graphics (CGI). An artist might even learn to work on an Oxberry camera stand, used to photograph animation drawn on field charts. Or, at some animation studios like Hanna Barbara (*The Flintstones* and hundreds of commercials), an artist might be involved in painting production backgrounds, animation drawings, inspirational sketches (concept artwork), or making character model statues.

In high school, I also wasn't aware of the rich contributions of others who paved the way for Walt, like Winsor McKay, whose Gertie the Dinosaur (see Figure 1–1) and animation of the sinking if the Lusitania in 1915 established him as a great ancestor of the art form.

The concept of telling a story through a series of drawings, which is the root of the storyboard, can be traced all the way back to the ancient Egyptians and further. Charles Solomon's *History of Animation* begins later, with the traveling magic lantern shows of the 1600s and takes readers from the Optical Illusions of Phantasmagoria in the 1800s to the animated cartoon—from *Felix the Cat* and *Mickey Mouse* in the 1920s to *Jurassic Park* and *The Lion King* in the 1990s.

A late-nineteenth-, early-twentieth-century contributor to the history of storyboards and animation was George Méliès, the French conjurer,

Figure 1–1 Winsor McKay with
Gertie the Dinosaur.

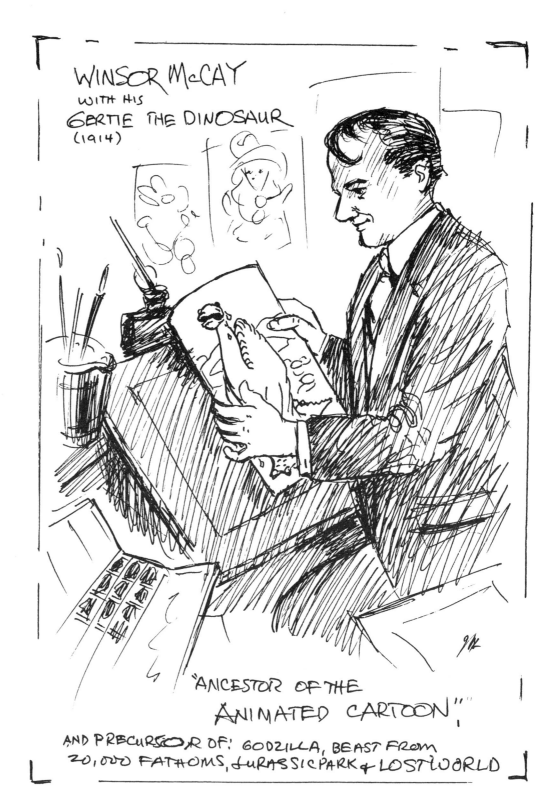

illusionist, theatrical set designer, and magician whose films projected optical tricks and fantasies. Examples of his films include *Cinderella* (1899) and *Joan of Arc* (1902), topped by his *Trip to the Moon* (1902), which still amuses and fascinates film audiences with its humor and inventiveness wherever it is shown. It is memorable for the rocket landing in the eye of the man in the moon.

Others who paved the way include Felix Messmer, whose expressive *Felix the Cat* (1914) was the world's most popular cartoon character, and Max Fleischer, creator of the Betty Boop cartoon series of the 1930s and whose *Cinderella*, for me, is even more inventive visually than the later Disney version.

Between these two came the inventive Ub Iwerks's artists in 1929, known to be among the "greatest animators of the silent era and who designed the physical appearance of Oswald Rabbit [bearing a first cousin resemblance to Mickey Mouse]" (Solomon, 1994). This was the beginning of the so-called Disney Era, which reigned through the early forties; and the world was to fall in love with Mickey Mouse, Donald Duck, Pluto, and Snow White.

In 1940, the ever-popular Bugs Bunny made his debut in "A Wild Hare" and became a living legend right through the 1950s and 1960s, under the inspired direction of Tex Avery, Bob Clampett, Fritz Freleng, and Chuck Jones. Recent storyboard drawings by Darrell Van Clitter for a possible upcoming feature, *Ballet Box Bunny*, capture the wabbit's feisty, debonair, suave personality. (For more visuals on Bugs Bunny, see Joe Adamson's *Bugs Bunny: Fifty Years and Only One Gray Hare*, with Forewords by Fritz Freleng and Chuck Jones (1990).

Tex Avery was especially notable among the giants of animation art. His inventive, original cartoon creations, particularly at MGM from 1942 to 1955, are still being imitated. Tex is considered by the cognoscenti of cartoons to be second only to Walt Disney. He worked first with Walt Lanz (Daffy Duck), next at Warner Brothers where he fine-tuned Bugs Bunny and redesigned Porky Pig in the 1940s (with the talented assistance of Chuck Jones), then at MGM (where he created his own "golden age" with memorable cartoon characters as Red Hot Riding Hood, the deadpan pooch Droopy, and many others such as the Slap Happy Lion and the King Size Canary).

Avery's fast-paced, irreverent, even surrealist gag style continues to influence contemporary cartoons (like *Who Framed Roger Rabbit?* 1988), the zany MTV "look," and even in recent films and commercials—after all, his witty "surprise the audience" techniques dictated much of the 1960s French New Wave.

In 1995, Disney's *Toy Story* was created by John Lasseter's studio, Pixar, pioneers of the computer-animated format. Pixar's use of fine rendering, especially in the subtleties of three-dimensional light and shade, kept *Toy Story* from appearing simply like a series of mathematical formulas.

Each of these animated cartoons, from *Felix the Cat* in 1914 to *Toy Story* in 1995, began as a drawing or series of drawings, just as so many popular cartoon characters like Popeye and Krazy Kat started as that prime example of a storyboard, the comic strip. In comics, you will notice a very clever manipulation of the figures in action within each of the frames. Cartoon artists must make dynamic use of space, compositional devices, and color. They must effectively utilize the foreground, middle ground, and background areas, which, in turn, frame the close-ups, medium shots, and long shots of the characters.

Cartoonists must keep children and sometimes even adults visually stimulated, so that they won't be bored by the characters and situations. The artists have to come up with an interesting story line and even stronger images, which are exaggerations of human or animal features, expressions, and body movements, to illustrate their stories. As always with cartoons, the main action revolves around conflict. This

type of approach can help one develop good storyboards. Conflict can be created merely by playing a large object or person against a small one, strong verticals against horizontals, red against green, large expanses of sky against a lone tree, or a ferocious thunderstorm against a defenseless person.

Ultimately, a cartoonist must place the story into a logical narrative sequence; and this, essentially, is the task of the storyboard artist. The use of the storyboard is a premiere aid in preplanning a filmed live action or animated feature. Eric Sherman states in *Directing the Film*, "The storyboard consists of making a series of sketches where every basic scene and every camera setup within the scene is illustrated—it is a visual record of the film's appearance before shooting begins." In *Lighting for Action* (Hart, 1992), written for the still photographer who wants to move up to video and film, I describe the storyboard as a tool designed to "give you a frame by frame, shot by shot, organized program for your shooting sequence."

Ron Huss and Norman Silverstein (1968) elaborate on the storyboard artist as one who, "guided by the Director, captures the actions and passions that will be translatable into film," that they involve "a continuity reminiscent of comic strips," remaining then "primarily pictorial."

Working from the original idea, storyboards enable one to organize all the complicated action depicted in the script, whether being done for live action films, animation, commercials, or a combination, they will illustrate what each selected frame of action contains. By doing one's own storyboards carefully and thoroughly, one knows exactly what is going to be done before the actual filming begins—every shot, every camera angle, what lights, reflectors, sets, and props will be used.

Of course, memorable scenes and sets don't just happen. One needs talented people to create them. And, on a commercial project, every piece of board and pound of plaster used in the building of sets, every performer, every costume, and every crew member has to be answered for and paid for. Germs of ideas and lengthy conferences involving the director, director of photography, set designer, and costume designer are part of this process.

Dozens of other creative people are involved in the extremely complicated preproduction process. The producer acquires the story property in the first place and raises the money to produce it. Producing it requires actors, costumers, grips, and other technicians like the carpenters, painters, composers of the soundtrack, even traffic managers and drivers. The entire production enterprise can be quite mind-boggling long before it is shot, edited, promoted, and distributed to local movie theaters. The whole operation is doubly impressive when one considers the logistics of getting together this group of people to decide what will be the "look" of the film to be produced, what will be its tone, and how will it be visualized—in other words, how the film will appear in its final form when shown to those who have become its targeted audience. Exactly to what created images will we all relate and respond?

The storyboard artist is the one who will make sense of the initial creative mayhem involved in getting a film produced. The storyboard artist's contribution to the creative team's efforts is to help in visually evaluating and synthesizing the narrative flow of the screenplay. The storyboard artist's job is to give cohesion, interpretation, and illustration to the visual spine, the "flux of imagery" that will constitute the screenplay. He or she will render or sketch, when requested by a particular director, all the necessary action in each key sequence or shot. Working

with the producer, director, director of photography, and often the production designer, the artist will create a vital blueprint that will be referred to by all of them during the entire shooting schedule of the production and frequently right into the postproduction editing process.

In a recent interview in *VISFX* by the editor, Bruce Stockler, (1998), Ray Harryhausen responded to a question on how he learned about storyboarding:

> I learned storyboarding from Willis O'Brien. He storyboarded everything. He started a film before *King Kong* called *Creation* [1931] at RKO. When Merian Cooper took over, he put the gorilla in it, and they added parts of *Lost World*, and they built that up to be *King Kong*. It was a great experience to work with him. He would make 20 or 30 drawings a day, little ones, about the size of this (indicating a napkin) . . . then he would paste them up and write captions underneath and we would do each scene that way. They were all numbered, so you knew when the close-up was coming, the camera angle and the framing, and whether you needed a rear-projector or a split screen or whatever.

2

The Storyboard Artist:
A Team Player

The evolution of the storyboard is intertwined with the history of twentieth century cinema itself. It's my guess that, if the very early master directors didn't use a storyboard per se, creative visionaries like D. W. Griffith, Eric von Stroheim, Charles Chaplin, and Buster Keaton were involved in some sort of preproduction planning, even if it entailed simply basics like the day and time of the shoot, what actors were involved, where the location would be, would sets have to be built and painted, what style costumes would be worn, who would run the camera, and what scenes were the director and the cameraman going to shoot at the designated time and location? Some directors like Eisenstein made simple sketches in the margin of the script (see Figure 2–1), while others probably kept them in their heads like John Ford or DeMille in the silent film period.

In any case, some form of preproduction concept sketching evolved, if only to give the construction and technical crews, and in particular the actors, some idea of what the next shot was going to consist. It's unlikely someone like Griffith, who was shooting 72 one- or two-reelers a year, circa 1910, would have had time to make detailed sketches of every scene scheduled (see Figure 2–2).

Although the storyboard per se was developed in its more sophisticated form by Disney in the thirties, Griffith certainly preplanned the setups, set construction, camera movements, crane shots, and so on and, indeed, rehearsed the actors to block each shot. Later, in *Gone with the Wind* (1939), David O. Selznick would apply many of Disney's preplanning animation techniques to his Civil War epic.

Frederico Fellini (*La Strada*, 1954; *La Dolce Vita*, 1960; *8 1/2*, 1963) was known occasionally to arrive on the set early in the morning and, like Griffith before him, keep scores of carpenters, actors, and technicians waiting around while he worked out in his head where and how the next shot was going to be accomplished. (Who could get away with that now, with budgets of $50–75 million being poured into some productions?) No doubt, he spent many hours with his technical people preplanning the use of the expensive sets, the lighting, and the camera positions that obviously were needed, for example, for a brilliantly imaged film like *La Dolce Vita* (1960) or *8 1/2* (1963; see Figure 2–3).

Preplanning for these films? Most certainly, because gigantic budgets demanded it. Storyboarding for action sequences? Probably, at least in drawings of concept sketches aligned with the script.

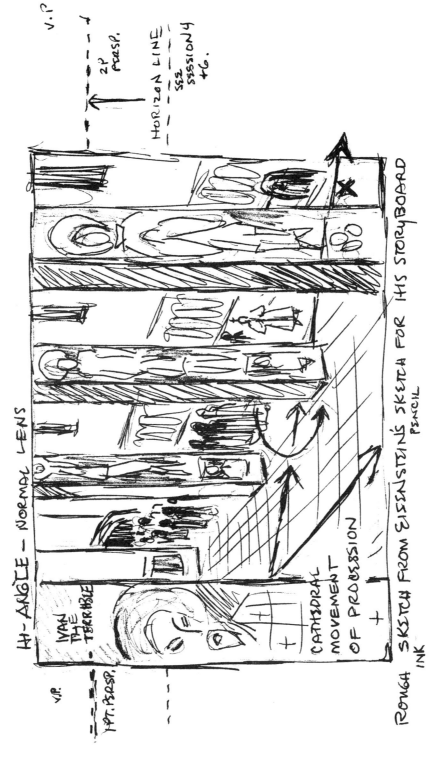

Figure 2–1 Hart's schematic interpretation of original Eisenstein's sketches for *Ivan the Terrible, Part II* (1958).

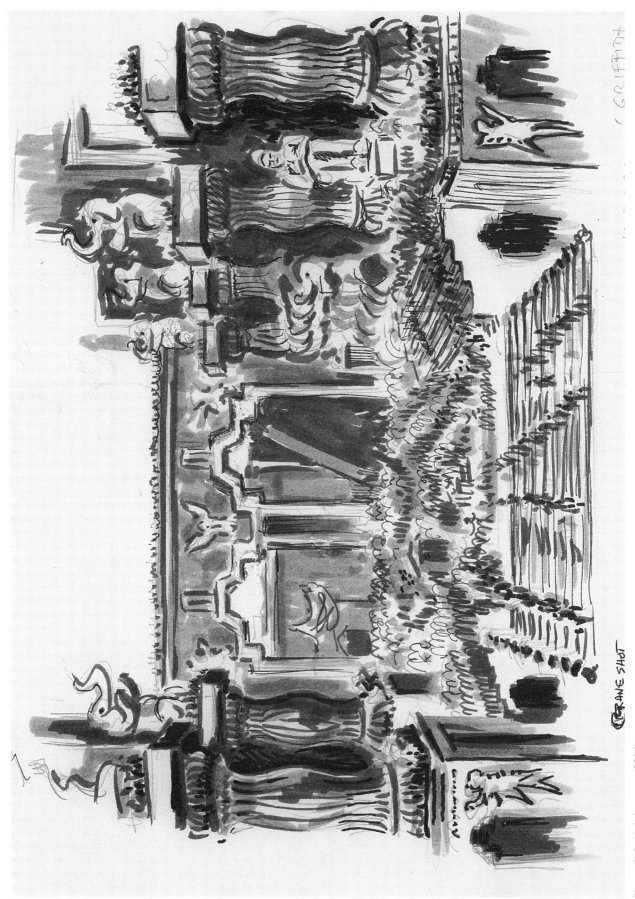

Figure 2–2 *Intolerance* (1916).

Figure 2–3 Tower scene from $8\frac{1}{2}$.

Later, in the thirties, Orson Welles, who worked under even tighter studio controls and budgets in attempting to film his legendary *Citizen Kane*, worked out all his key scenes in close collaboration with his award-winning cinematographer, Gregg Toland, by storyboarding each key frame, especially those scenes involving cast members, extras, and utilizing extreme depth of field (see Figure 2–4).

Even as far as budgeting time was concerned, those directors contemporary to Welles, like John Ford, DeMille, Victor Fleming, Frank Capra (who made the salient point, "To lower the odds against a film being 'quality'—there is no substitute for intensive attention to pre-production"; 1971), and William Wyler, (*The Best Years of Our Lives*, 1947), were all aware that selected storyboards could help realize the "look" of the film and indicate an actor's movements, giving the positions of cameras and lighting setups—implementing the set designer's constructions. Each of these production elements ideally would be worked

Figure 2–4 Interpretive sketch from production still from *Citizen Kane* (1941), interior of Xanadu.

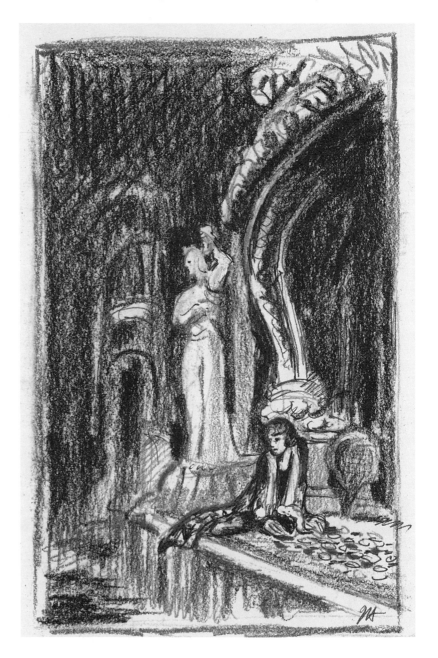

out ahead of time and dealt with in the consideration of each shot right up to the final, "Cut and print it!"

The great, innovative Eisenstein made a smooth transition from silent movies in the 1920s to sound films of the 1930s and 1940s in Russia. A talented and professionally trained artist (like Alfred Hitchcock in England) who became a theatrical set designer before he got into film, Eisenstein designed the sets and costumes for all his films.

Although his classic *Potemkin* (1925) was shot almost entirely at the actual historical locations depicted in the film, his later work like *Alexander Nevsky* (1938) and the two-part *Ivan the Terrible* (1945, and 1958) required massive sets built to satisfy the needs of the individual story lines (see Figure 2–5). So he made many preliminary sketches, showing not only the settings themselves but also the action and movement of the actors within them (again working in close collaboration with his brilliant cameraman, Andre Tissé). It is safe to say, then, that Eisenstein was one of the early directors, or auteurs, who employed some rudimentary visuals/techniques that would later be incorporated into storyboard construction (see Figure 2–6).

Note: We have seen earlier the contributions of early animators such as Winsor McKay, who perfected the storyboard technique, and Walt Disney's Ub Iwerks. Walt insisted on his dream factory's use of the cartoon-style, storyboard process. Disney studios and its perfection of the animated cartoon is legendary, as are Walt Disney's pioneering efforts (along with others like Max Fleischer and his Betty Boop cartoons in the early 1930s) in bringing about many of the innovations and techniques to which the development of current storyboard styles owe their existence.

Disney and his conceptual artists refined the use of the storyboard as the essential method of previsualizing the story to be told (with rough inspirational or concept sketches first, next workbook sketches in color, then sequential animation renderings, and finally painting the approved production cels), so that all the creative personnel knew exactly how each sequence would pertain to the overall story line, which in itself contained, "the essential composition of shots and sequences" (Culhane, 1983) (see Figure 2–7).

Storyboarding was an absolute necessity due to the thousands of individual cels that had to fill 24 frames per second on 35 mm film and eventually had to be hand colored. These demanded much greater care than the average film, in preparing and painting the separate cels or frames that constituted all the scenes or "shots" that were to unify the continuity of the storytelling process.

Just as in a live action feature, the original rough concept sketches weren't even rendered until a great deal of painstaking research had been done on period costumes, furniture, architectural detailing, and even the types of kitchen implements used in that time period—for example, the late middle ages. For instance, the interior of the dwarfs cottage had to look authentic in every detail when the very curious Snow White first enters the hidden dwelling.

For the audience to accept the "once upon a time" atmosphere created by the Disney creative team, all the objects and backgrounds had to appear "real." Even though their story was a fairy tale, anything that seemed phony would destroy the make-believe. Even developing the persona, the personality of Snow White, involved intensive research into her style of costume, hair, and facial characteristics; how she walked, gestured, turned, or sat down (utilizing the Rotoscope process of interpreting live actor's movements). Eventually, color scheme

Figure 2–5 Analytical
sketch made from a shot in
Alexander Nevsky.

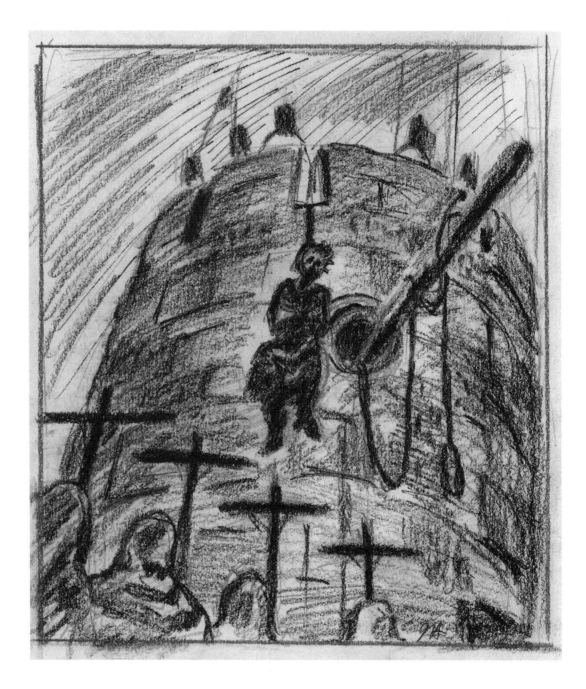

sketches (story sketches) would be made to indicate her correct skin tone and the color of her eyes, lips, cheeks, and hair. All these diverse elements then had to work together into the dynamics of the narrative flow—the *Snow White* story line.

The other characters in *Snow White*, like the dwarfs and the queen, had to be delineated so artfully, so freely, so that they, too, would contribute to the narrative flow, right along with the completed environmental elements (interior and exterior layouts delineating foregrounds, middle grounds, and backgrounds), whose function was to enhance the human characters themselves and to become presences that enhanced the entire mood of the final production.

Eventually, concept sketches were presented to Disney for approval, at which point they were rendered in watercolor, color keyed, and used to

THE FUNCTION OF THE STORYBOARD

☆ INDIVIDUAL FRAMES INDICATE AND ILLUSTRATE THE 600 SHOTS THAT MAKE UP AVERAGE FILM.

☆ FLOWING ARROW REPRESENTS THE NARRATIVE FLOW OF THE STORYLINE (SCENARIO) I.E., THE CONTINUITY OF THE FINAL SHOOTING SCRIPT

★ THE STORYBOARD IS THE VISUALIZATION OF THE WRITTEN WORD (SCREENPLAY) AND ITS STRUCTURE.

★ IT SERVES THE VISUAL NEEDS OF THE DIRECTOR, THE DIRECTOR OF PHOTOGRAPHY, THE PRODUCER AND THE SPECIAL EFFECTS TEAM.

Figure 2-6 Storyboard construction schematic illustrating some of Eisenstein's concepts of the construction of a given film (as in *Alexander Nevsky*).

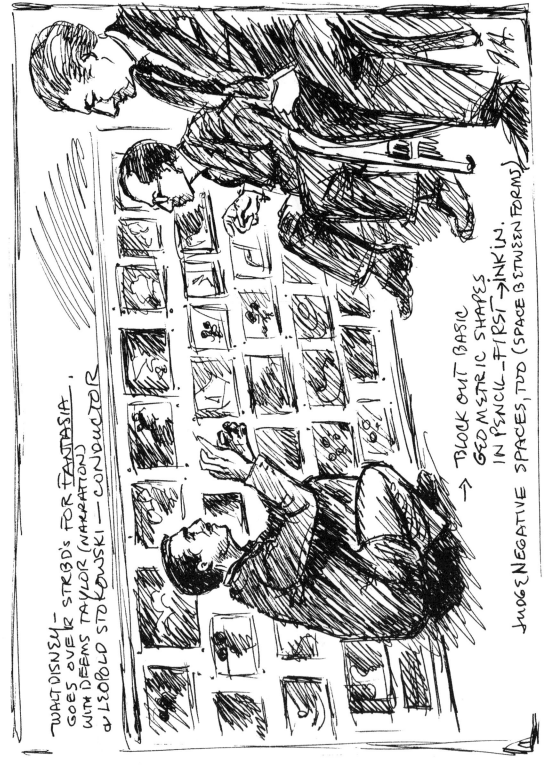

Figure 2–7 Walt Disney and staff. Storyboards occupy the entire studio wall directly behind them. To illustrate, by sketching figures in ink, the complete narrative flow.

assist background artists. Once the main characters, along with go-aheads for backgrounds, were given final approval, they could be animated to move about and perform within the individual layouts and scene composites themselves. Precisely where each character was motivated to move within a given shot usually was indicated with directional arrows.

From this "action motivated" narrative, the visual thrust of the fairy tale itself was put onto finished storyboards. These storyboards illustrated each move of the main characters who played out the continuity of the plotted story line. Many of these same techniques are used today at Disney and by all animators. Story structure, storyboarding, background art, and so forth still are the prime motivators for such recent animated efforts as *The Lion King*, 1994.

When the prolific David O. Selznick was faced with the intimidating task of producing the 1,200-page best seller *Gone with the Wind* (a Technicolor spectacle of the Civil War period that was to become the most expensive movie ever made up to that point), he insisted on careful preplanning and storyboarding every major scene to be shot in the four-hour-long film. The experience his production team had gained previously in the use of special effects on *King Kong* (1933), came in very handy in preparation for the extensive use of matte paintings and composite photography that *Gone with the Wind* would demand.

Not only did Selznick hire the most expensive actors in the movie business (like Clark Gable as Rhett Butler), he also employed the top designers and technical personnel available in Hollywood. Heading the list of this creative pool, along with the director Victor Fleming (*The Wizard of Oz*, 1939), was, again, the eminent William Cameron Menzies as production designer, designing the "look" of each key scene and even indicating the camera angles and framing of each shot. (He later was to receive an Academy Award for his brilliant use of color.) Lyle Wheeler as art director (set designer) and Lee Garmes as the director of photography (see Figure 2–8) followed the bidding of the production designers and the directors, creating stunning lighting for the film (see Figure 2–9). Selznick's legendary attention to meticulous detail—covering all facets of the production process, especially those of preproduction—would pay off handsomely with a shelfload of Oscars garnered for the biggest grossing hit in Hollywood history. (I just saw the recent re-issued, restored color version, and it's better than ever!)

One salient point can be made: Many great producers and directors in the history of the motion picture used some form of preplanning. They had become aware of how much time and money could be saved in balancing their budgets if their preproduction people utilized a carefully laid out storyboard that would become the "visual spine" of the screenplay. In other words, they could readily see, by referring to storyboard sketches, who had to spend what for what purpose.

Director John Ford, who supposedly kept the continuity of his shots all in his head, received valuable visual support from several great art directors including James Basevi. We can marvel at Basevi's brilliantly conceived compositions in *The Grapes of Wrath* (1940), *The Searchers* (1956), and *My Darling Clementine* (1946).

I recommend you view the following films. Observe the art direction and production design that contribute to their stunning visual presentations, many of which are illustrated in this book. Since the storyboard is concerned with illustrating the flow of action in each key scene, it is concerned basically with the movement of the actors performing in front of the previously designed sets and lighting. The films I recommend are Ernst

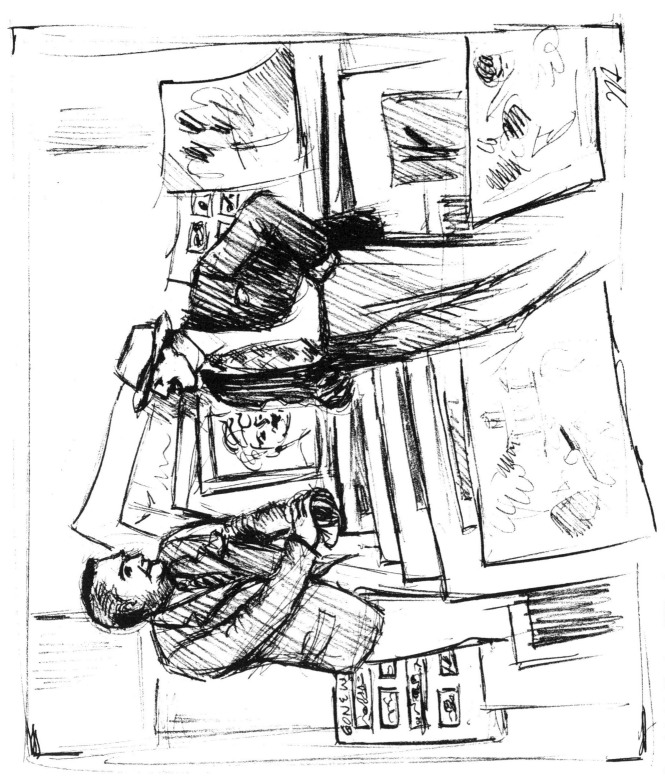

Figure 2–8 Lyle Wheeler and William Cameron Menzies approve storyboard production sketches of *Gone with the Wind.*

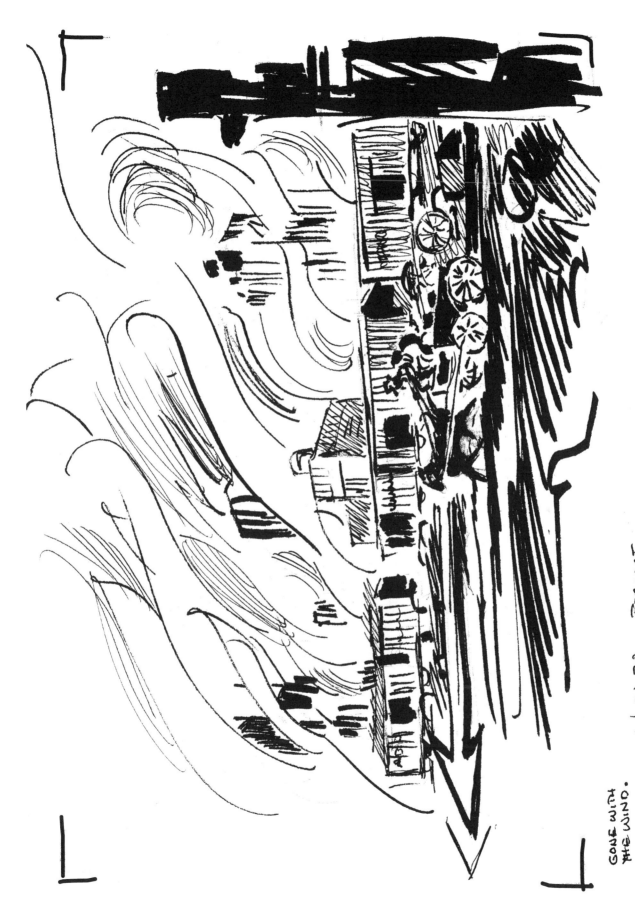

Figure 2-9 An interpretive sketch of the burning of Atlanta.

Lubitsch's *Ninotchka* (1939), David Lean's *Lawrence of Arabia* (1962), Victor Fleming's *Wizard of Oz* and *Gone with the Wind* (both 1939), Alfred Hitchcock's *Dial M for Murder* (1954), Frank Capra's *Hole in the Head* (1959), Steven Spielberg's *Jaws* (1975), *Indiana Jones and the Temple of Doom* (1984), and *Jurassic Park* (1994). Of course, I include the legendary Orson Welles's *Citizen Kane* (1941). Working with innovative cameraman Gregg Toland, Welles found the use of storyboards to be a primary tool of preproduction.

In observing the many illustrations or stills in this book, you will observe that each frame of the storyboard creates its own world. It requires the use of great design, perspective, mood, and mise-en-scène. Whether the film is a comedy, tragedy, or melodrama, great film directors can create a very spatial world, peopled with interesting, in-depth characters, who, by the force of a dynamic plotline, reward us with great visual entertainment.

For those of us who have seen them, certain realms of experience have been indelibly imprinted on our memories by the graphic images Alfred Hitchcock created for his films. He was responsible for such hair-raisers as *Psycho* (1960), *The Birds* (1963), and *North by Northwest* (1959; see Figure 2–10), in which each shot was filled with stunning images full of visual impact, each designed to flow with the narrative action of the screenplay. He made exciting use of the montage concepts culled from Eisenstein, Griffith, and Chaplin and imprinted them with his own suspense-oriented style.

Hitchcock was a major proponent of the necessity of storyboarding every one of his productions. In many of his movies, like *The Birds*, elaborate special effects that involved composite shots consisting of live action sequences combined with matte paintings and blue screens, made the execution of storyboards imperative.

Hitchcock (like Eisenstein) is the prototypical director whose career spanned from the silents into sound films, continuing right up to his last film, *Family Plot*, in 1976. From an advertising layout man in a London Department store to art director for *Woman to Woman* in 1923 to full-fledged director of *The Lodger* in 1926, "his background in advertising layout was to help him in his directorial duties. In planning each film he would make hundreds of sketches [storyboards] illustrating the camera angles and the facial expressions he wanted from the main characters" (Spoto, 1976).

More recent filming has given us such imaginative directors as George Lucas, whose storyboarding of his *Star Wars* trilogy films helped to coordinate and implement all of the composite shots that involved actors, space craft, animated miniatures, matte paintings, and other special effects, many of which were conceived by master storyboard painter Robert M. Guerre. Another film with stunningly executed special effects was John Cameron's *Terminator 2: Judgment Day* (1991).

Industrial Light and Magic (ILM), founded by Lucas to handle in-house the special effects of his films, has continued to work with other producers and directors creating more SFX magic with Steven Spielberg's *Jurassic Park* (1994), Jan De Bont's *Twister* (1996, making millions only because of its special effects), Tom Cruise's potboiler *Mission Impossible* (1996), and the current *Titanic* (1997).

Twister, it must be said, is replete with heart-pounding, very visceral SFXs created by the estimable ILM team. All those nonstop tornado thrills in *Twister* were storyboarded beforehand, so that not only the director, De Bont, but also the producer, art director, director of photography, and the entire string of technicians could consult the storyboards

Figure 2–10 *North by Northwest* (1959).

during the entire shooting schedule. De Bont said, "You have to make storyboards, and the storyboards have to explain to every department exactly what is demanded of them" (Wiener, May 1996).

ILM has been busy doing special effects for the commercial market in addition to the previously mentioned directors. Here, too, is a medium that, because of its own tight budgets and time scheduling of talent and rented equipment, demands the necessary luxury of a detailed storyboard. The art of the storyboard, with all of its techniques and adaptations, has been adapted to the requirements of the divergent needs of commercials, industrials, music videos, computer animation, and such productions (see Figure 2–11). However, there is nothing new to this. Disney animators were doing this in Chicago for commercials and industrials in 1971.

Anyone attempting to shoot any kind of story line, even the harried film student or independent filmmaker filming his or her first documentary, should use the storyboard as a visual device, not only to serve as a day-to-day guide for setting up shots (with their inherent problems of lighting, blocking, and pace), but also as a precious time-saver and a chosen aid in controlling budgets of any size.

A case in point was Gregory La Cava (*Stage Door, My Man Godfrey*). In *The Name Above the Title*, Frank Capra described La Cava as a very witty director, who was guilty of "inventing scenes on the set." La Cava had proclaimed that "he could make motion pictures without scripts. But without scripts the studio heads could make no accurate budgets, schedules, or time allowances for actors' commitments. Shooting off the cuff, executives said, was reckless gambling; film costs would be open-ended, no major company could afford such risks." Capra goes on to tell us that La Cava's meteoric rise was followed by a very sad fall because of his lack of preproduction planning.

In contrast, Capra describes the legendary director Ernst Lubitsch, who directed Greta Garbo in *Ninotchka* (1939), as "the complete architect of his films." His scripts were detailed blueprints, replete with all the required sketches, drawings, and specifications. Every scene, every look, every camera angle, was designed in advance of photography and he seldom, if ever, deviated from blueprints in the actual shooting. "His stamp was on every frame of film from conception to delivery."

A more contemporary case for the need for good preproduction planning is Terry Gilliam's *Baron Munchausen*. In *Losing the Light* (Yule, 1991), actor Charles McKeown was quoted as saying, "If you start a movie unprepared, you never catch up. You lose morale and there's an instant sense of failure, no matter how hard everyone works. On *Munchausen*, nothing was ready, nothing was right."

Missed deadlines, escalating budgets, and problems with communication damaged the collaborative effort and jeopardized the film. Apparently, one saving factor was the storyboards. To an actor insisting on more motivation, Terry is quoted as saying, "It might not be in the script, Lee, but you'll find it on the storyboards" (Yule, 1991). Said the actor himself, "If you took your eye off a combination of the script and the storyboards on this incredibly complicated film for one minute, you were lost."

The value of good preproduction planning and storyboarding as a part of that process cannot be overstressed. Consider what cinematographer Hiro Jarita, ASC, said of director Henry Selick while they were collaborating on the shooting of the technically demanding live/animation film, *James and the Giant Peach* (1997; see Figure 2–12), "I pre-programmed each of the different lighting situations. That way I could go

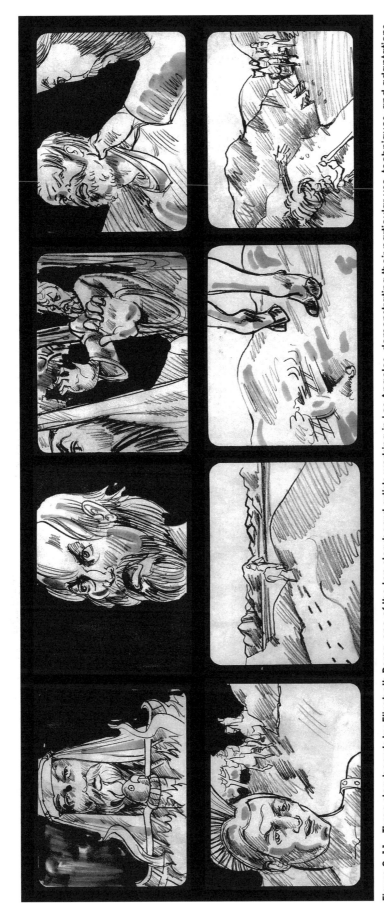

Figure 2–11 Three storyboards by Elizabeth Perez, one of the top storyboard artists working in Los Angeles, demonstrating their particular use, techniques, and adaptations for commercial, industrial, and music video clients, rendered in black and white and color, for New Man Jeans, The Art Hotel Limelight Productions (music video). Reprinted with permission.

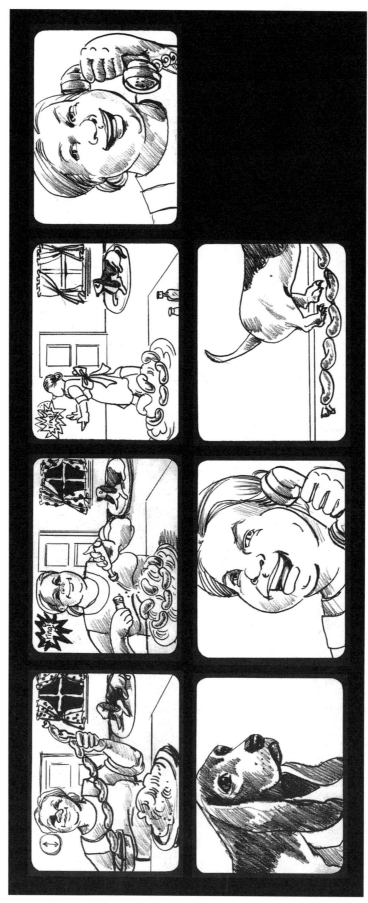

Figure 2–11 *Continued*

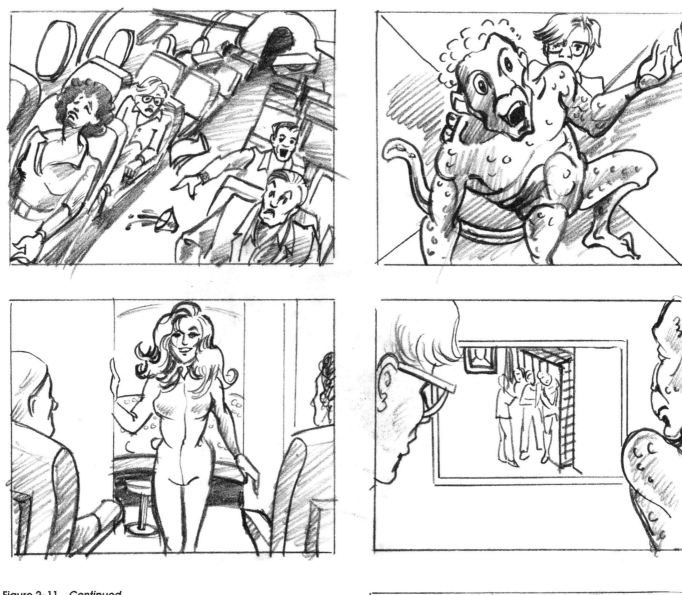

Figure 2–11 *Continued*

EX. FORCED/COMPRESSED PERSPECTIVE

Figure 2–12 *James and the Giant Peach* (1997).

from a day shoot to a night shoot in 29 minutes. That, of course, forced us to do a lot of pre-rigging. Fortunately, Selick had done a great deal of storyboarding" (Blair, June 1996).

As illustrated in Figure 2–6, the art of the storyboard is a controlled art, a sequential art—an art form concerned with the illustration or depiction of a given story line with one specific end in mind, the realization of these kinetic drawings in filmic terms; that is, a movie for theatrical release or TV showing, a documentary, or a commercial. The storyboard represents the line of dynamic movement dictated by a given script that has been chosen for production.

Based on basic comic strip art forms, the storyboard, in effect, is a shot-by-shot visual programming of the suggested action of the script and, as such, dictates its own artistic requirements. It must demonstrate graphic visualizations for the producer, director, director of photography, and (of special recent interest) the director of special effects. To mention just a few examples, consider the growing sophistication and phenomenal costs of SFX exploding in recent productions like *Independence Day, Twister*, and Spielberg's *The Lost World*, which was budgeted at circa $100 million. Suffice it to say, this increased reliance on SFX makes demands on the storyboard artist and his or her imagination even more acute and more challenging (see Figure 2–13).

The storyboard then is broken up into flowing action that emanates from each preplanned shot. Since the shot is the heart of every image set up, it contains its own special essence, its own dynamic. Its primary purpose, illustrated in the storyboard, once again, is to realize in the most kinetic way the intentions of each dramatic section of the script,

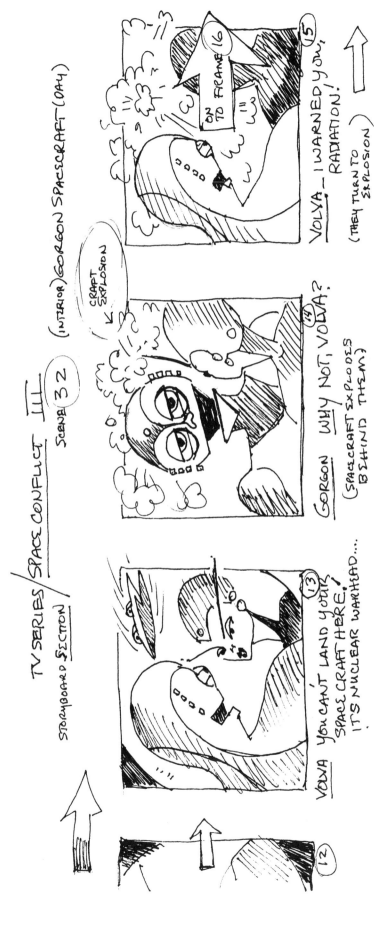

Figure 2–13 Storyboard concept sketches for a TV series proposal entitled "Space Conflict III."

giving most specific assistance to the director in capturing his or her personal vision. The individual shot implies more than it suggests, and since each shot is the keystone of every scene in the script, it will be advisable here to demonstrate shots from several classic films. (The inherent essence of the phrase, *the shot* will be discussed at further length in Chapter 3.)

D. W. Griffith, in *Birth of a Nation* and particularly in *Intolerance*, developed editing and montage techniques that, along with his creation of the close-up, iris, pans, and tilts, became the foundation of film grammar and, in turn, influenced worldwide film direction, particularly and most dramatically for Sergei Eisenstein in Russia.

Although Eisenstein is justly a legendary figure for the filmic strength of *Strike*, *Alexander Nevsky*, and *Ivan the Terrible*, Parts I and II, he is most remembered (and revered) for the absolute graphic power of his Odessa Steps sequence from *Battleship Potemkin*. This memorable action sequence in itself can serve as the premiere "catechism" and learning tool for the student of storyboarding. It is analyzed in greater detail in Chapter 5.

From this brief background of the beginnings of the storyboard and its use by the "greats," in Chapter 3, we explore in greater detail

1. The artistic training and required background of the potential storyboard artist.
2. Exactly what storyboard artists should know about the variables contained within the imagery of the shot and how it serves the continuity of the narrative at hand.
3. How the storyboard itself serves the multiple needs of the entire preproduction, production (principal photography), and postproduction team.

3

Drawing the Basic Storyboard: The Story Concept Is What Counts

Steven Spielberg's storyboard sketches for *Indiana Jones and the Temple of Doom* are little more than chicken scratches, but since his concepts for the action sequences were at least indicated, even primitively, he was able to visually convey his ideas to a professional storyboard artist, who, in turn, rendered them in, shall we say, a more realistic manner.

Once again, the concept of the story line and its validity is what counts in conveying the visual interpretation of a written scene when it is broken down into the shots—shots that the director has decided specifically are needed to interpret the continuity of the screenplay. Our purpose here is to make you familiar with the storyboard process and help you develop your drawing and drafting skills in actually rendering them, and I hope, to develop your own style.

Supposing a director or producer asks you to help him or her visualize a scene. You say, "Wait a minute, I'm not an accomplished storyboard artist yet, I'm only a temp, here to work in duplicating." The producer says, "Aw, c'mon, your father tells me that you're studying storyboarding, so let's just keep it to stick figures, OK?" Your response, "That I think I can do."

To devise a good storyboard, ask yourself and your production heads the following questions:

- What is the story about?
- Who are the characters?
- What do they do and say, if dialogue is indicated?
- Which characters are in the foreground, middle ground, and background?
- With whom are they in conflict?
- Where does the conflict take place?
- How many lights and light stands are needed to illuminate the locales?
- What intensity is demanded?
- What should be the main light sources, for both indoor and outdoor shooting?
- Where should the key light be positioned?
- When are long, medium, and close-up shots necessary?
- What kind of reflectors, filters, gels, gobos, and cookies are called for to create the right mood?
- What colors dominate each scene?
- What types of sets, costumes, and makeup are required?

All these questions become clear when illustrated in the storyboard.

Let's start out by simply drawing some very basic figures in action. Incidentally, it is a very good idea to carry a sketchbook with you at all times, so that you can make quick sketches of the people, places, and objects you encounter every day. This way, through practice, you will develop facility in rendering figures and the like in a more natural way.

Figure 3–1 shows some examples of quick sketches that I have done, many of which were taken right from the TV screen as I watched movies, either on the AMC, TCM, or Bravo channels.

As you make sketches such as these, keep in mind the proportions of the body. Notes at the side of most of these "quickie" drawings indicate light sources. Try to render your sketches in 15 or 20 seconds. This way, even if they are not perfect, you at least will be getting the "gesture" or direction of the body's movement. Just like a good storyboard, they will have a through-line, a mode of behavior. They will indicate through their gestures or body stance where they are going and what they are doing. Ask yourself, what is my motivation? Why am I performing this particular action?

Ask yourself further questions when drawing characters involved in a action. Let's say the script has a scene depicting the aftermath of a murder—two characters, men, mid-thirties. There is the inevitable chase scene.

What's going on here? Why is the runner running? Is he a cop chasing the killer? Is he the killer running from the cop? How would each be dressed? What would their demeanors project—Hate? Anxiety? Fear? What?

At this point we've become pretty adept at drawing the human figure in its simplest form. Let us now start to place them inside the individual rectangular frames that make up the shots.

In Figure 3–2, a two-shot, Charles Foster Kane has followed the politician who discovered him with his mistress out onto the stairway. Kane is yelling after him that he "won't get away with it!" The politician, indifferent to Kane's invectives, continues toward the exit. Arrows indicate the line of action. The camera will frame this flow of action. Welles directed cinematographer Gregg Toland to hold on the low angle shot, to let the politician exit out of the right of the frame as Kane continues his diatribe. This simple sketch would be enough for a director of photography to follow.

Placed in sequence with the shots that logically would go before and after it in the story line, it becomes part of a storyboard. Just below the sketch is a diagram showing the action as if the camera were positioned on top of the scene. This extremely high angle (attic view?) later would be used by Hitchcock in *Psycho*, when Norman stabs the inquisitive detective at the top of the stairs in the Victorian house.

To reemphasize the "rough to ready" concept, please refer also to Figures 5–1 and 5–17. The rough preliminary visualizations in Figure 3–3 were done for a satire on Bergman's *Seventh Seal* (1957), where the mode of action indicates a death figure about to accost an unassuming young man as he walks through the woods, showing

- The direction toward which the man is walking.
- A possible position of the death figure.
- A reaction shot of the victim.
- Death touching "Everyman."
- Death going on his merry old way.

Figure 3–4 shows the finished storyboard.

Figure 3–1 Rough sketches from my sketchbook to help in achieving a more natural, "at ease" drawing style for the demands of the storyboard.

ACTION

RUNNING
JUMPING

TENNIS

ICE
SKATING

DRAW FROM
SPORTS PHOTOS

PROPORTIONS AXIS LINE

HEAD
1/7

1/3

OF
BODY HEIGHT

START WITH
STICK FIGURES

VOLUMES
IN SPACE

HAND IS
SIZE OF FACE

BASKETBALL

ADD OVALS
OR SPIRALS

TRAPEZE

Figure 3–1 Continued

Figure 3–1 *Continued*

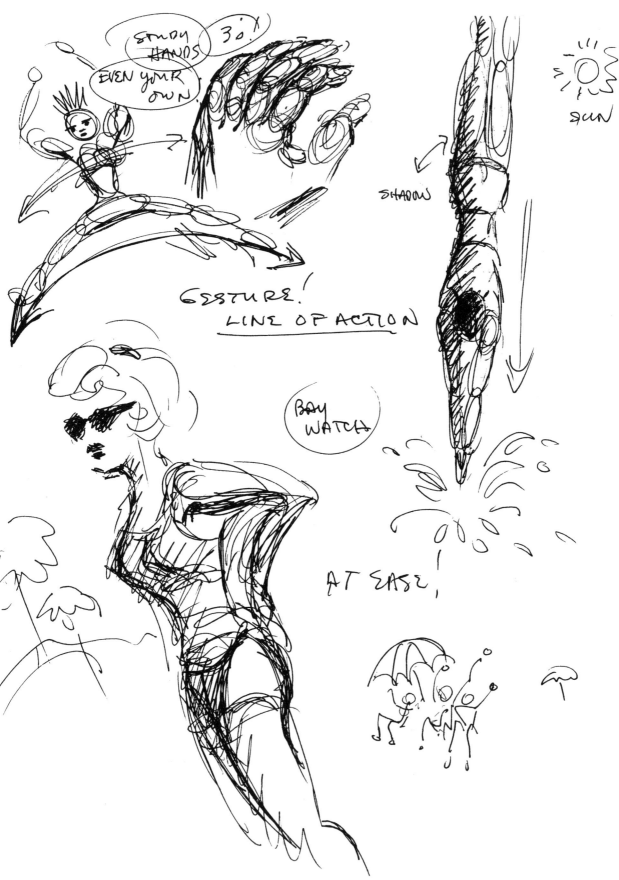

Figure 3–1 *Continued*

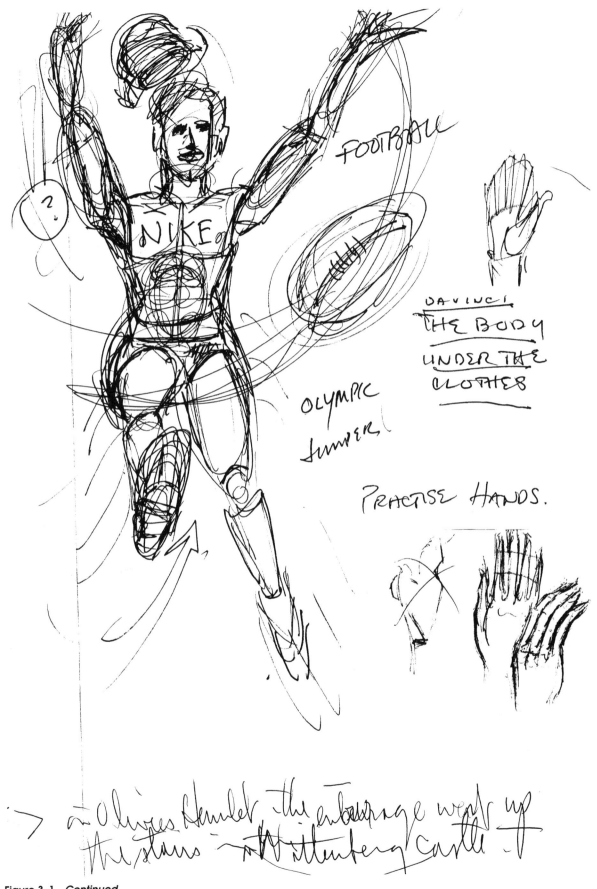

Figure 3–1 *Continued*

FORESHORTENING OF FIGURES

THINK ELONGATED TRIANGLES

ERG?

REVERSE

FEET FIRST

HEAD FIRST

RODIN/SCULPTOR

`THE HUMAN BODY HAS INFINITE PROFILES.'

THE LINEAR BEGINNER

Figure 3–1 *Continued*

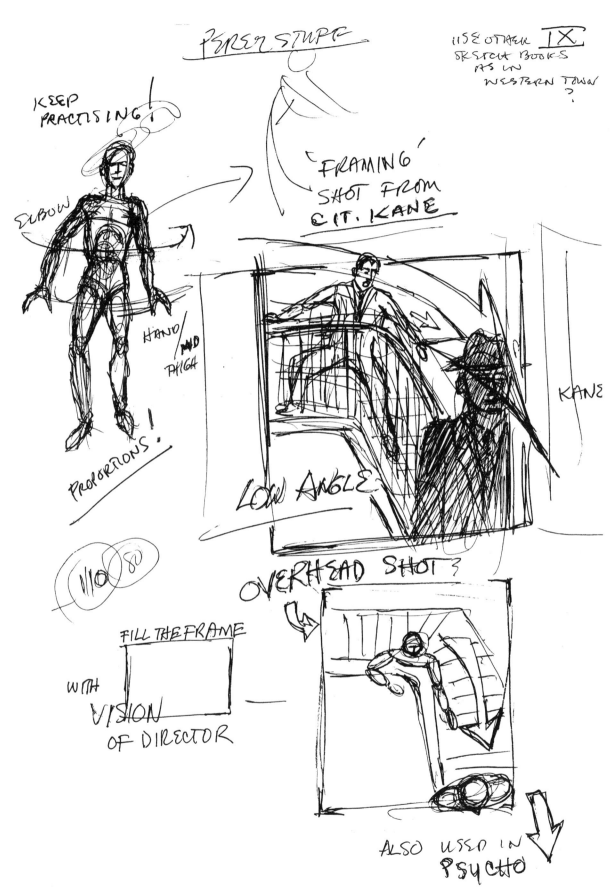

Figure 3–2 *Citizen Kane* (1941).

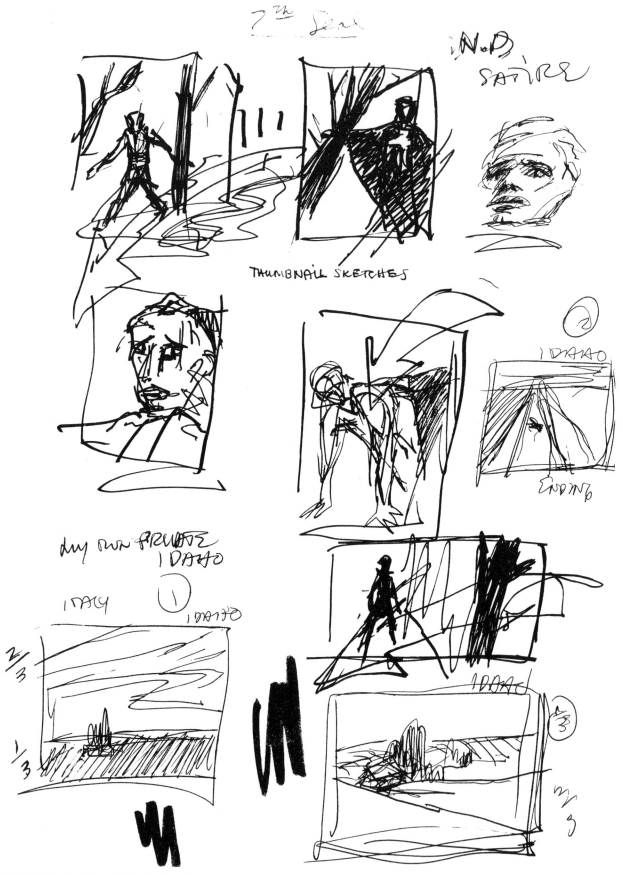

Figure 3–3 *The Seventh Seal* satire. These are just sketchy ideas for blocking the actors.

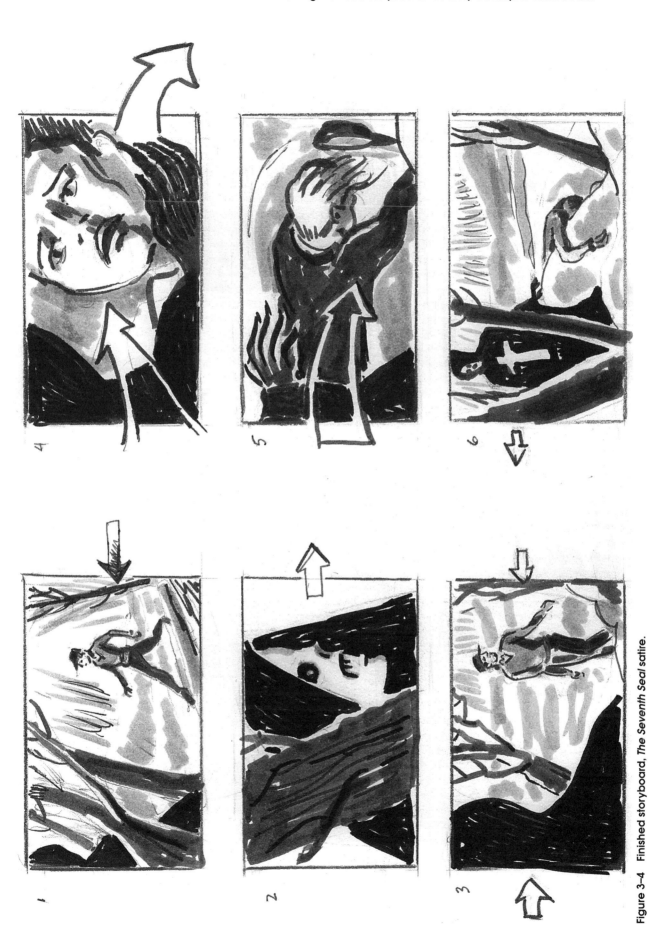

Figure 3–4 Finished storyboard, *The Seventh Seal* satire.

Note again, that, with the continuity placed within the rectangular ratio of the frame (frontal plane/frame), a clearer picture is seen of the placement of the actors in the foreground (FGD), middle ground (MGD), and background (BGD). And although there is no obvious one-point perspective, it is indicated with the framing of the trees, the receding walk, and the size of the figure of the man when he is placed in the frontal, middle, or back plane. Note that the foreground framing of the trees adds not only to the design of the "moving picture" but aids in the spatial feeling of the shots. Also, the varied use of close-ups, medium shots, and long shots adds to the simple dynamism of the sequence.

I did a storyboard for a screenplay entitled *Venus Mountain*, by Lanny Foster. The screenplay contained some terrific action sequences that cry out for visualization. Figure 3–5 shows a stick figure interpretation for those of you who are still searching for a drawing style. Remember, I started out with this sequence by making very simple sketches in the margin of my copy of the script. (Since some directors actually start out this way, why not me?)

You follow the action that takes place between the characters Cardiff and Mary. As denoted in the script, Cardiff walks down the corridor, goes into his own large office, turns on the lights, and finally goes to his desk, all the while being stalked by a revengeful Mary, who eventually, with gun in hand, confronts him in his office. This entire scene is observed by two assassins, one with binoculars and the other holding a gun, seen through one of the windows in the office building opposite.

Working with Mr. Foster (who also wanted to direct), we broke down the scene into the basic shots that it required with these initial rough sketches. He wanted to capture the intense flow of action that would build up to Mary threatening to kill Cardiff. So, keeping the continuity in mind, the power that well-designed frames and the use of fluid, not-distracting camera work can bring to a scenario, I started with these marginal thumbnail sketches. They follow the nine shots that we felt this particular page of the script needed to "tell the story" visually.

Going from shots 1 through 9, you can follow the sequence of action:

Shot 1. A pan shot of Cardiff going down the corridor to open his door, filmed at a slightly lower angle, but not too low because he is seen from Mary's POV (point of view).

Shot 2. An over-the-shoulder shot of Cardiff as he turns on the light in his dark office.

Shot 3. He throws his coat on sofa, moves to the bar, to the window, to the desk and tape deck.

Shot 4. Cardiff in MDG, framed in doorway of office (Mary's POV) as her gun slowly intrudes into left side of frame.

Shot 5. The barrel of the gun slowly advances from left frame into left center of frame. (Keep close-up on the gun, with a wide angle lens as it moves toward Cardiff in MGD right of frame). Cardiff looks up.

Shot 6. Cut to close-up (CU) of Cardiff, where it freezes.

Shot 7. Mary and Cardiff in two-shot CU "facing off."

Shot 8. Cut to CU of observer in window opposite with binoculars pointed at Mary and Cardiff. Other man in window slowly lowers and points high-powered rifle at them.

Shot 9. CU of Mary and Cardiff framed in binoculars (assassin's POV).

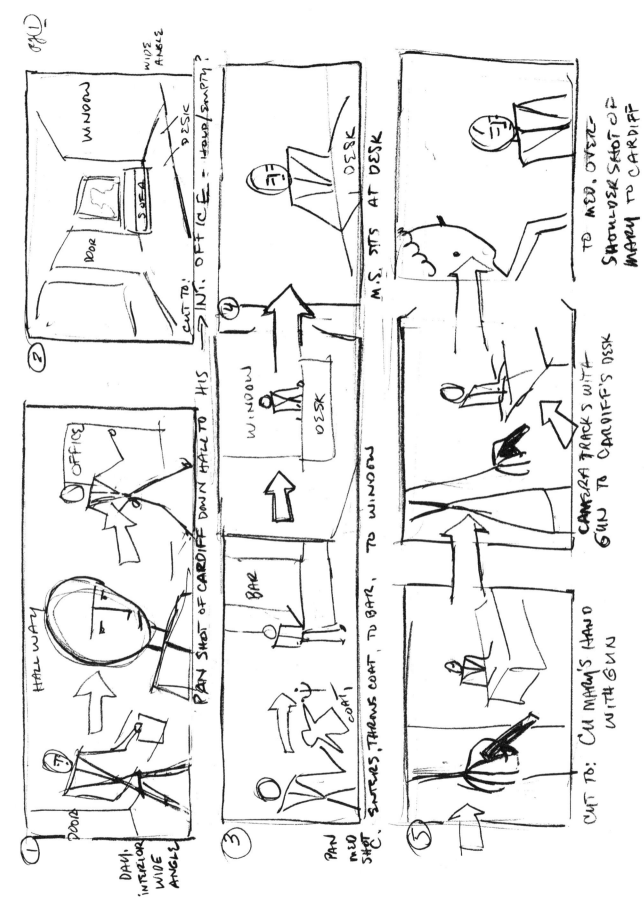

Figure 3–5 *Venus Mountain*, stick figure interpretation. Reprinted with permission.

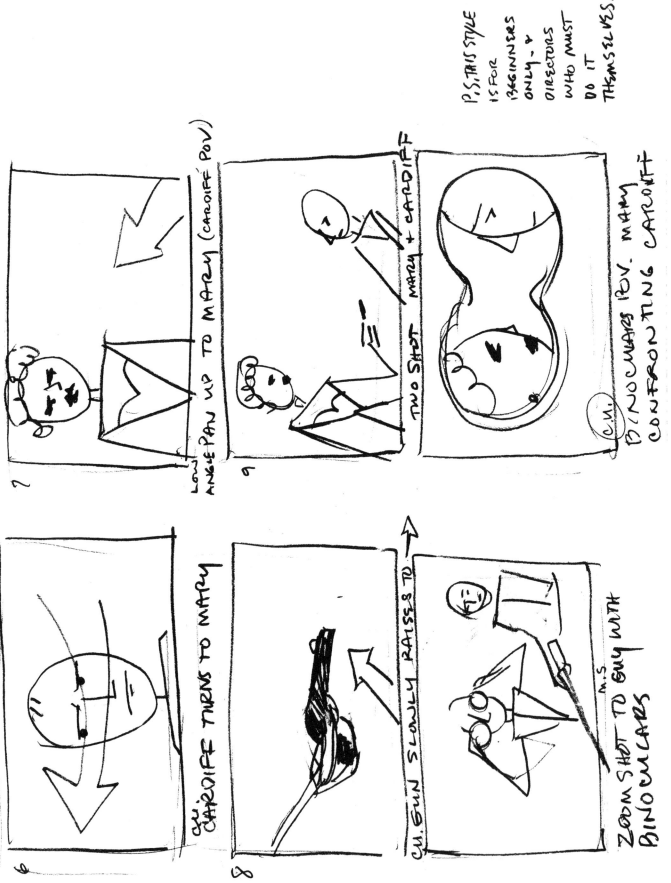

Figure 3-5 Continued

In a discussion with the director, it was decided to blend shots 4 and 5 into one 10 second pan shot (see Figure 3–6).

Incidentally, in this second adaptation of the shot sequence, for clarity, we added CUs of Cardiff turning to Mary in Shot 6; medium shot (MS) of Mary in Shot 7; another CU of the gun in Shot 8 to the two-shot of them both in Shot 9, before the medium close-up (MCU) of the binoculars in Shot 10.

The storyboard at this particular stage could be tightened up and given a more finished look, but even at this stage of development, enough detailed information is presented to satisfy the director's needs plus those image indicators that the director of photography (lighting requirements are pretty obvious) will want to interpret for the director. Even the simple renderings of office corridors and interiors will be of benefit to the production designer as well as the producer, who will be looking at lighting rentals and set construction.

From a comedy script (requiring high key lighting) written by Ron Massaro, *The Summer of '69,* I have selected a scene that takes place at a summer resort. The climax of the scene occurs when an innocent-looking rocket is ignited and goes off in a wrong direction, "kerplunk" in a cake baked to celebrate the moon landing. In the story board in Figure 3–7, Amanda, the "assistant" to Mr. Doll, the director of the resort, while trying to impress him with her home-made rocket, is unexpectedly carried by it into the moon cake.

This rendering of the storyboard was worked out with the screenwriter, specifically, because the selection of shots, lenses, angles, and so forth is left to the director and not indicated in the screenplay itself.

As shown in shots 1 through 14, rendered in this very simple outline style of drawing—almost like a comic book—indications are made not only for dialogue needed for the sequence of shots but also the time of *day* or *night, interior* (INT) or *exterior* (EXT), plus the suggested framing of shots placed in the lower left-hand corner of the frame by the director. This is a style you might want to develop for yourself, as it is not a huge step from the use of "fleshed out" stick figures. So, keep those drawing exercises going every day, from life situations and from the movie and TV screens, recording in your sketchbook your instant observations of people, places, and things; and you'll experience a new facility with the rendering of any of these things.

One of my favorite pan shots exploited in movies that I have sketched quickly from the TV screen is this shot from *Black Orpheus* (1959; see Figure 3–8), directed by Marcel Camus and based on the classic Orpheus saga—you know, Orpheus trying to retrieve Euridice from Hades. Only in Camus's interpretation, the mis-en-scène and the kinetic action that it inspires takes place at Carnival time in Rio de Janeiro.

In this shot from the film, not only do we have the sweep and grandeur of a beautifully composed frame, made up as it is of the strong vertical thrust of Sugarloaf Mountain placed to the right of the frame, we also have the use of that powerful design element—the circle. In the film, a large circle of gold is used throughout, not only as a symbol of life and the sun, but also for a carnival banner, and thus a continuing leitmotiv, a visual connecting device that ties one scene to the next.

In this shot we see the golden circle carried from the FGD, to the MGD, where it disappears with the crowd behind the rise in the hill just past that MGD. Holding his camera for a few seconds on the "setting sun" in the same MS shot, Camus slowly pans his camera to the left, where it stops as it overlooks the Rio harbor, the Trocadero, and the

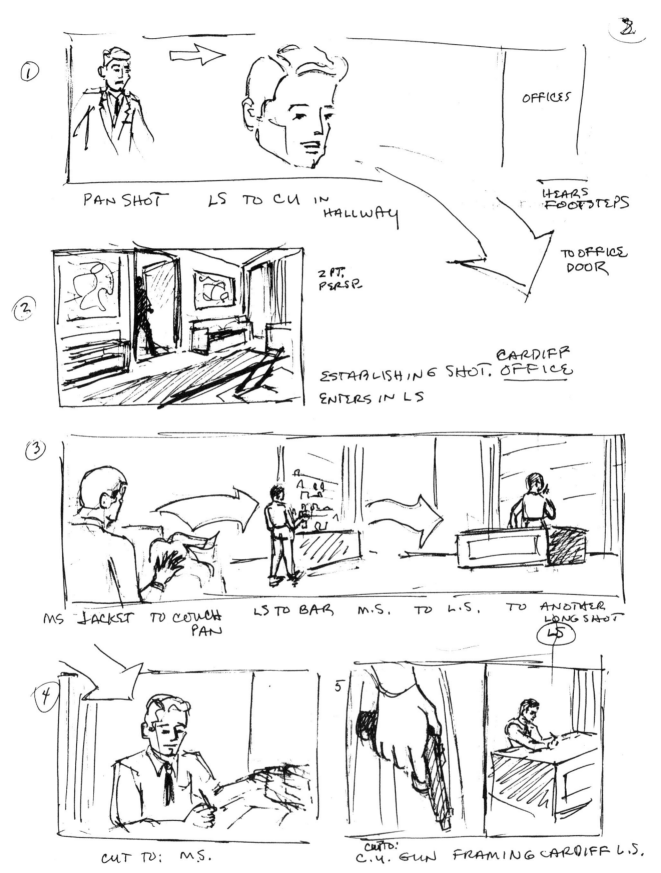

Figure 3–6 *Venus Mountain,* more complete storyboard, now with the types of the shots (close-ups, pan shots, telephoto shots, etc.) that the director and the director of photography will need for the actual shooting of this section of the script. Reprinted with permission.

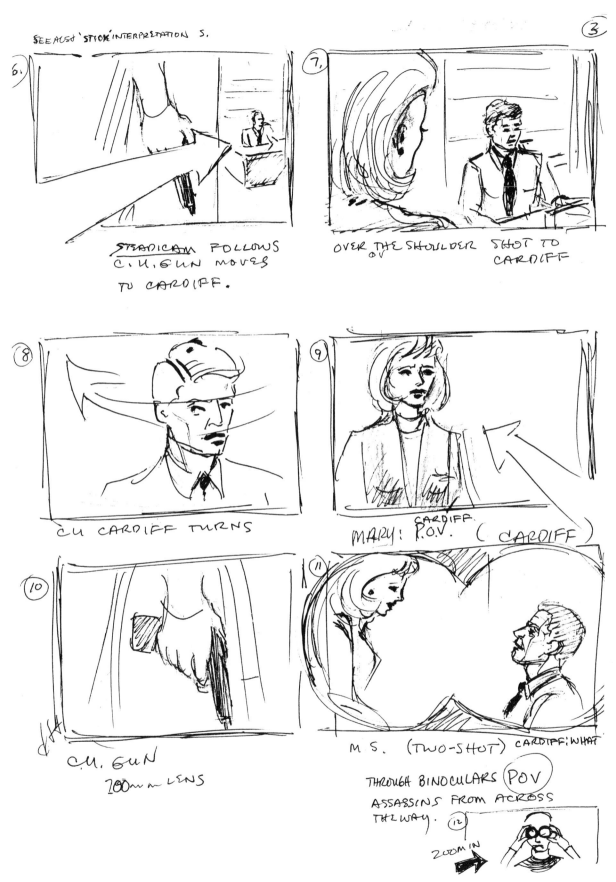

SEE ALSO 'STICK' INTERPRETATION S.

6. STEADICAM FOLLOWS C.U. GUN MOVES TO CARDIFF.

7. OVER THE SHOULDER SHOT TO CARDIFF

8. CU CARDIFF TURNS

9. MARY: P.O.V. (CARDIFF)

10. C.U. GUN 200mm LENS

11. M.S. (TWO-SHOT) CARDIFF: WHAT

THROUGH BINOCULARS POV ASSASSINS FROM ACROSS THE WAY.

12. ZOOM IN

Figure 3–6 *Continued*

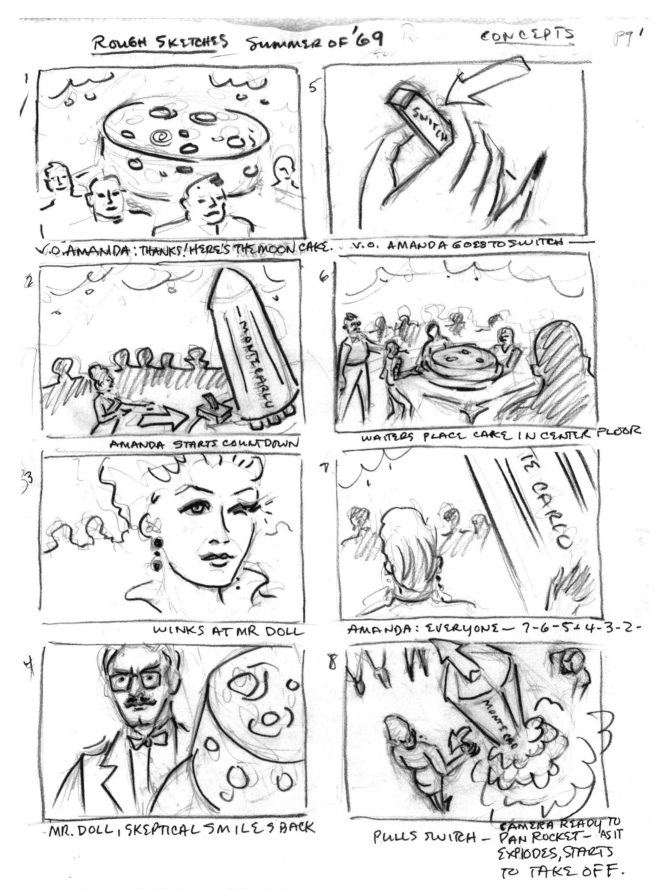

Figure 3–7 Storyboard for *The Summer of '69*, rocket scene.

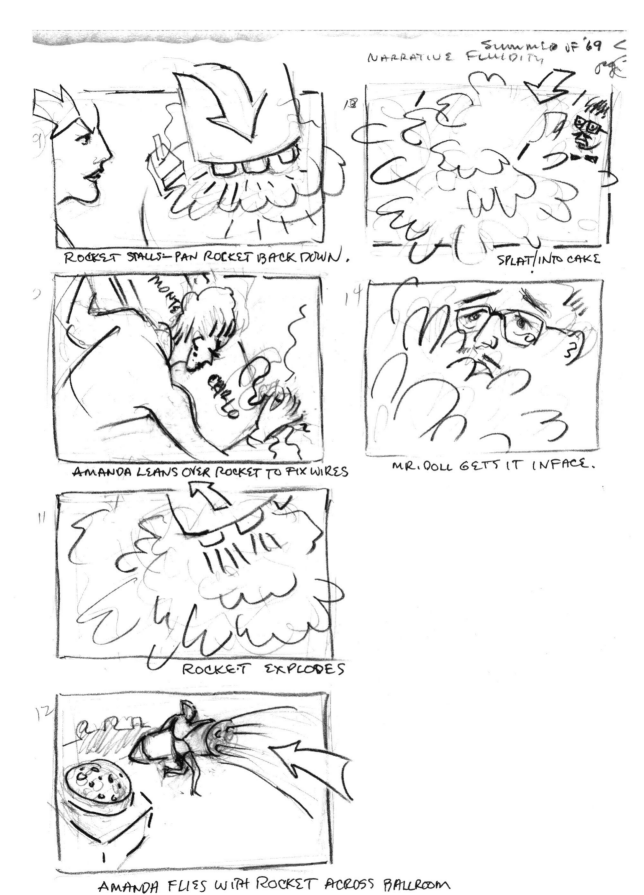

ROCKET STALLS—PAN ROCKET BACK DOWN.

SPLAT/INTO CAKE

AMANDA LEANS OVER ROCKET TO FIX WIRES

MR. DOLL GETS IT INFACE.

ROCKET EXPLODES

AMANDA FLIES WITH ROCKET ACROSS BALLROOM

Figure 3–7 *Continued*

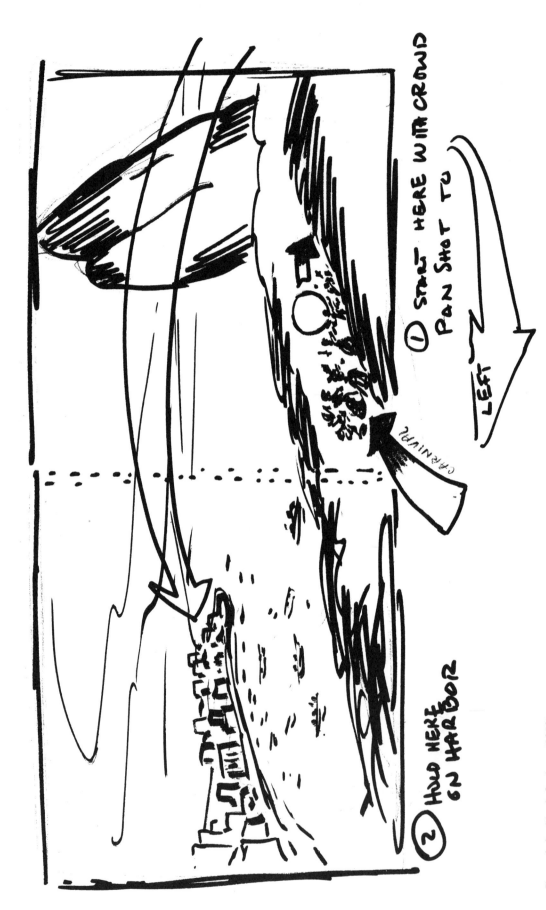

Figure 3-8 *Black Orpheus* (1959).

Carnival, of which the revelers will soon become part. No crane shots here, no CUs, no special effects, just that slow pan, creating a powerful composition that in turn becomes an integral part of the story line action.

The famous still from *Gone with the Wind* (1939) shown in Figure 3–9 has several design elements going for it. Scarlett, running down the path in front of Tara, is framed by (going from FGD, to MGD, to BGD; that is, frontal plane to middle plane to rear plane) the path itself, the large trees, the pillars of the porch, the front door of Tara, and the Tarleton twins inside the portico on the left (see Figure 3–10). The fourth panel is an interpretation of the two-point perspective of Tara. Thanks go to production designer William Cameron Menzies and art director Lyle Wheeler for superb design elements in this medium shot from the opening of the film.

"The concept is what counts" was never more applicable to a shot interpreted in Figure 3–11 from *Beauty and the Beast* (*La Belle et la Bête*), codirected by Jean Couteau in 1946. It's a prime example of one-point perspective, yes, but the idea of Beauty entering the Beast's hallway and seeing candelabras being held by life arms is a stunning visual concept, and it was adapted by the Disney animators in their feature film in 1991. The arrow at the base of the frame indicates Beauty's floating movement toward the camera.

The Beast from 20,000 Fathoms (see Figure 3–12) was constructed using a technique called *claymation*. This was done with stop-motion three-dimensional (3D) modeling to capture the movements of the dinosaur in this feature from 1953. The arrow obviously indicates his forward motion through the city. Notice that he is framed to the right center of the picture plane with his head turning inward to the action. The cars in the immediate FGD in this low angle shot not only are placed there for him to destroy but also to act as a framing device compositionally.

Speaking of imaginative *framing* and the use of *low angles*, Figure 3–13 shows a clever use of both in Stanley Kubrick's epic *Spartacus*, filmed with Kirk Douglas in 1960. That's Kirk on the right, doing battle with Tony Curtis. Both are cleverly framed by the FGD legs of another gladiator. The director of photography, Russell Metts, ASC, received an Academy Award for his brilliant use of color.

Figure 3–14 illustrates a sequence of shots taken from *Terminator 2*, directed by James Cameron in 1991. It is the scene where the boy is pleading with the Terminator not to destroy himself. These storyboard sketches have been done in a very rough conceptual way using only a Rolling Ball No. 7. This touching scene has been broken down into the necessary shots that the director felt told the story. As you can see, they consist of a variety of over-the-shoulder shots, two- and three-shots, and close-ups.

In other words, using just minimal lines, the concept of the scene and each shot that makes it up can be rendered with impact. Enough imaging is put in here that this section of the storyboard continuity easily can serve as a guide not only for the director but also for the director of photography because an indication of light sources can also be seen.

Figure 3–9 Sketch from a scene in *Gone with the Wind.*

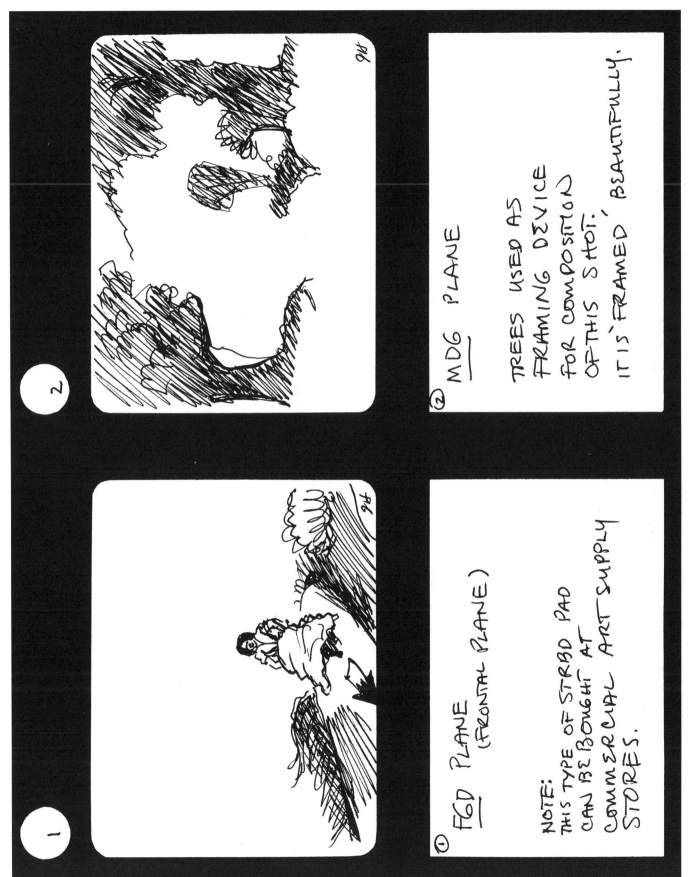

Figure 3–10 *Gone with the Wind,* four panels, shown here in analytical sketches to interpret the use of design elements.

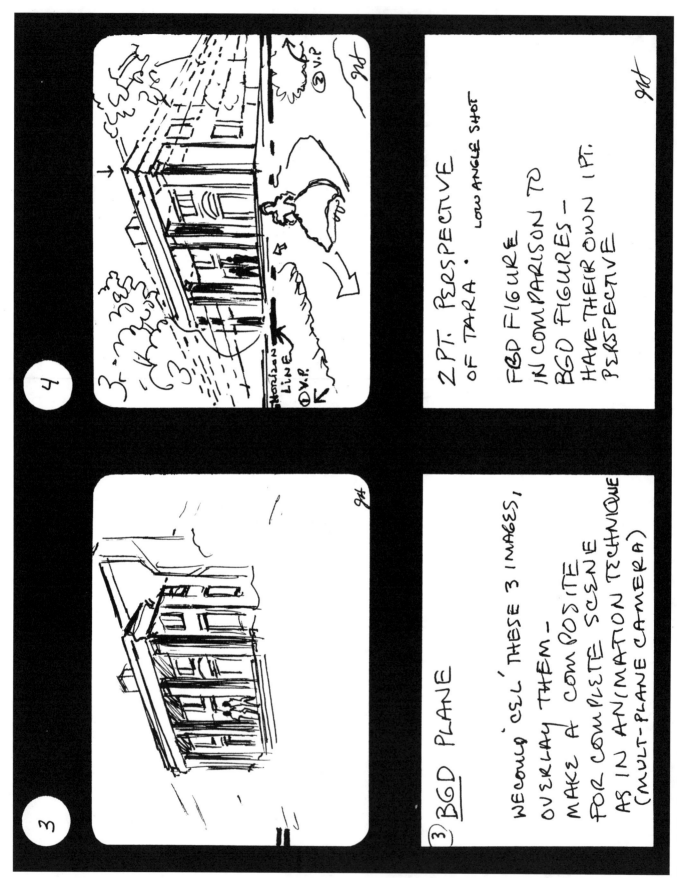

Figure 3-10 *Continued*

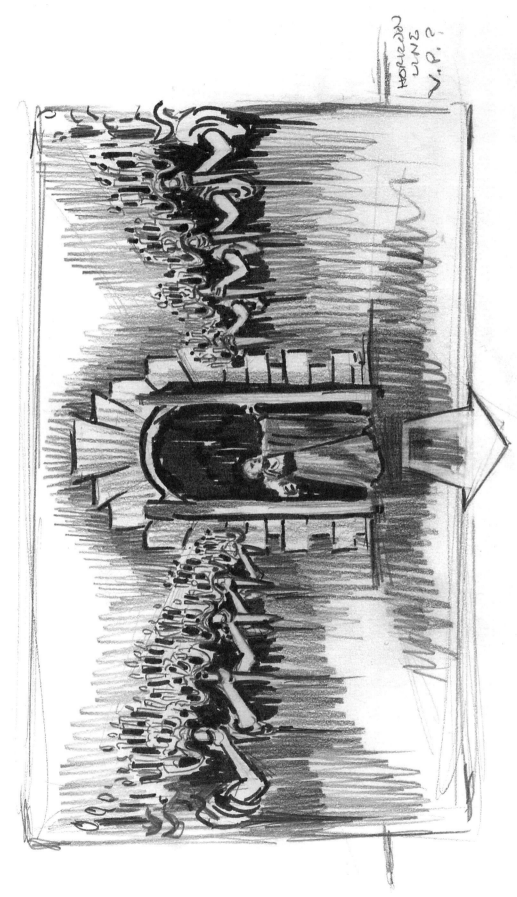

Figure 3–11　Sketch from scene in *Beauty and the Beast*, an example of one-point perspective.

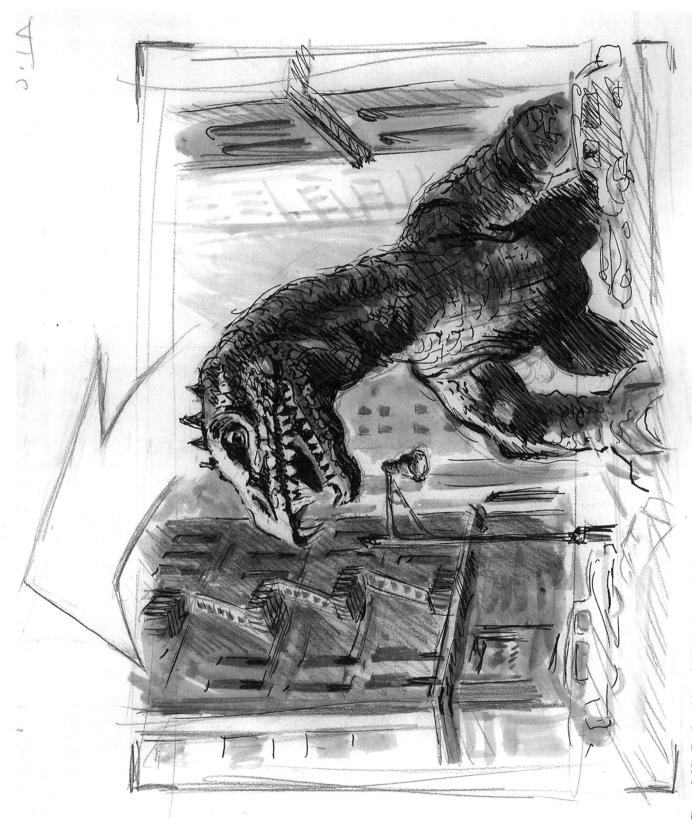

Figure 3–12 *The Beast from 20,000 Fathoms* (1953).

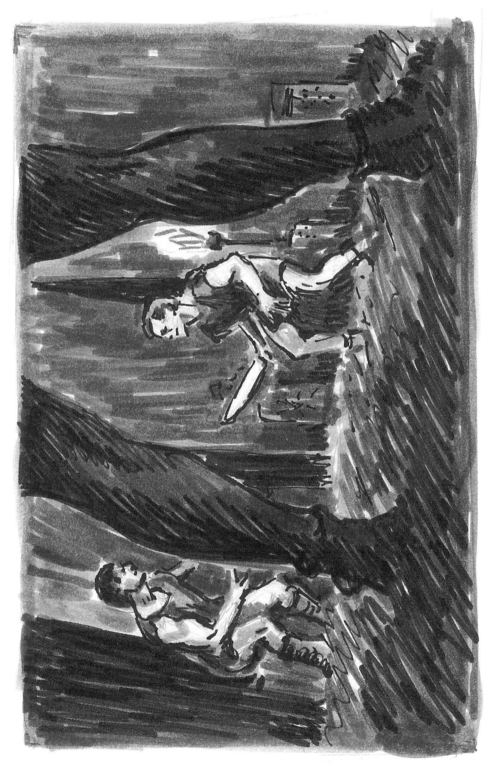

Figure 3–13 *Spartacus* (1960).

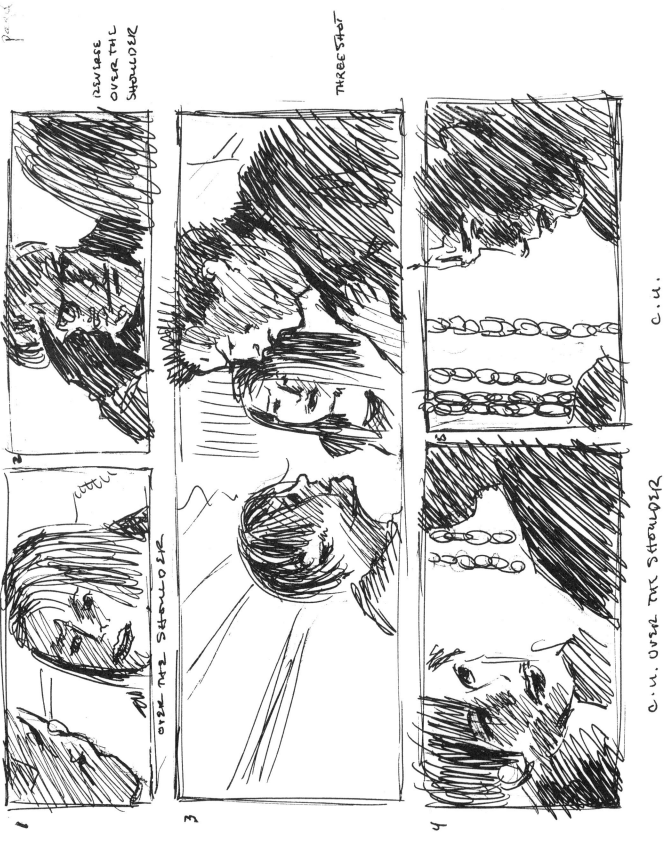

Figure 3-14 *Terminator 2: Judgment Day* (1991).

Figure 3-14 Continued

Exercises

1. Get a hold of a copy of Syd Field's *Four Screenplays* (1994). Select a key scene from each of the screenplays—*Thelma and Louise, Terminator 2, The Silence of the Lambs*, and *Dances with Wolves*—and storyboard it.
2. Like the *Terminator 2* storyboard, format your frames with the horizontal rectangular film ratio of the wide screen—for 35 mm, the aspect is 1.33 to 1; that is, a 4 to 3 relationship of the frame width to the frame height.
3. Pick the scene that has the most dramatic impact for you, one, as in the *Terminator 2* shots in Figure 3–14, that has an ending or culmination to the scene.

Each storyboard should have at least 10 to 15 frames in it. Keep the drawings as simple as possible. You will be the director and select the camera angles and the positioning of the actors (over-the-shoulder shots, etc.).

4

How the Storyboard Meets the Needs of Each Member of the Production Team

Trying to satisfy the visual and narrative requirements of the producer, the director, the director of photography or the cinematographer, the art director or production designer (or both), the set designer, plus the now very important special effects (SFX) team would be no small task under any circumstances. To whom does this chore pass? Often, into the capable hands of the storyboard artist; and he or she needs to be prepared to "create on demand" or at least to be able to deliver professional quality storyboard sketches under pressure when the producer, director, cinematographer, and production designer want to see visual concepts that will illustrate hundreds of shot sequences. Of course, this is why art training is so very important and why a thorough knowledge and facility in drawing, particularly of the human figure in motion as it is played out against a background of three-dimensional planes, is a primary requisite.

For instance, wouldn't it be helpful if a producer could see the storyboards of any given screenplay to figure out costs and stay within an agreed-upon budget (having already worked out a deal for the property). David O. Selznick, the king of producers, went over every storyboard sequence of *Gone with the Wind* with production designer William Cameron Menzies and art director/set designer Lyle Wheeler, both of whom received Academy Awards for their brilliant imagery, giving it a visual consistency that survived three very different directors—Sam Wood, George Cukor, and Victor Fleming (who got the Directing Oscar).

The director will want storyboards to see where he or she is going with shot sequences, blocking of actors, camera setups, and lighting. The director will go over the storyboards of *Sheriff!*, for instance, with the director of photography, who also wants to see the storyboards to tell which cameras to rent, which lenses to use, and what film stock and lighting design will create the right atmosphere for the picture.

As an example, here's a list of possible lenses the director and director of photography may consider when using a 35 mm Syncsound movie camera like the Platinum Panaflex 24/25 or the Arriflex BL III outfit. The 35 mm movie camera is used for filming commercials and

music videos as well to achieve the sharper imagery of film rather than video:

- 35 mm spherical prime lenses—used to film the final shooting script. The lenses can go from 8 mm to 35 mm (wide angles).
- 50 mm lens for normal imaging.
- 75 mm to 200 mm (long lens)/telephoto. Lenses can go from 300 mm to 800 mm for shots taken from an extreme distance, like shooting from the top of a mountain to a portrait shot of climbers in the valley.

The producer, director, cinematographer, and production designer also will want to see storyboard visuals that will illustrate special effects, if any, so that they can figure costs, shot setups, lighting and framing, plus designing the sets in conjunction with model builders, miniature makers, blue screen technicians, and so on.

The *Dictionary of Television and Film* has a great definition of SFX:

> Any visual action, image, or effect that cannot be obtained with the camera shooting in normal operation directly at the action; and which requires pre-arranged special techniques of apparatus added to the camera, action, processing, or editing. Special Effects include contour matting, multiple image montages, split screens, and vignetting; animation; use of models or miniatures; special props such as break-away glass and furniture; simulated bullet wounds, injuries, explosions, floods, fires, and any mechanical or visual effect whether created on location, in the lab during procession, or in editing in postproduction.

Is it any wonder then, that "the powers that be" want to see what's happening? Detailed sketches have to be made, not only of the actors movements, but of any SFX that are indicated in the final shooting script (see Figure 4–1) so the production isn't flying blind.

With special effects, as with everything else, the concept is what counts; and storyboards help render the concept. For example, as I watched the twentieth anniversary screening of *Star Wars*, it occurred to me that the jaw-dropping special effects of this ultimate science fiction film were a result of the creative imaginations of Ralph McQuarrie.

Ralph not only did conceptual storyboards, some the size of a postage stamp, for George Lucas's ILM (Industrial Light and Magic), he also rendered finished production paintings illustrating Darth Vader's mask, Storm Troopers' costumes, awe-inspiring settings such as the Rebel Ceremony set, the interior of the Death Star, the Death Star trench, plus the design of space ships like the Millennium Falcon.

Ralph had able assistance from the legendary matte painting artist Peter Ellenshaw (used as background scenics in composite shots involving live action). Other storyboard artists were involved with *Star Wars*, working under the direction of Joe Johnson. New storyboarding was done for computer generated characters like Jabba for the anniversary release of *Star Wars*. (Further illustrations may be seen in Titelman's 1997 book, *The Art of Star Wars*.)

Beauty and the Beast (*La Belle et la Bête*), directed by Jean Cocteau, was made during the last days of the German occupation of France in 1945; and I use it here as an example of film as a collaborative art form at its most challenging.

Cocteau's filming style was derived from his association with the surrealists in the late twenties and early thirties, some of whom, like Salvador Dali and Luis Buñuel, made their own reputations with, at the

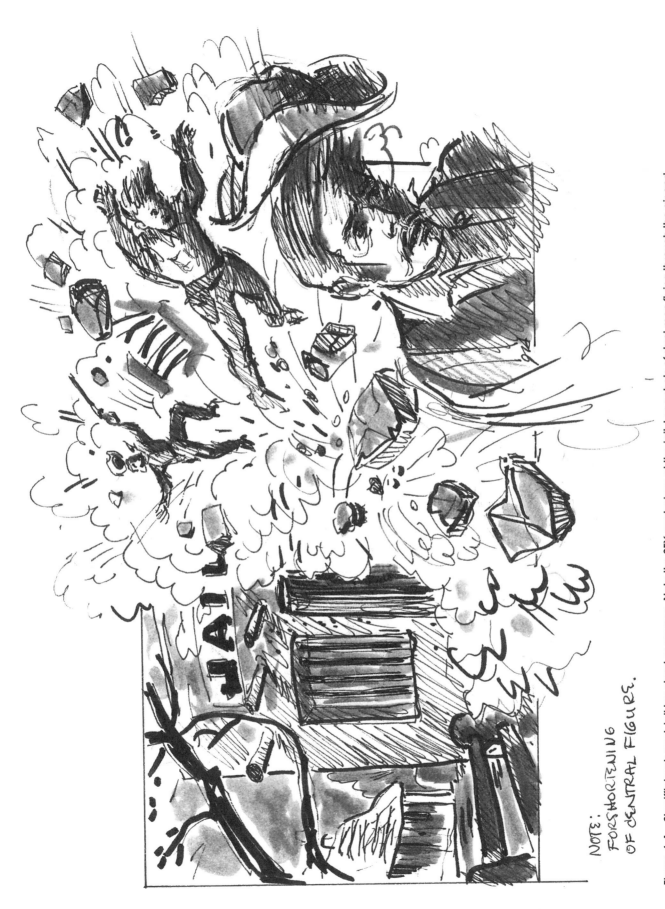

Figure 4–1 *Sheriff!* storyboard, jail breakout sequence. Note the SFX explosions at the jail. Long shots of stunt men flying through the air and subsequent close-ups of injuries to leads will be needed.

time, outrageous films like *Un Chien Andalou*, which contained the memorable cutting of the women's eye (see Figure 4–2), an example of brilliant editing for shock effect.

Interpreting the visual field as a symbolic dreamscape along with the other surrealists is evident in all of Cocteau's films starting with *Blood of the Poet* (1930) through *Beauty and the Beast* and culminating, I think, with his *Orphee* of 1950. All of Cocteau's films should be required viewing.

My favorite is still *Beauty* (even better than the Disney version of 1991), which starred Jean Marais as the frighteningly imposing Beast (Figure 4–3), whose chateau with its surrealistic environment evokes dreamlike movements and many "Is this really happening to me?" situations that confound Beauty at first. Observe, for instance the long row of human arms that hold lit candelabras to guide Beauty into the inner spaces of Beast's foreboding, yet ethereal dwelling (Figure 3–11).

This inventive visual device also was used by Disney Studios in its animated version of 1994. Much of Cocteau's sets were covered with black velvet (see Figure 4–4), not only to add to the dreamlike effect but to make the objects in gray and white stand out and, just as important, to disguise the lack of elaborate paneling and the like to go easy on the budget.

Another brilliant piece of art direction and set design are the sculpted faces that frame the fireplace in the room where Beauty is trying to have dinner (see Figure 4–5). She looks up to notice that the faces have come alive and they are observing her movements.

If ever a collaborative effort was needed to create this masterpiece of filmmaking—a movie that was produced, directed, and shot under the most trying circumstances—it happened here. And, Cocteau's uncanny imagination produced dazzling special effects without one computer in sight. Taking the narrative demands of this fantasy fairy tale, he conjured up his own magical kingdom of filmic slight of hand.

Take, for instance, Beauty's first glance of the Beast in Figure 4–3. She is startled to see not only a repelling beastlike creature, but one who happens to be dressed as a very proper seventeenth century gentlemen and whose sad eyes reveal a tortured spirit imprisoned within his beastliness.

Working closely with his cinematographer and lighting designer, Cocteau conjured up other montage effects, like a magical glove with which the Beast permits Beauty to instantaneously visit her father. A magnificent white horse (see Figure 4–6), always shot in shimmering soft focus, carries Beauty back home, sort of like Dorothy's red slippers. Except that, here, Cocteau did not need color to make colorful points.

Cut to the end of the film where Beast lies dying, having been shot by an arrow from the bow of a statue/guard while stealing jewels for Beauty in a bewitched glass house. When she finally kisses him, fearing his death, he suddenly springs up alive, turning, of course, into an extremely happy and handsome prince. By having Marais fall forward onto the ground, Cocteau then reversed the footage and it appears that the beast springs up from the ground as though pulled by invisible wires. Then he cuts to a nice clinch and kiss, after which the two rise up from a very low angle shot ascending to the heavens amid billowing costumes and clouds (played against a primitive blue screen?) toward the heavens, to the accompaniment of an enchanting and appropriate "happy ending" sound track.

It is a wondrous film, truly a "must see." Wondrous on the surface but also, it turned out, a surrealistic nightmare to produce. Obtaining financing involved trying to convince Credit Lyonnais that this "fairy

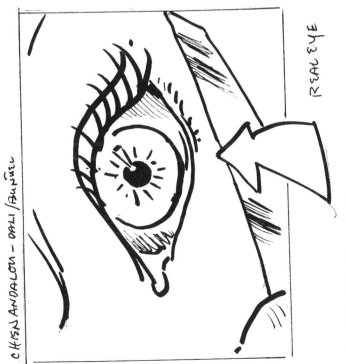

Figure 4-2 Cutting the eyeball.

Figure 4–3 *Beauty and the Beast* (1946).

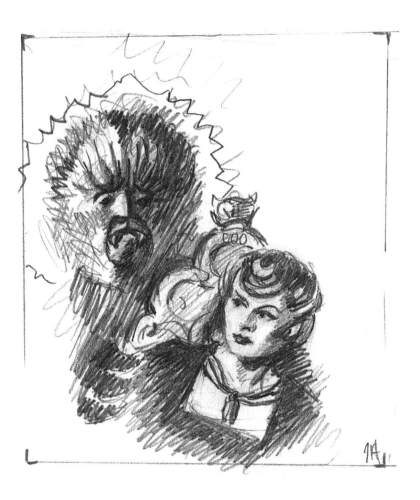

tale" production would sell at the box office. In addition to producing, Cocteau insisted on directing the film.

Can you imagine, after personally writing the scenario, having to face the almost insurmountable tasks of getting the proper shooting permits from the French bureaucracy during the German occupation, casting the various leads and character parts, making production sketches for the set design, basic storyboarding, and working with top Parisian couturiers in designing the period costumes? Add to this the artisan/carpenters, who needed detailed elevations involving exact measurements that, when executed, would bring to three-dimensional life Cocteau's blueprints of his set designs.

Not every production will present the stultifying difficulties Cocteau had to confront and solve. Some film's productions have come close, such as Joseph Mankiewitz's elephantine, cost-overrun *Cleopatra* of 1962. Unlike the case of Renaissance-man Cocteau, most films will have a separate producer, who will be responsible for putting together his or her own package and deal with the issues of funding and budgets.

Traditionally, productions of the French film industry project "family." In the Hollywood scenario, the compartmentalizing of all of the various unions can be intimidating to directors from Europe or Asia. The ideal situation in film production is to work like a family, with every member of the creative force working together to achieve, as with Cocteau, a final product that bears the stamp of the director's conceptual vision.

BEAUTY & THE BEAST

BEAUTY'S BEDROOM
WITH MAGIC MIRROR

Figure 4–4 *Beauty and the Beast*, Beauty's bedroom with the magic mirror.

Figure 4–5 *Beauty and the Beast*, fireplace SFX.

Figure 4-6 *Beauty and the Beast*, Beauty on the magic horse.

Many names roll by in film credits, and most of those belong to people behind the scenes. All producers and directors realize that the ideal situation is to have all the different creative departments responsible to them working as a smooth, well-oiled mechanism—one in which every member of each different team endeavors to satisfy the narrative and the visual demands of a particular scenario that has been targeted for a final production.

Ego certainly has its place in the artistic environs of a movie, TV, or animation studio. All of us need to feel secure in our talents and our chosen professions. But it is important to remember that there is room for everyone. Be a good listener. Consider the other person's point of view regarding artistic problems. Above all, keep a good sense of humor. Remember that you share a common goal—the finished film that goes "into the can."

Exercises

1. Role play the producer, the director, the director of photography, and the production designer. Using tact and diplomacy, tell the storyboard artist what you want. Then, as a storyboard artist, make rough concept sketches for each member of the team as a result of his or her visual demands.
2. Pretend you are the director of a live action film production. Pick three key scenes from a screenplay of your choice and have your storyboard artist (you) make the lighting sketches.

5

Actually Drawing the Components of the Storyboard

Go to the How-To section of any bookstore and you will find many "how to draw" books written specifically to train burgeoning artists. Books with particular emphasis on drawing the human figure in action will be of immense help for the beginning storyboard artist (see Figure 5–1). For those who will be taking film courses, classes leaning specifically toward the unique art form known as storyboarding will be taught and mastered.

For our purposes here, I would like to illustrate some very basic drawing methods that will aid you in developing, I hope, your own special style as a storyboard artist. For me, being aware of the three-dimensionality that exists in the external, perceived world about us is of primary importance, for it will motivate any drawing, even the simplest one (Figure 5–2), to indicate and inform the figures in action within the frames of the storyboard (Figure 5–3), to have that 3D reality about them—the three-dimensional reality of objects and forms existing in a given space.

The sun is our basic light source; and where there is a light source, the form that its rays fall on will cast a shadow—this concept often is missing in supposedly realistic representations.

You can actually draw figures just by indicating the play of light and shade falling on it and shaping it (see Figure 5–4). This light and shade depiction on a figure or object will give it its three-dimensionality.

I remember, in a college art class, the drawing instructor insisting that I draw the light and shade on a hat over and over again until I rendered its structure correctly. You see, the light falling from a side window caused the side of the hat opposite the light to fall into shadow—that shadow must conform to and shape the structure of the hat, thus giving it its three-dimensionality, as in the still from *Cat Ballou* in Figure 5–5. Observe the light and shade shaping the objects depicted.

As an additional aid in delineating the human figure, I suggest the purchase of an anatomical model, usually made of wood with pliable arms, legs, torso, and head (Figure 5–6).

When I was a graduate art student taking a sculpture class, the concept of light falling on three-dimensional forms became more obvious—light and shade shape an object or figure and give it its solid placement in reality (Figure 5–7).

I recently purchased one of those artist's models at an art store for $12.95 here in New York City. It stands about nine inches tall and is

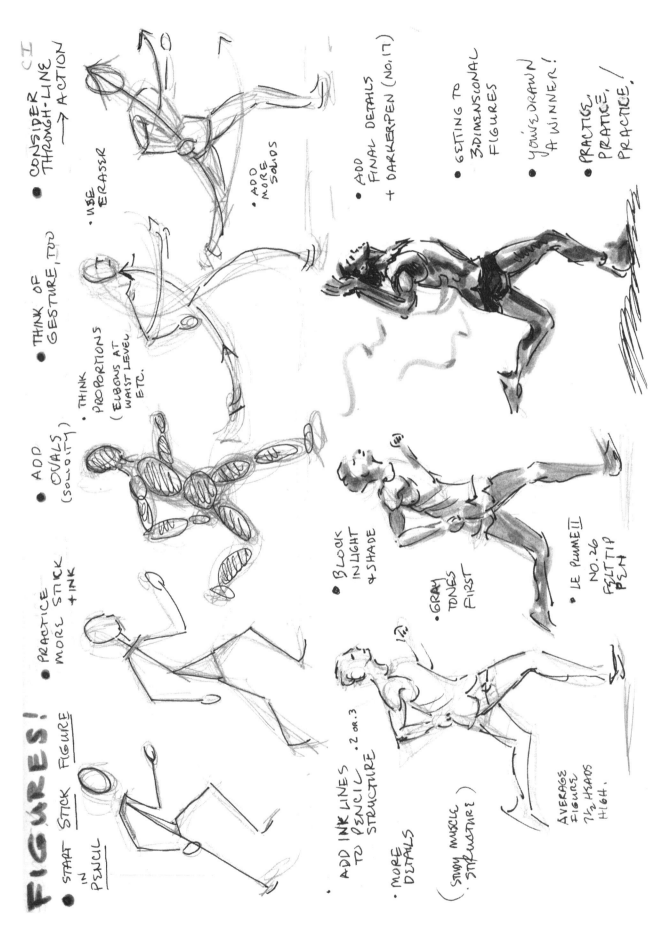

Figure 5–1 Figure running, from stick to full-dimension, delineated with light and shade.

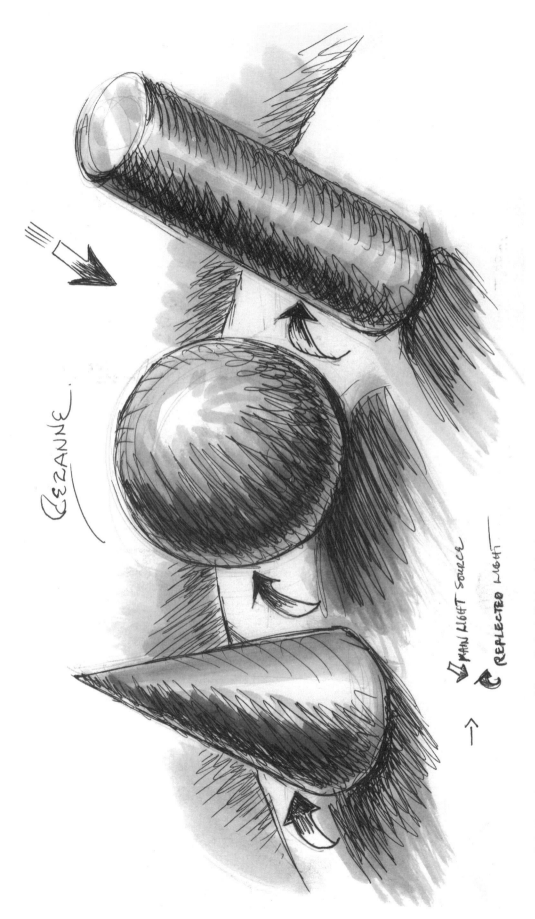

Figure 5-2 The sphere, the cone, and the cylinder in light and shade.

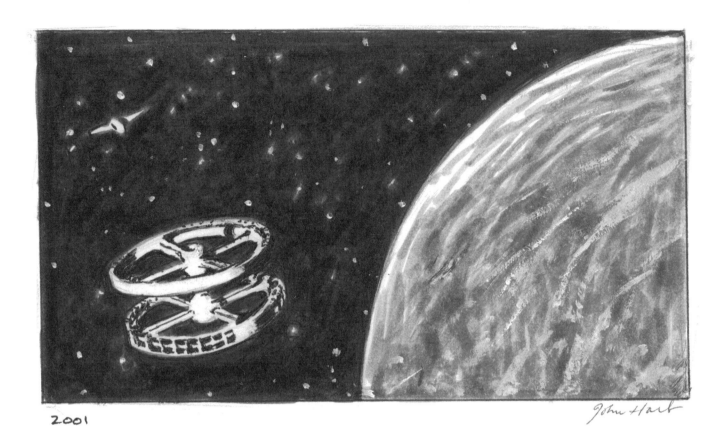

2001

John Hart

THE CIRCLE!/AS A DESIGN ELEMENT

Figure 5–3 *2001* (1968). The 3D circle as a design element is evident in this shot.

great for rendering the proportions of the body in your storyboard images. And, don't just try sketching the model from straight on. Set the arms, legs, hands, head, and so forth in, say, a running position. Then close your left eye, and pretending that your right eye is the camera lens, pick up the figure or model and "zoom in" on it from different angles—low angles, high angles, even turn it slowly in front of your "lens"—and sketch it from these diverse positions (Figure 5–8). This technique will help you develop a more creative eye for your storyboards. Unusual angles make for more interesting storyboards! Not to mention that, at the same time, you are improving your drawing skills.

We might take a moment to discuss the use of color, the psychology of color, its tones, hues, and intensities and their use in films. Just check out "Gamfusion filters" (888-GAMCOLOR), used to change the mood of a scene, and you'll see how many shades of the color spectrum are available to the cinematographer.

Once, when shooting an industrial film for an insurance company, the actress playing the wife in the scene was talking with her husband on the phone. It was getting to be dusk and, in the scene, she was worried about her husband coming home late. To indicate late afternoon, we slowly slid a sheet of bastard amber gel over the key light so that it imitated the orange "sun going down mood" for the shot. Simply put,

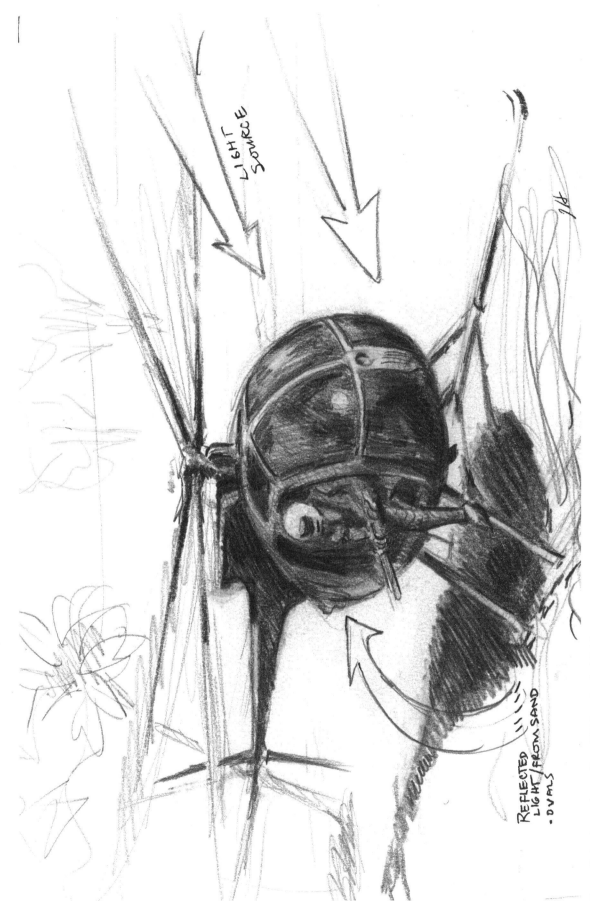

Figure 5-4 *Apocalypse Now* (1979), reflected light.

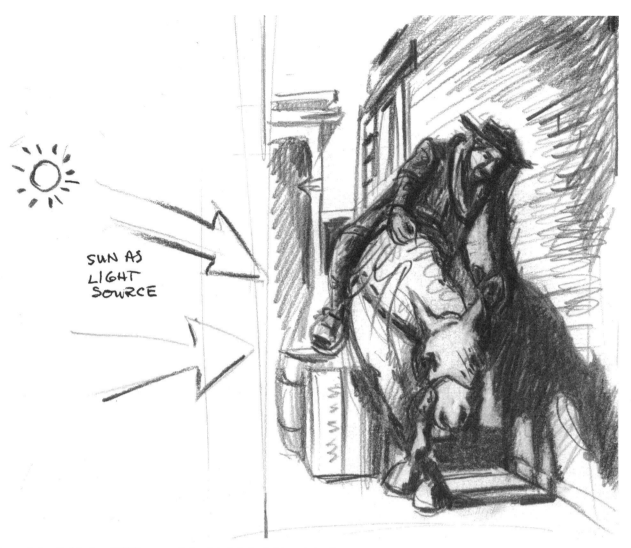

SUN AS
LIGHT
SOURCE

Figure 5–5 *Cat Ballou* (1965), an analytical sketch for light and shade.

though, it's obvious that, to change the tone or mood of a given scene, two points are to be kept in mind: Comedy is light (see Figure 5–9), and tragedy is dark. We might say that melodrama (most of the film content that we've been seeing lately) can be a combination of both, and that doesn't necessarily mean that the movie has to be shot completely in tones of gray.

It also is not difficult to consider that the "light" color yellow denotes cheerful, optimistic, summertime, and so on. Blue, outside of being a background for puffy white clouds, often is used to denote a depressing scene and for night shots and such. Note, in the sketch from *Batman and Robin* in Figure 5–10, that blue is the dominant color of Mr. Freeze. Also notice the arrows used as action lines.

Red, yellow, and blue, being the primary colors, can be made into secondary colors by mixing at will. Yellow and blue make green; red and yellow deliver an orange, and so forth. Purple (blue and red), especially when a bit of black is added to it, starts to lean into the darker spectrums. Red reads danger, and all you have to do is watch its extensive use in films as visual jolt for murder and mayhem. Just remember, save red for something really "hot."

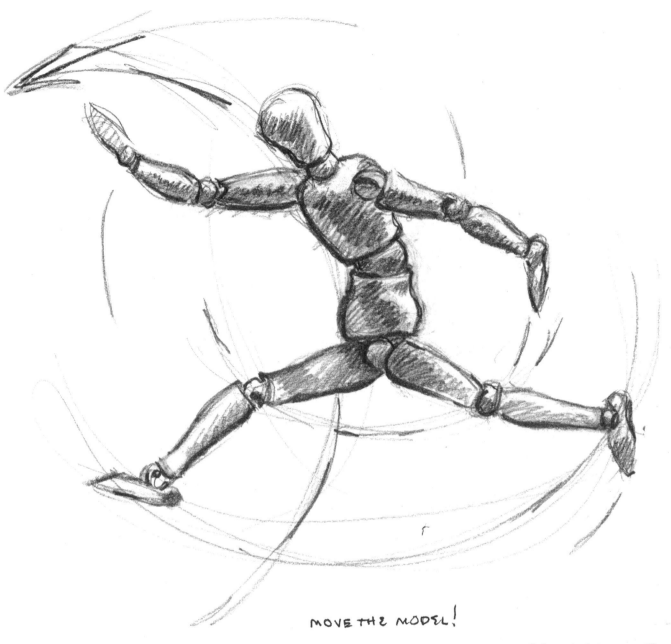

MOVE THE MODEL!

FIGURE MOVEMENT
LEGS/ARMS
BETTER TOO LONG
THAN TOO SHORT

EXAMPLE OF:
CONTRAPOSTO / TWISTS AWAY
FROM CENTERED
TORQUE: WEIGHT

VOLUMES MOVING IN SPACE

Figure 5–6 Using an anatomical model.

Green is the color that projects calm and the environs of the forest, like John Wayne at ease walking through the lush Irish landscapes in John Ford's *The Quiet Man* (1952), until he encounters Maureen O'Hara, sporting her long, flaming red, windblown hair (Figure 5–11). After that, it's a battle royal through the brownish town until their final clinch

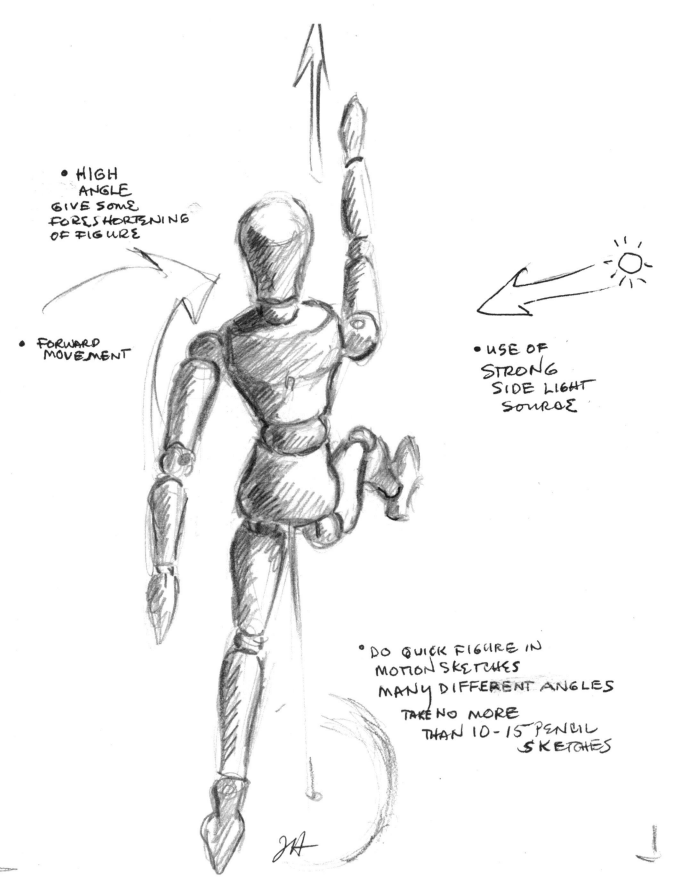

- HIGH ANGLE GIVE SOME FORESHORTENING OF FIGURE

- FORWARD MOVEMENT

- USE OF STRONG SIDE LIGHT SOURCE

- DO QUICK FIGURE IN MOTION SKETCHES MANY DIFFERENT ANGLES TAKE NO MORE THAN 10-15 PENCIL SKETCHES

Figure 5-7 Include light and shade in drawings of the model.

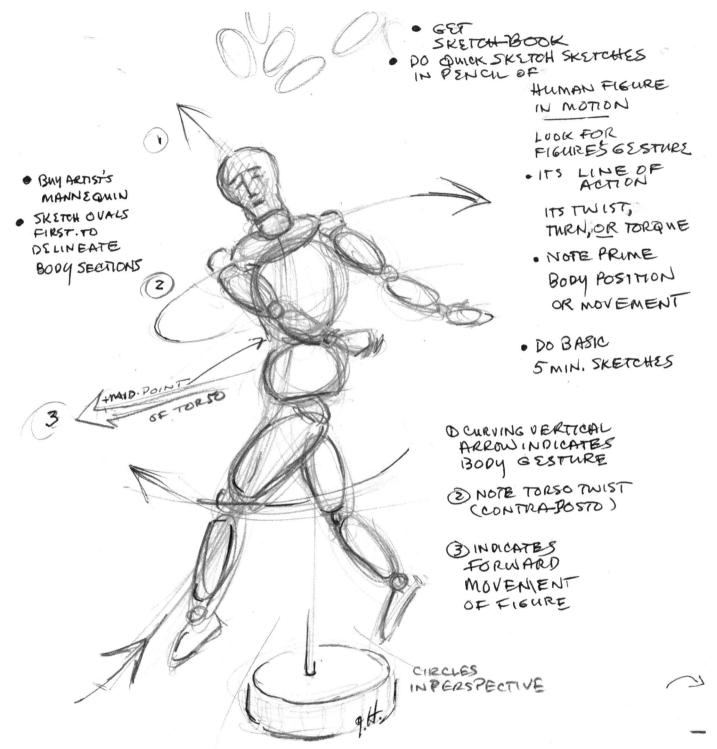

- GET SKETCH BOOK
- DO QUICK SKETCH SKETCHES IN PENCIL OF
 HUMAN FIGURE IN MOTION
 LOOK FOR FIGURE'S GESTURE
- ITS LINE OF ACTION
 ITS TWIST, TURN, OR TORQUE
- NOTE PRIME BODY POSITION OR MOVEMENT
- DO BASIC 5 MIN. SKETCHES

- BUY ARTIST'S MANNEQUIN
- SKETCH OVALS FIRST. TO DELINEATE BODY SECTIONS

① ②
③ + MID. POINT OF TORSO

① CURVING VERTICAL ARROW INDICATES BODY GESTURE
② NOTE TORSO TWIST (CONTRA-POSTO)
③ INDICATES FORWARD MOVEMENT OF FIGURE

CIRCLES IN PERSPECTIVE

Figure 5–8 Using the model to sketch the human figure in action, whose height is normally 7 $\frac{1}{2}$ heads high depending on sex and racial characteristics.

amidst the shamrock greens surrounding their thatched roof cottage. In the background—a brilliant blue sky.

Like mixing shades of black and white, color also can be "grayed down" or toned down to soften its effect. As with any art form, save the

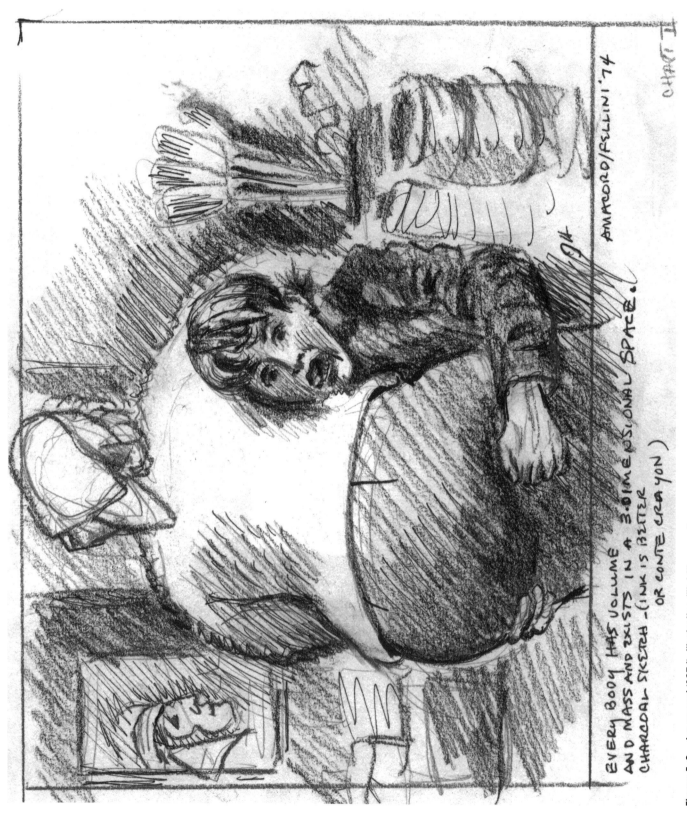

Figure 5-9 *Amarcord* (1974), illustrating "light" comedy.

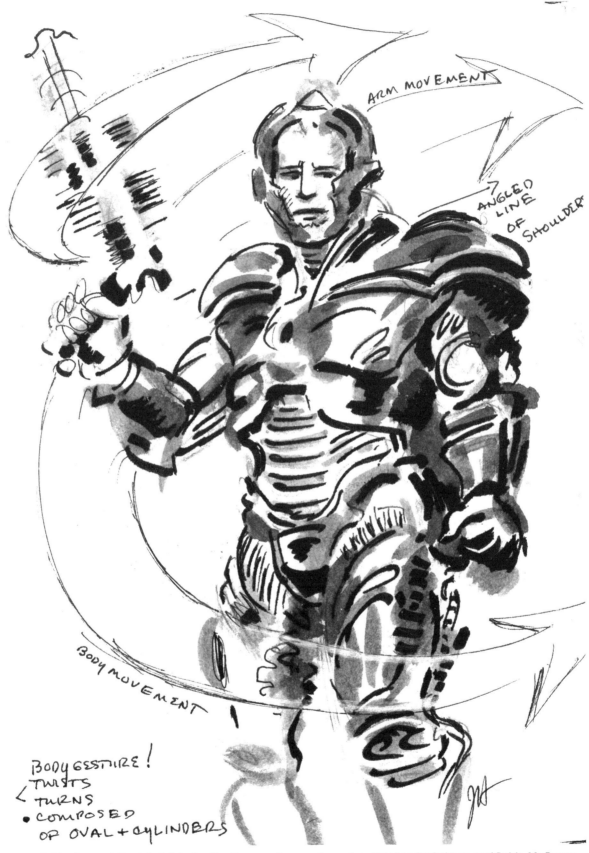

Figure 5–10 An analytical sketch indicating the use of arrows for action direction for *Batman and Robin*, Mr. Freeze.

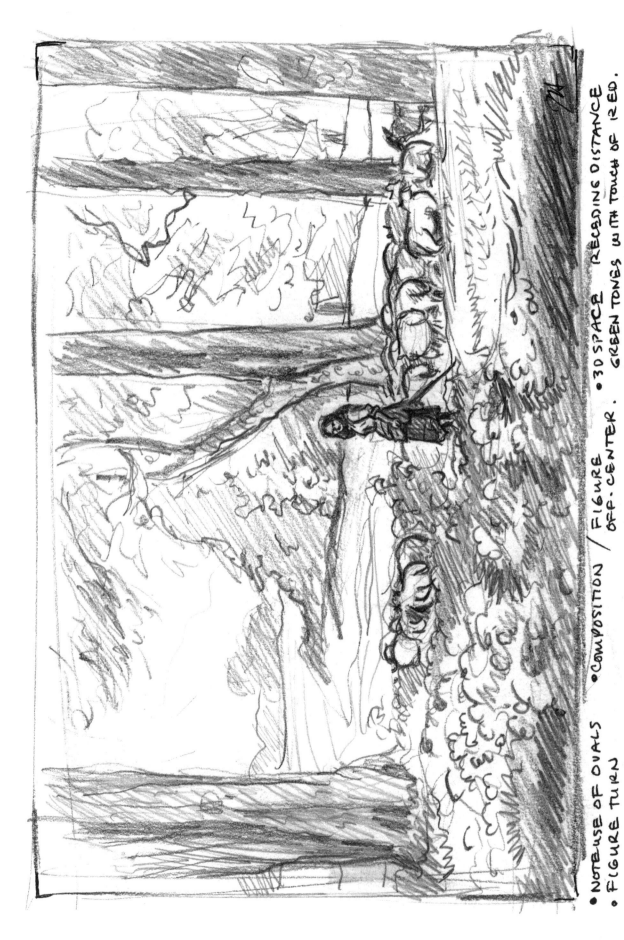

• NOTE USE OF OVALS • COMPOSITION / FIGURE • 3D SPACE RECEDING DISTANCE
• FIGURE TURN OFF-CENTER. GREEN TONES WITH TOUCH OF RED.

Figure 5-11 *The Quiet Man* (1952).

blatant, strongest color for the strongest image, the peak moments in the script.

And as with good acting, don't give it all away at once. Too much of anything can be boring. Learn early to be subtle, and save the fireworks for the Fourth of July, or as background high jinks for climatic red-lipped kiss between Cary Grant and Grace Kelly in Alfred Hitchcock's *To Catch a Thief*, a romantic adventure film sprung on the public in 1955. However, I do believe that as a romantic comedy it could just as well have worked in black and white. I mean, we perceive fireworks for what they inherently are just as well in black and white.

So, color can be muted, grayed, "played down" to render it more subtle or to make it recede to the background. Current examples include *Mrs. Brown* (1997), with its soft woodsy umbers and verdant forests and grounds, which could be contrasted to the rich Tibetan reds and yellows panoplied in Martin Scorese's *Kundun* (1997). Add white to any primary color, and you move it into the chromatic area of pastels. Think of Degas's ballet dancers.

Try to screen the 1940 *Thief of Baghdad* (shown frequently on AMC) produced by The Archers, with Oscar-winning Technicolor cinematography, then wait for the shot when the evil Wazir (in an opulent black turban) persuades the princess to smell a lustrous blue rose. In close-up, the razor-sharp shot has maximum visual impact. It is different and stands out as the ultimate blue flower because the rest of the colors in the scene were filmed in soft creamy tans and pastel pinks for contrast.

We could say, picking up on that Actors Studio bromide, "what's the motivation?" and apply it to the use of color as it is going to be used in a given screenplay. No matter what period of time is dramatized, its chromatic values always are motivated by the mis-en-scène and the emotional-psychological makeup of the characters. Actors are instructed by competent acting coaches not to give away the all the emotions in the beginning of a scene. The same advice could be given where the restrained use of color is concerned.

According to Auguste Renoir, "The best color use can be observed right there in nature, and you will note, nature uses its chromatic repertoire with a great deal of discretion." Check out the use of color by the Impressionists in any art history book. Note: Tips like putting a dash of red off-center in a green landscape always works or a splash of orange in a predominantly white and gray scene can give the shot a visual punch. Moving close to a black and white film, one can use monochromatic colors; that is, colors and their shades and hues based usually on one tertiary color like brown (the right mix of orange and purple).

One classic example of the subtle use of color with soft, yet lustrous intensities, is the Japanese masterpiece *Gate of Hell* (1953), which received Oscars for best foreign film and for costume design. Another Oscar for color and costume design was awarded to Cecil Beaton for *My Fair Lady* (1964; see Figure 5–12).

For me, *Gate of Hell*, a drama of medieval betrayal in Japan, is a synthesis of brilliant, yet quiet coloration. It is a film that perhaps transcends the chromatic bridge between the black and white film and the color film. If I were to recommend one book that is a compendium of the best of Hollywood's black and white and Technicolor films, it is Ronald Haver's *David O. Selznick's Hollywood* (1985). It's full of high-quality films from an exciting producer resulting in the spectacular Technicolor mis-en-scènes of *Gone with the Wind* (1939), directed by

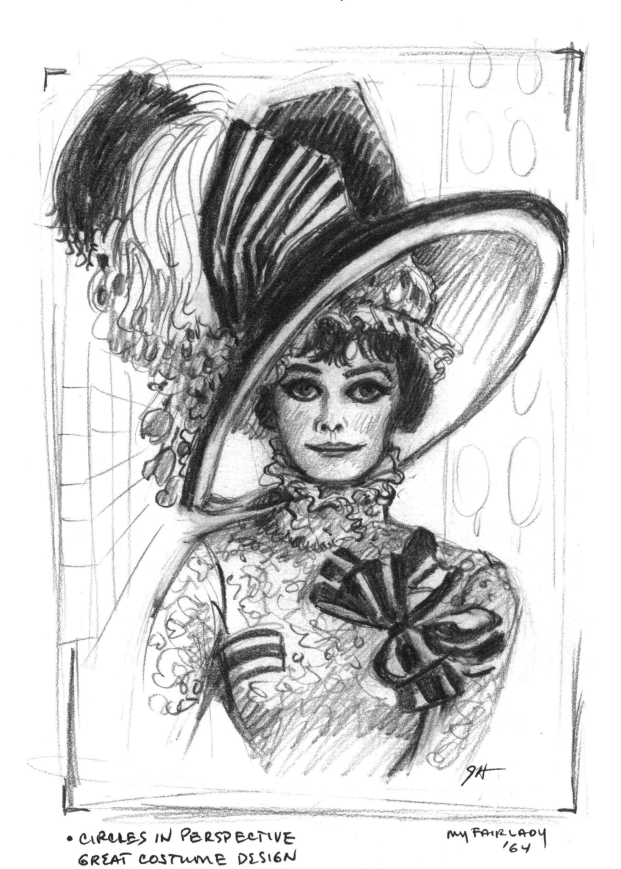

• CIRCLES IN PERSPECTIVE
GREAT COSTUME DESIGN

MY FAIR LADY
'64

Figure 5–12 *My Fair Lady* (1964).

Victor Fleming, or in the rich, lustrous black and white cinematography of *Rebecca* (1940), directed by Alfred Hitchcock.

This book should be owned by anyone interested in the entire gamut of filmmaking. It contains at least 1,500 illustrations in black and white and color. From preproduction conferences involving storyboarding, set design, costume design, set decoration, all the way up to the actual production scheduling involving original shots and camera setups (see Figure 5–13), this volume alone could give us insight into the multiple areas of visual enhancement that make for breathtaking filming.

Producing a film, commercial, or animated cartoon requires intensive collaborative efforts. The storyboard artist, working from the concepts given him or her by the director, can be one of the key creative figures helping to integrate all of the diverse elements that will go into developing the look of the finished project.

The visual application of black and white cinematography comes through a well-rounded knowledge and technique of its rich, tonal styles when viewing the immortal black and white film classics. Rent any of the aforementioned films on videotape. Keep a sketchbook— make rough sketches of moving figures (Figure 5–14). Try using stick figures, cylinders, figures, scribble figures. Remember! It might be difficult at first, but it's a start and you will become more proficient with more practice.

Filming in black and white has made a big come back, used to great effect, for example, in Spielberg's *Schindler's List* (1994), which actually was released on color stock, giving it a richer chiaroscuro effect. This very popular film style is derived from legendary detective movies like Humphrey Bogart in *The Maltese Falcon* (1941), directed by John Huston, and *Out of the Past* (1947), directed by Jacques Tourneur.

These trenchant films (with actors sporting the requisite trench coats) have been tagged with the term *film noir* by the French nouvelle vague (what's new?) and the New Wave crowd in the 1960s—take your pick. *Film noir* translated by me would be "Shoot it inexpensively at night in and out of the black shadows." The common theory is that, because the *This Gun for Hire*-type of detective films were made during World War II, expensive sets and lighting equipment were scarce. The films were shot in low light situations, making audiences less likely to notice the lack of gargantuan sets and the wartime cutback on the use of electricity.

We readily can see the influence of the film noir genre in Jean-Luc Godard's *Breathless* (1959) and in the searing drama *The 400 Blows* (1959; see Figure 5–15) by the ever-stimulating François Truffaut, who also gave us *Day for Night* (1973), his Oscar-winning "how to make a movie" script conceit.

Here again, *Day for Night* could have had just as much dramatic impact if it had been shot in black and white (and thoroughly storyboarded), and a movie that influenced Truffaut tremendously was Hitchcock's *Psycho* (1960; see Figure 5–16). Who needed color in the infamous shower scene? Anyway, Hitchcock decided that the most realistic looking blood could be simulated best in black and white by using chocolate syrup. Incidentally, a result of Truffaut's homage to Hitchcock is evident in his "dark" comedy *The Bride Wore Black*, released in 1968.

Although the current public wants color served with its films, the storyboard artist can save money for the producers *and* give them the visceral impact they seek with storyboards executed in black and white with the added dimension, perhaps, of shades of gray. Keep in mind that the color orange in its various shades and hues, especially when its

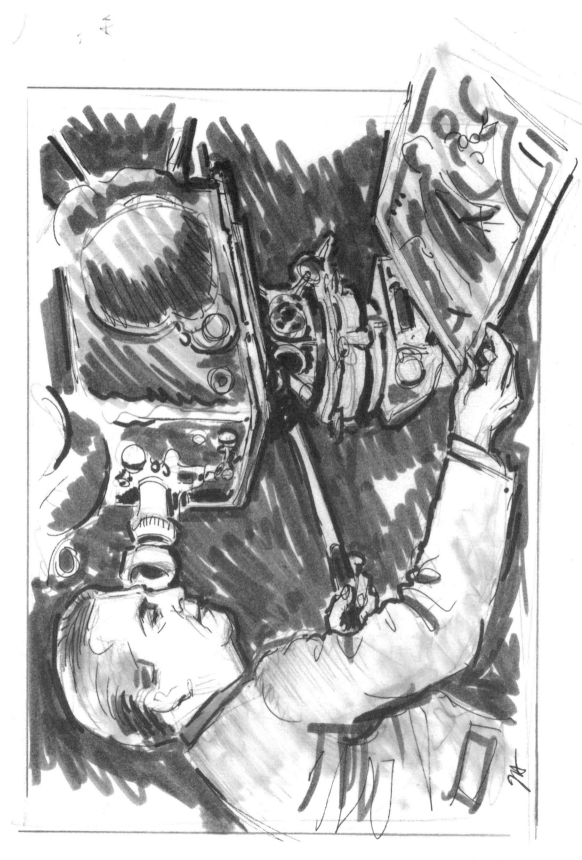

Figure 5–13 An interpretive sketch showing Menzies checking camera positions against his storyboard for *The Devil and Miss Jones* (1941).

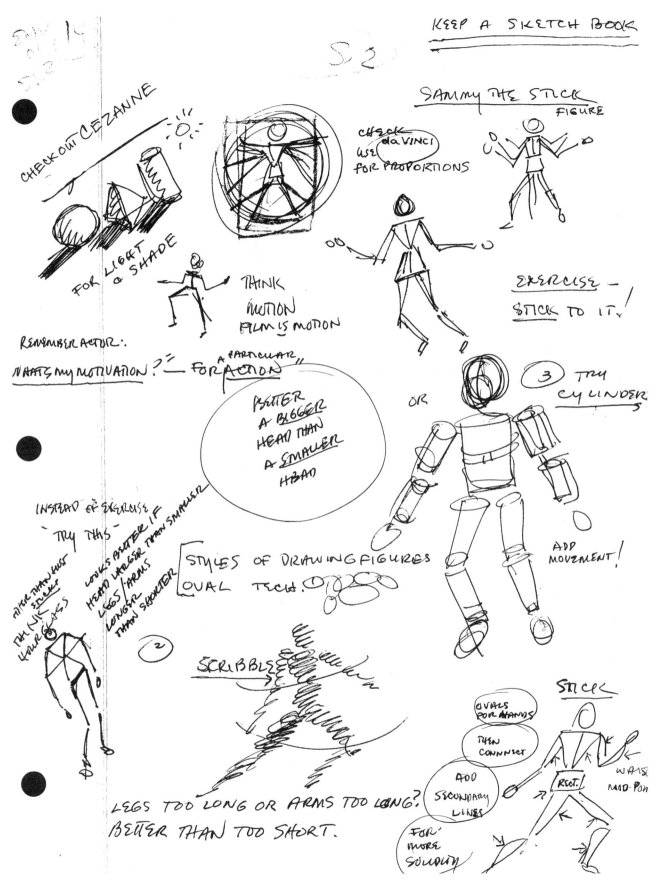

Figure 5–14 Sketchbook exercises.

Figure 5–15 *400 Blows* (1959).

tined with red, is a natural for sunsets or something like *Dane's Inferno* (1935), if it were to be reshot in lurid color. And, for the extremely high incident of explosions in current blockbusters, red-orange works every time. Perhaps, you could throw in a bit of hot yellow, as witnessed in those unstoppable computer assisted lava flows used to great effect in *Volcano* (1997).

Good design also is about developing a sense of proportion, a feeling for what "works" behind the frame. A large tree framing the shootout at OK corral? A small tree? No tree at all? How about the action hero framing the scene instead or, maybe, just a close-up of his gun in the extreme foreground, with an open gate in the left middle ground (see Figure 5–17)?

The artist's entire effort should be to keep the viewer visually stimulated. Viewers want to see the results of the creative eye. An awareness of the various planes that exist behind the picture plane will help the artist think not only in great composition terms but three-dimensionally as well. For instance, does the large figure in the foreground plane "play off" against the smaller figure existing in the plane of the barn door? With the distance of depth of field involved, we certainly wouldn't want them to be the same size. In reality, life as we observe it consists of a series of receding planes.

In Figure 5–18, the frontal plane is made up of two large vertical tree limbs on which fish are being dried. The second plane has the boy moving off center left of the frame on a horizontal limb. Existing in the third receding plane is a girl with outstretched arms to the right of the frame. Water receding toward the horizon could be considered a fourth plane. The figures have been rendered simply but solidly.

I finish this chapter with some basic sketches that I've made from one of the most famous films of the twentieth century, the silent film *The Battleship Potemkin* (1925) directed by Sergei Eisenstein (Figure 5–19). Frames 76 through 80 show us the design elements and conflict of forces at work in each dynamic shot. Frames 82 through 84 have been drawn very simply, but they still convey the sequence of action. In frame 85,

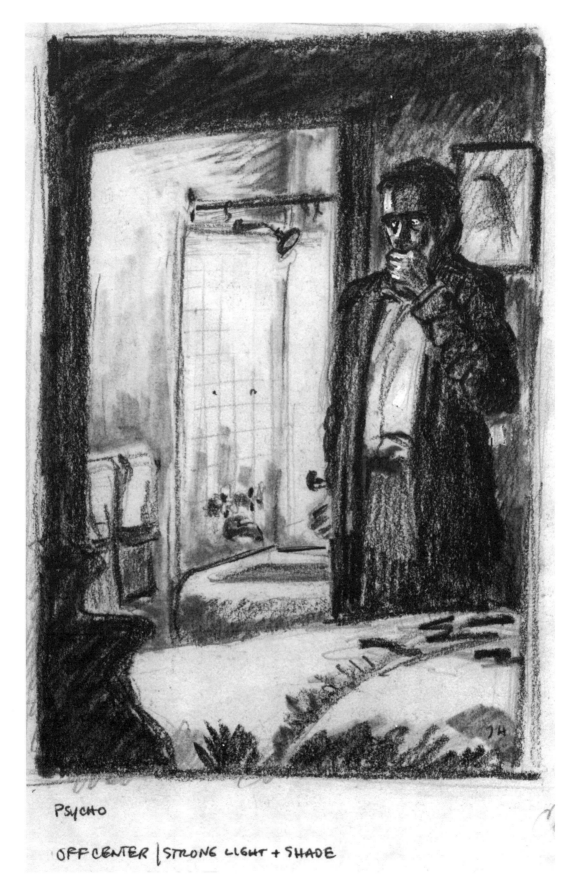

PSYCHO

OFF CENTER | STRONG LIGHT + SHADE

Figure 5–16 *Psycho* (1960).

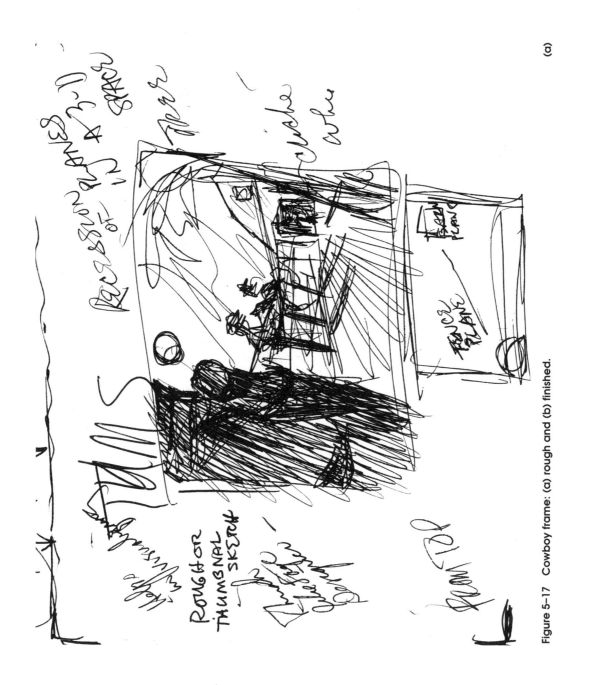

Figure 5–17 Cowboy frame: (a) rough and (b) finished.

SHRIPP '97 (HART)

→ NOTE RECEDING
PLANES — FORGROUND TO MIDDLE GROUND TO BACKGROUND
(FRAMING THE SHOT — 1 PT. PERSPECTIVE — LIGHT SOURCE ?
& FRONTAL PLANE

FINISHED SKETCH

(b)

Figure 5-17 Continued

RECEDING PLANES • PLACEMENT OF FIGURES
OFF-CENTER
FRGD FRAMING.
SOFT OVERHEAD LIGHTING

TIKO + THE SHARK

Figure 5–18 *Tiko and the Shark* (1966).

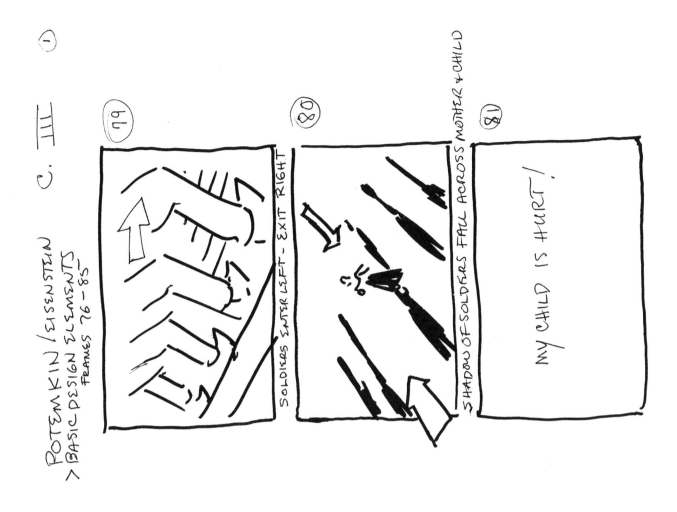

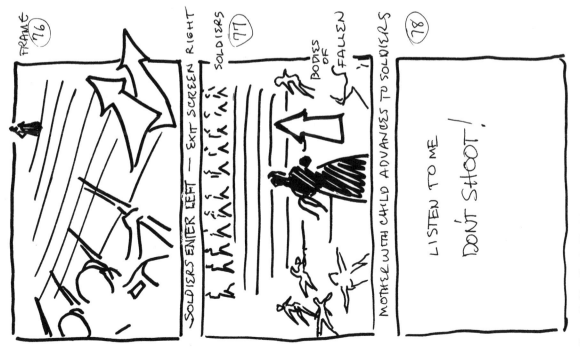

Figure 5-19 *The Battleship Potemkin (1925).*

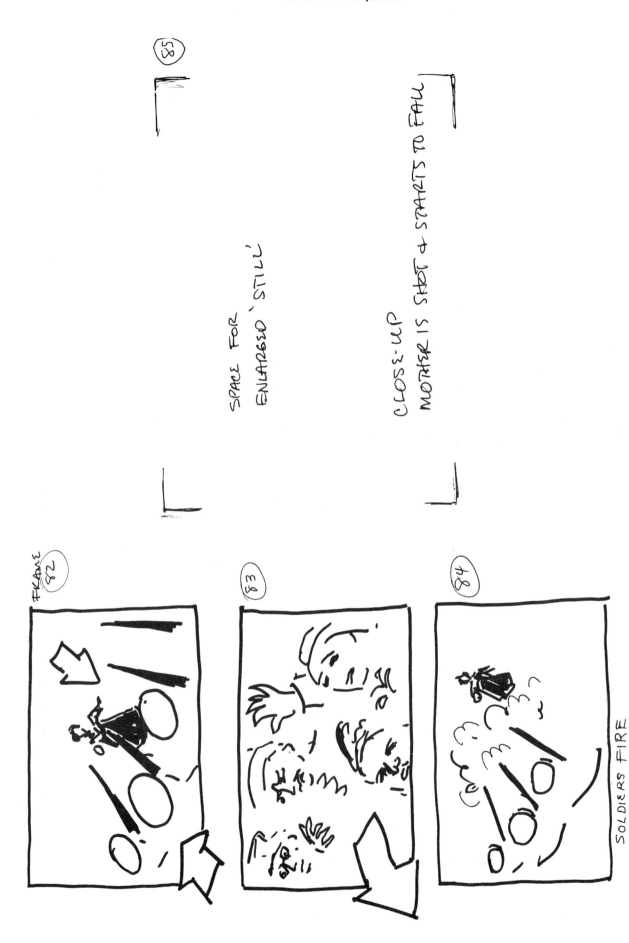

SPACE FOR ENLARGED 'STILL'

CLOSE-UP
MOTHER IS SHOT & STARTS TO FALL

FRAME 82

83

84

SOLDIERS FIRE

Figure 5-19 Continued

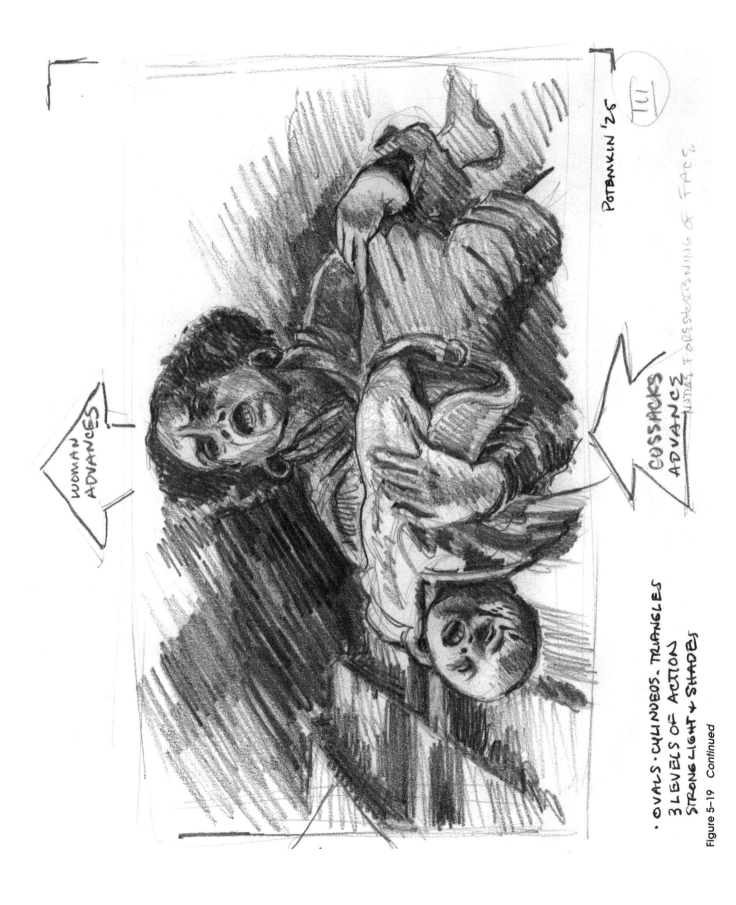

Figure 5-19 *Continued*

the mother is shot and starts to fall. It has been rendered in full dimensional light and shade.

Perhaps, with practice, patience, and persistence, you can make such a transition from simple figures to full dimensional renderings. Although in this book we are trying to help the "untrained" become more proficient artists, so that they feel more facile in rendering storyboards, we also have to remember that one's original concepts or ideas are important, too. It's my hope that, through the use of the techniques in this book, you will be able to visualize these prime concepts in a more professional way through storyboarding.

Exercise

Sketch with stick figures the body walking, running, sitting, jumping, throwing, and fighting. Do three sketches of each movement.

NOTE: Being able to draw the human figure quickly and with great facility requires a great deal of discipline on your part. Don't forget to carry that sketchbook with you and make sketches from life!

6

More Drawing Techniques: Drawing the Moving Action Figure in the Storyboard

The John Cameron film *Titanic* (1997) has been described by one critic as the *Gone with the Wind* of disaster movies, and I agree. If nothing else, *Titanic* should be seen for its seamless use of special effects, computer graphics (CG), and compositing (by Digital Domain), one of the many reasons for its having been heavily storyboarded. I was particularly impressed with Cameron's use of a very fluid camera technique, possibly because the ship was modeled on the computer. Disney's *Lion King* also benefited from of this ability to "fly" the camera anywhere. Burton's *Nightmare Before Christmas* extensively used computer controlled cameras to achieve the same fluidity.

Figure 6–1 shows some rough sketches in pen and ink taken from memory and involving a scene that takes place on the prow of the *Titanic*. It begins when the character played by Leonardo De Caprio gives his love interest, played by Kate Winslet, a "let's pretend" flying lesson. Establishing shots (which tell the viewers where they are) of them having arrived at this spot on the prow of the ship have already been seen, of course, before this low-angle scene was shot.

You will notice that I have kept the sketches very simple. Like any beginning artist, I use little more than triangles to draw the ship and use basic stick figures to indicate the placement of the two lovers.

Frame 1. We see them in a medium shot heading further out to sea in late afternoon. The arrow here is used to indicate the camera moving along with the ship. Again, I have used simple line drawings to indicate their position right of the frame.

Frame 2. The arrow indicates that the camera will begin its move from a low angle medium shot beneath the prow of the ship to take in the actors as it continues to move above them. Here, again, the drawing itself is simple enough that anyone could draw it. De Caprio's character at this point begins to move behind Winslet.

Frame 3. This frame indicates that Cameron's camera has continued its ascent from below the actors to take them in straight on and then to rise above them as though we were sea gulls flying above them. Again, the drawing is not complicated nor is

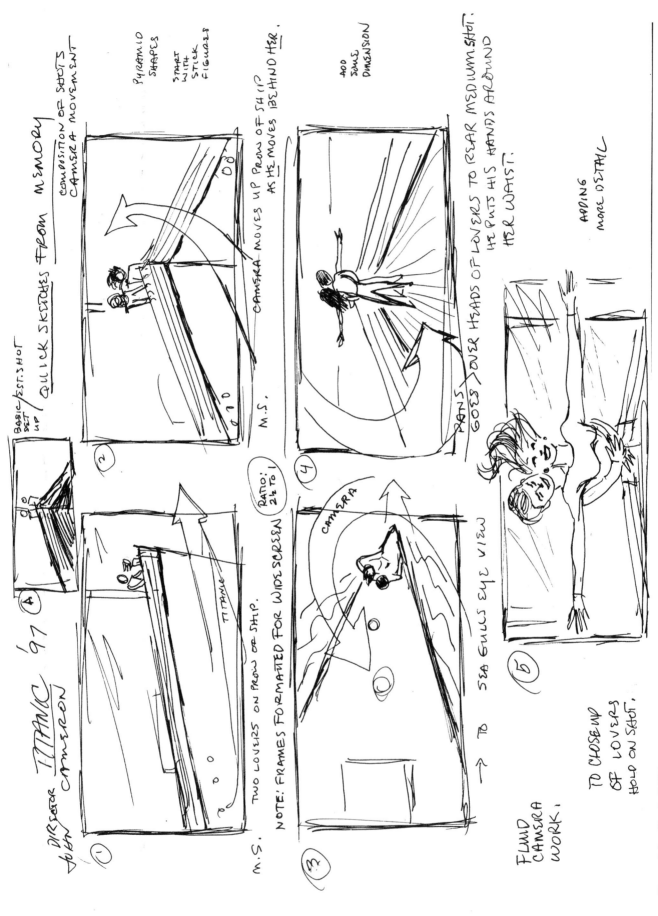

Figure 6-1 *Titanic* (1997).

the arrow, indicating the arc of the camera movement (helicopter shot).

Frame 4. The frame shows that the camera has moved along a 180 degree arc that came up from below, over, and now is behind the two actors, so that now we see them in a reverse shot heading toward a beautiful sunset. I have fleshed out the figures a bit here but kept the rendering as simple as possible while still indicating that he has now put his arms around her.

Frame 5. If I recall, Cameron cut to a close up here of the lovers facing the lens and us, bathed in the glow of the sky colors with the wind and the music adding audio enhancement to an already dynamic visual thrill. For this shot, I added a bit more detail to the figures. Even with this simple storyboard, any director would know what camera positions and moves to do in order to accomplish these shots.

Getting the knack of drawing the human figure is not easy, but here are some more ideas that will be of help. Some of the drawings in Figure 6–2 are little more than doodles, but in drawing even these simple exercises, you will become more facile at rendering the human figure in motion. After dozens and dozens of attempts, eventually you will develop a style of your own, even if its still a little on the crude side. Refer, too, to the developmental drawings of the runner in Chapter 5, where, as here, a constant referral to the proportions of the human body is a must. (Keep that artist's model handy.)

Note in these sketches that you can start out with a stick figure but you don't have to necessarily stay with it. You can simply double the lines as seen in frame 2.

In frame 3, I try using ovals, remembering the principle of threes—upper arm, lower arm, and hand; upper leg, lower leg, and foot; the chest, the waist, and the hip. Even the human head, as in frame 8, is divided into three sections: the top of the head to the eyebrows, the eyebrows to the base of the nose, and from the base of the nose to the chin. Notice that the ears always are placed in the middle third between the eyebrow and the nose.

In frame 4, I used a coil or spiral technique to flesh out the stick technique. In frame 5, I broke up the various thirds of the body parts into cylinders.

Try each of these techniques and see which might work best for you. By frame 6, I hope, you will have arrived at a possible style of your own, showing the figure drawn more completely, so that by frame 7, you can add some simple indication of light and shade. All you have to keep in mind is this: Where is the light source? For instance, if you place a bright light to the right of an egg (which has the same shape as the human head), the left side will fall into shadow.

As another reminder, try to invest in that artist's model of the human figure and keep referring to it for those all-important proportions. And keep comparing: Compare the size of the head to the width of the shoulders, the bend of the elbow to the waist, the knee to the length of the arm. Some of these comparisons have been worked out in the illustrations in Figure 6–3.

Going back to a simpler theme and time, Figure 6–4 shows some rough idea sketches followed by a more complete storyboard sequence, both taken from a student film that I directed when I taught at the University of Notre Dame.

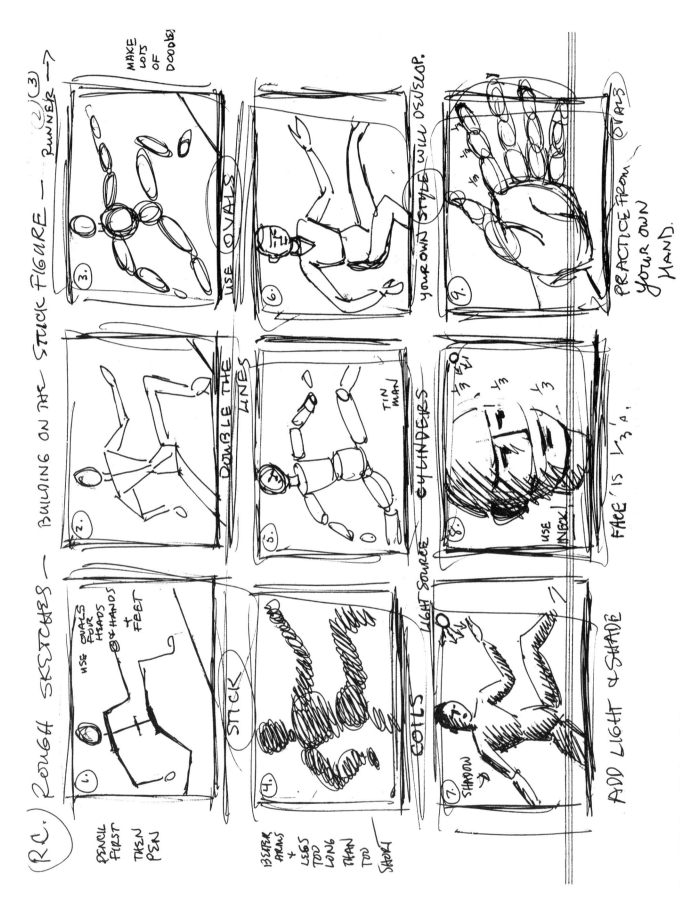

Figure 6–2 From stick figures to stacked figures.

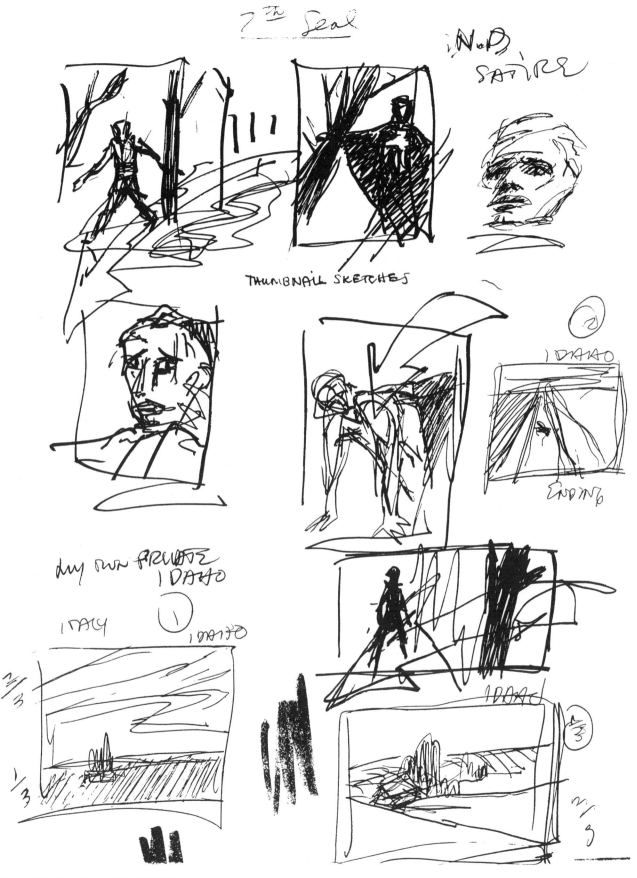

Figure 6–3 *The Seventh Seal* (1957).

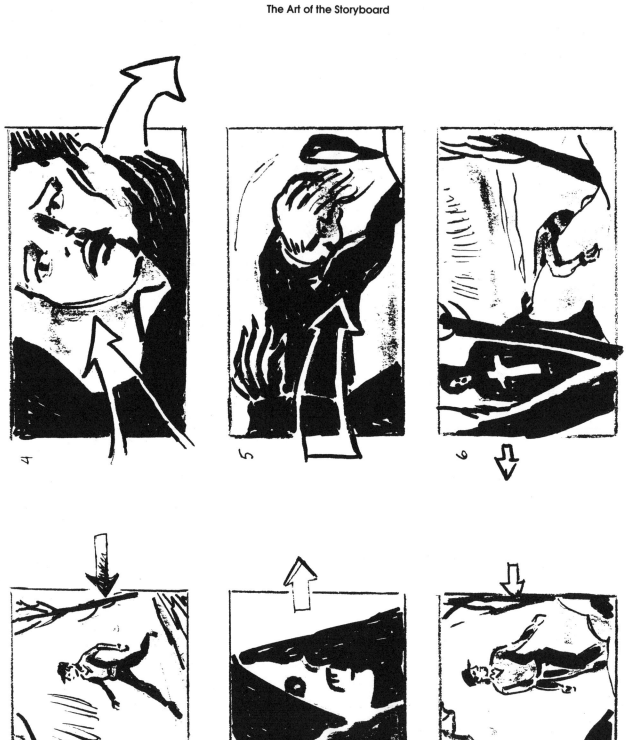

Figure 6–4 Completed storyboard for a satire on *The Seventh Seal*.

Illustrated here is one of my early attempts at storyboarding and, yes, the idea sketches in Figure 6–4 are on the crude side, but they are at least indications of where I wanted the actors to move within the frame, utilizing directional arrows to point out that movement. Keep in mind that the concept is what counts, and even these preliminary idea sketches eventually helped to make the shots indicated. Boldness and simplicity of execution will make the point quicker than overly elaborate drawings.

Frame 1. Long shot of Everyman walking through the woods.
Frame 2. Medium close-up of Death figure.
Frame 3. *The Seventh Seal* sketch.
Frame 4. Close-up of the frightened man.
Frame 5. Man falls after being touched by Death figure.
Frame 6. Death figure continues on his way in a LS. Note use of arrow to indicate movement of figure out of frame.

While I was the director-teacher on the shooting of this satirical short subject, I appointed a student director of photography, whose job was basically simple as we were using only winter's available light and took advantage of a built-in light metering system.

We did not need to carry reflectors with us, either white or aluminum boards, because snow in itself, I reminded the class, makes for terrific reflections and fill for shadows, giving the faces a sort of outdoor bounce glow.

The budget on this production was minimal, covering the cost of film and processing. I did the editing (like John Ford) in the camera because I wasn't sure that an editor would be available.

Costumes were the day-to-day apparel of the students. We made it a contemporary scenario to avoid the use of medieval costumes. The death figure's costume I borrowed from our recent production of *Hamlet*—a flowing black robe adorned with a large white cross on the chest and sporting an impressive black hood that would hide the face of the actor until his important close-up. The story line simply concerned the Everyman character being accosted by Death as he walks to his home.

In the storyboard in Figure 6–4, I tried to keep strong, simple design elements working for us. You will note the use of foreground framing in every shot, either with the trees in frames 1, 2, and 6 and the death figure itself in frames 3, 4, and 5. The black figure is combined with the trees in 1, 2, 3, and 6. Only two close-ups were used, in frames 2 and 4, for maximum impact.

Note also, in each of the frames, the center of interest is never placed in the center of the frame but off-center for a strong design sense. The drawings themselves have been kept simple but effective in their rendering of the moving figure within its given space.

A more finished storyboard covering the basic shots needs to tell our little story. Our small film crew worked quickly and efficiently in the cold snow. The communication between us worked to the benefit of all. No burst of artistic temperament was seen, and emotions certainly stayed cool. It was so cold out there, actually, that I was afraid that our borrowed Bolex with its wide angle, medium, and long lenses would freeze up. The camera didn't; and when shown to our "film department," the piece proved to have been an appreciated exercise in simple film technique and production.

Figure 6–5 shows an example of figure placement taken from the storyboard concept and as used in the eventual shot taken from the film itself.

Arrows indicate in this shot the kinetic action taking place in this pyrotechnic SFX frame. The actors are running from the car explosion, of course. Their action has been framed off-center in this shot—good framing. A three-dimensional quality has been achieved here with the leads bolting quickly into the foreground and the car (in one-point perspective) going from the MGD to the flames in the BGD. In this rendering

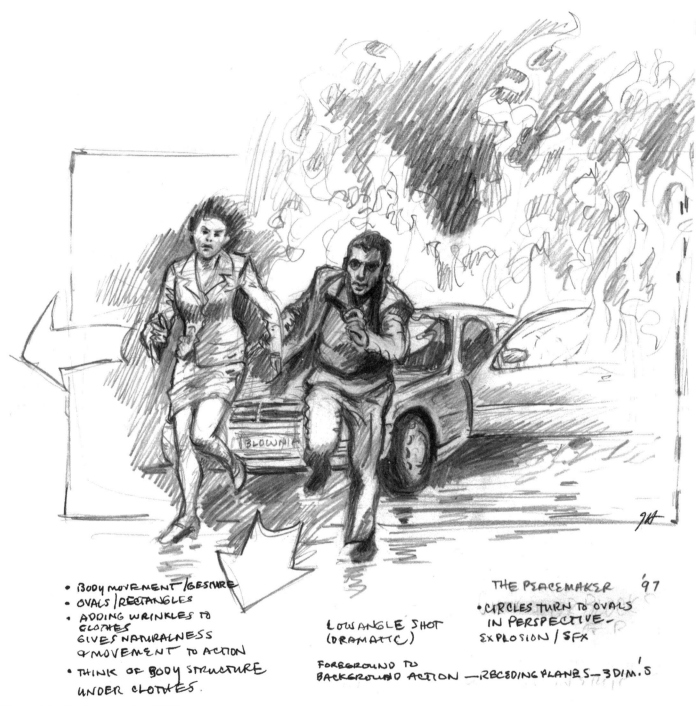

BODY MOVEMENT / GESTURE
OVALS / RECTANGLES
ADDING WRINKLES TO CLOTHES GIVES NATURALNESS & MOVEMENT TO ACTION
THINK OF BODY STRUCTURE UNDER CLOTHES.

LOW ANGLE SHOT (DRAMATIC)

FOREGROUND TO BACKGROUND ACTION — RECEDING PLANES — 3 DIM.'S

THE PEACEMAKER '97
CIRCLES TURN TO OVALS IN PERSPECTIVE — EXPLOSION / SFX

Figure 6–5 *The Peacemaker* (1997).

you can see that I have certainly given the dashing figures the full-dimensional treatment. Keep practicing and perhaps you can, too.

Although the shot in Figure 6–6 from *Citizen Kane*, directed by Orson Welles, is a bit out of sequence with the other examples I have chosen, it is a superb example of combining several action and story elements into one shot. The mother is placed in the FGD signing the papers that will take her son away. The lawyer has been placed just behind her. The father is in the MGD next to the open window. The son is seen through the window as he throws a snowball at the window. I have tried to render the light and shade that are falling on the figures in a strong but simple way using a felt-tipped pen for the chiaroscuro effect. Intense, elemental compositional devices are at work here, placing the figures strongly in the frame but also projecting the narrative action—fulfilling brilliantly, the wishes of the director, the cinematographer, and the scenarist.

In the shot from *Dr. Strangelove* in Figure 6–7, the use of the circle or oval as a solid compositional devise is at play in the suspended light fixture and the round table beneath it. Even the highlighted backs of the chairs around the table augment the use of concentric circles.

The war map in the BGD with its vertical dots play nicely against the curve of the light that illuminates the table, chairs, and figures in them. Great set design and lighting give strength to the world crisis handled in the War Room. Another example of creating a three-dimensional world created to exist inside a simple frame.

I am particularly fond of the shot in Figure 6–8 from *Whistle Down the Wind*, a British film made in 1961. In this frame, we observe the children running from the FGD through the MGD into the BGD, indicated with an arrow that also serves to point out how a scene can have a three-dimensional effect even without the use of one-point perspective.

This scene is a prime example of how a camera lens can capture a movement that breaks into the spatial area of the frame and instigates a recession in space. Note how the trees serve as a dramatic framing element for the figures.

Instead of the eye-level recessive movement of the figures in *Whistle Down the Wind*, Figure 6–9 shows a shot that is horizontal in its movement from left to right within the picture plane. I have drawn the moving figures in silhouette and had to work hard to give the bodies the effect of their forward movement. (Practice, practice, practice!) This is a version of *Hamlet* filmed in Russia in 1964, and the director, in this shot, imparted a strong sense of the recession of space by his placement of actors played off against buildings.

The FGD curve of the hill forces the eye of the viewer to look at the black figures walking to the right of the frame in the MGD. Because of their blackness they stand out against the grayer castle in the BGD. In this shot, the director created dimensional, recessional space within the pictorial frame simply with the use of blacks and grays.

A Frank Capra masterpiece filmed in black and white and containing one of the largest sets (constructed in full scale and in miniature) ever to be built for a Hollywood film, *Lost Horizon* was released in 1937 and earned an Academy Award for art direction for Stephen Goosen. It was photographed by Joseph Walker.

In the shot in Figure 6–10, the arrow indicates the emergence of the characters who had been lost in the Himalayas as they enter Shangri-La. Impressive to say the least, this still conveys to the audience the wonders befalling the characters entering this fully three-dimensional

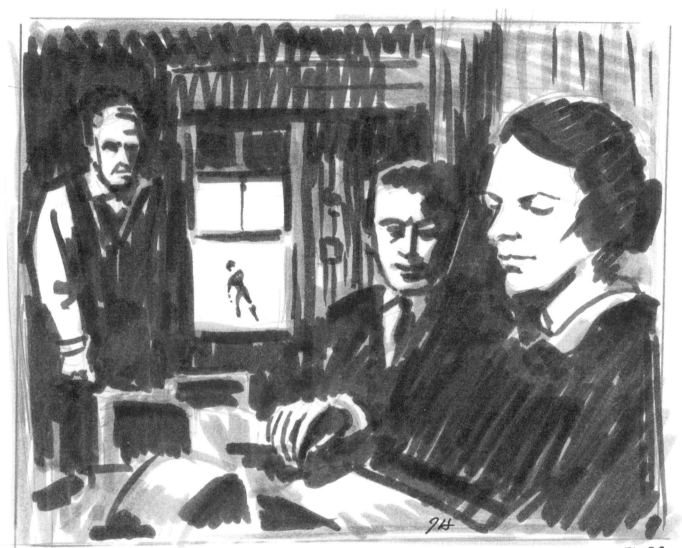

• CITIZEN KANE '41 ORSON WELLES
 /MOM • DAD • BOY
• RECEDING PLANES/FGD, MGD, BGD.
• DEPTH (OF FIELD) → FIGURES RECEDE, TOO.
• OFF-CENTER FRAMING OF THIS SHOT
• NATURAL LOOKING LIGHT SOURCES

Figure 6–6 *Citizen Kane* (1941).

mis-en-scène created by some of the best production designers in the world. As they enter, they are framed in the FGD by jutting rocks on either side of them, contrasting to the softer places of pools, gardens, and smaller figures in the MGD, while the impressive simplicity of the main buildings loom up in the BGD.

It has been made very obvious to the audience the intentions of the director and his creative team. They indeed had created, with their visual magic, this Shangri-La setting and motivated all of its characters to fulfill their destinies as put forth in the narrative action of the scenario.

Winterset, a film based on the play of the same name, was released in 1936. As one can see from this sketch, the characters involved are all

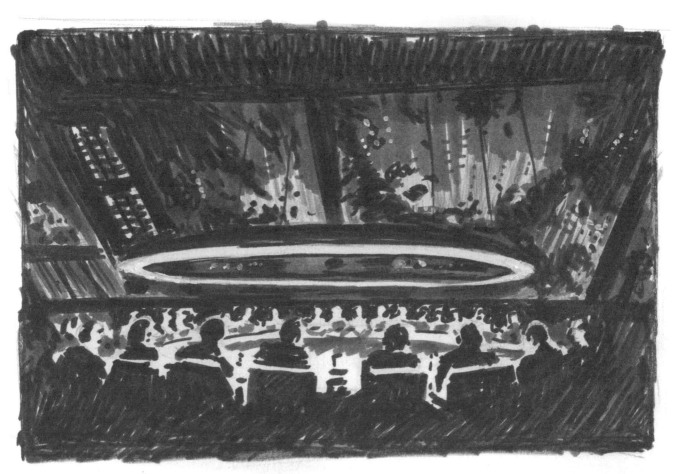

DR STRANGELOVE '64, KUBRICK

● CIRCLES IN PERSPECTIVINE ● CONCENTRIC CIRCLES
● OVERHEAD LIGHTING SOURCE.
● WIDE ANGLE LENS

Figure 6–7 *Dr. Strangelove* (1964).

influenced by the Great Depression of the thirties. The shot in Figure 6–11 portrays some of them trying to warm themselves by a makeshift fire at the base of the Brooklyn Bridge, alongside the East River. The set designer has certainly placed them in three-dimensional surroundings that give the audience a definite sense of place, of atmosphere, and of intimidation by the size of the structures enclosing them.

Here is an illustration of a basic one-point perspective setup. The main vanishing point is just left center of the receding bridge, with the horizon line being just above the standing figure at the left of the group. The understructure of the bridge goes back in space even more because of the gray fog that blurs its details the more it recedes.

The placement of well-drawn, motivated figures that kinetically move in an interesting way through the three-dimensional space created for them is one of the primary jobs of the storyboard artist. The use of these shots from important films is to demonstrate how the problem of dynamic placement of figures within the continuity of the storyboard

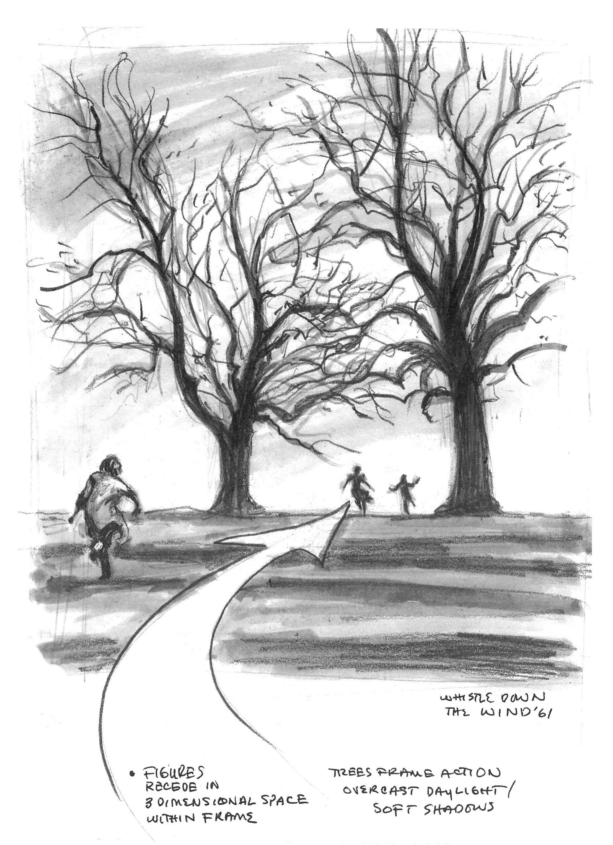

WHISTLE DOWN
THE WIND '61

• FIGURES
RECEDE IN
3 DIMENSIONAL SPACE
WITHIN FRAME

TREES FRAME ACTION
OVERCAST DAYLIGHT/
SOFT SHADOWS

Figure 6–8 *Whistle Down the Wind* (1961).

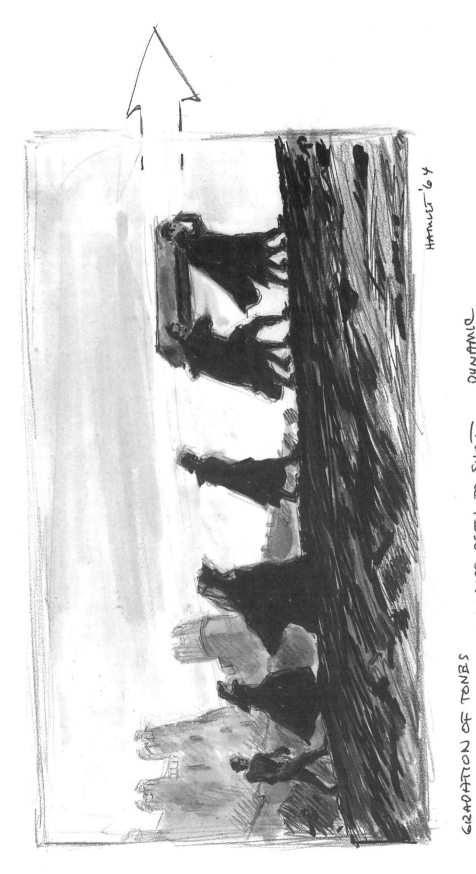

GRADATION OF TONES

SILHOUETTE OF BGD FIGURES ADDS DEPTH TO SHOT

RECTANGLES, TRIANGLES, OVALS IN FIGURES

DYNAMIC LOW ANGLE SHOT.

HAMLET '64

Figure 6-9 *Hamlet* (1964).

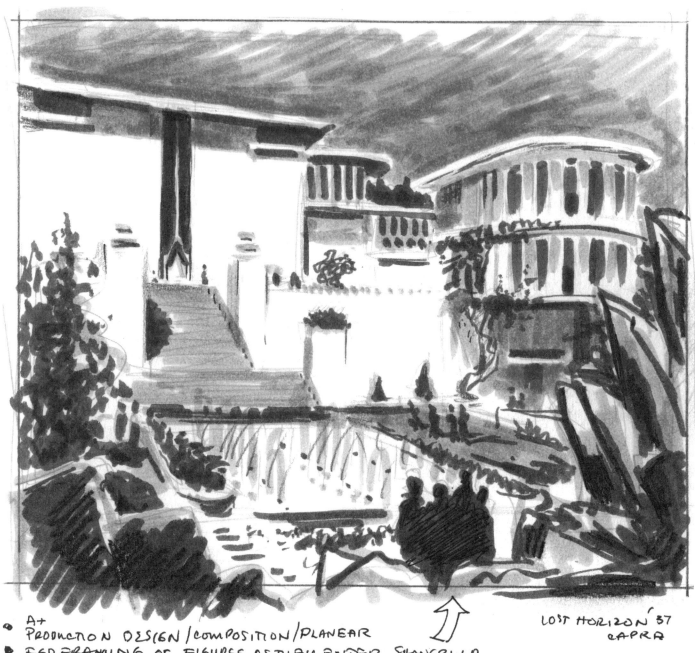

- A+
- PRODUCTION DESIGN / COMPOSITION / PLANEAR
- FGD FRAMING OF FIGURES AS THEY ENTER SHANGRI-LA
- NOTE PERSPECTIVE OF POOL LINES RECEDING TO STEPS

LOST HORIZON '37
CAPRA

Figure 6-10 *Lost Horizon* (1937).

frames have been solved, even if the figures themselves have been rendered in a simple way, as in this sketch.

Indications of the sets constructed or actual buildings and locations used also must be indicated in the storyboard artist's renderings. Making use of dark areas played against lighter tones will create contrasts that add to the strength of the individual places existing within the individual frame. Note how the shaded FGD base of the bridge stands out against the grayer main structure of the bridge that stretches into the BGD. The main center of interest in this shot are the actors, everything

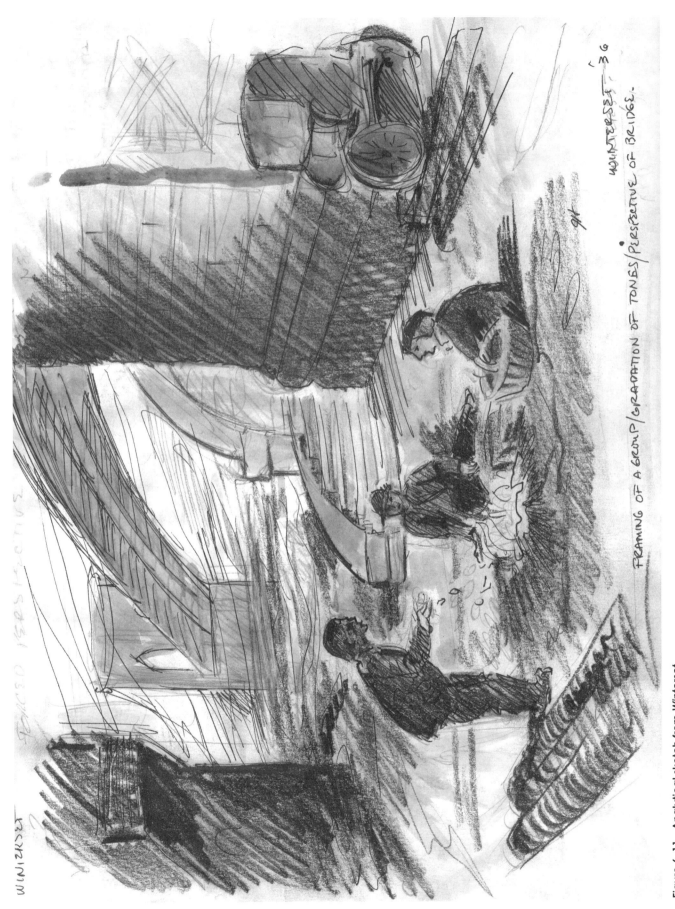

Figure 6–11 Analytical sketch from *Winterset.*

else must serve only to frame them in a given environment. NOTE: Avoid distracting backgrounds.

The following two figures are examples of storyboards executed by John Tartaglione. The styles dictated by the subject matters are slightly different. Figure 6–12 shows a storyboard from a new script for a comedy called *Anything for a Laugh* (1998).

In storyboarding this sequence of the screenplay, John has given each shot what he feels will best convey the action of the story line. You can follow the narrative in frames 1 through 20.

These characters have been drawn in a simplicity of style that lets them convey the kinetic action (indicated below each frame) very directly.

I think that the artist has given imaginative thought to the placement of his characters, arranging them in interesting ways: sometimes in close-up in the foreground plane, other times, as in frame 7, running horizontally through the kitchen in the MGD.

It's a chase scene all right. The character Jackie, chases Tom and Anthony with a threatening baseball bat through several sets, and in and out of houses (which, you will note, are not elaborately drawn, but you do know where you are).

Arrows again indicate the main direction of the characters. Sometimes, the storyboard artist will alternate the right to left action, as in frame 10, with the left to right action in frame 13. He also has added variety by placing the secondary characters in the FGD, in frame 10, then indicating the secondary character in the BGD in frame 13. Do you think that it is too much of a jump cut from frame 15 to frame 16? If so, draw one that you think might work. Try to keep with the present style.

John has kept the use of close-ups to a minimum because of so much body action. Saving it for a very dramatic purpose, as in frame 20, makes the use of the close-up even more effective.

The artist has achieved, in a very direct way, a visualization of the action of the script. With his storyboard visualizations, he also has shown us, graphically, where the characters are going, what is the motivation, and how they fulfill the intended action of the narrative.

In Figure 6–13, John has interpreted and rendered a sequence from John Ford's epic western *Stagecoach* (1939) in a different drawing style. He uses a graphite pencil, stronger blacks and whites for more contrast, more dynamic close-ups taken from the film narrative, and a stronger line.

Perhaps, his style here is an advancement from the storyboard of *Anything for a Laugh*. Perhaps, the impact of an Indian attack, in which one of the characters might find it necessary to shoot the women, motivated him to render his images in a stronger, bolder style. Following the narrative flow of *Stagecoach* is not difficult, and the intent of both the antagonists (Indians) and the protagonists (John Wayne and the passengers) is obvious—kill or be killed—and the tension mounts until the deus ex machina, the U.S. calvary, arrives to save the day.

Notice how the various cuts from medium shots in frames 1 and 2 to dramatic long shots of the attacking Indians is used. And, as in any Ford film, we are made to identify with the emotions of his characters in a very big way, as with the device of "the other woman" trying to protect the baby in frames 2, 5, and 6. Notice also the FGD and BGD combinations in 2, 5, and 6. The Indians are alternated by the director to be seen in the BGD in 2, then used in a menacing medium shot in 3, then back to a long shot in 4.

Frames 7, 8, and 9 are contrasted to the other shots, because they are tight close-ups, pointing in a more explicit way to the predicament of

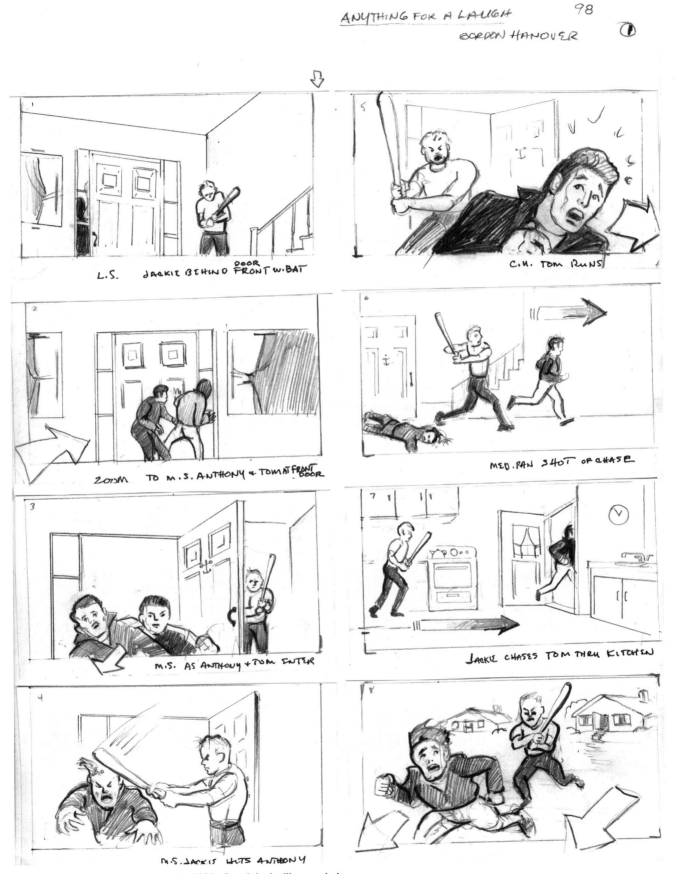

Figure 6–12 *Anything for a Laugh* (1998). Reprinted with permission.

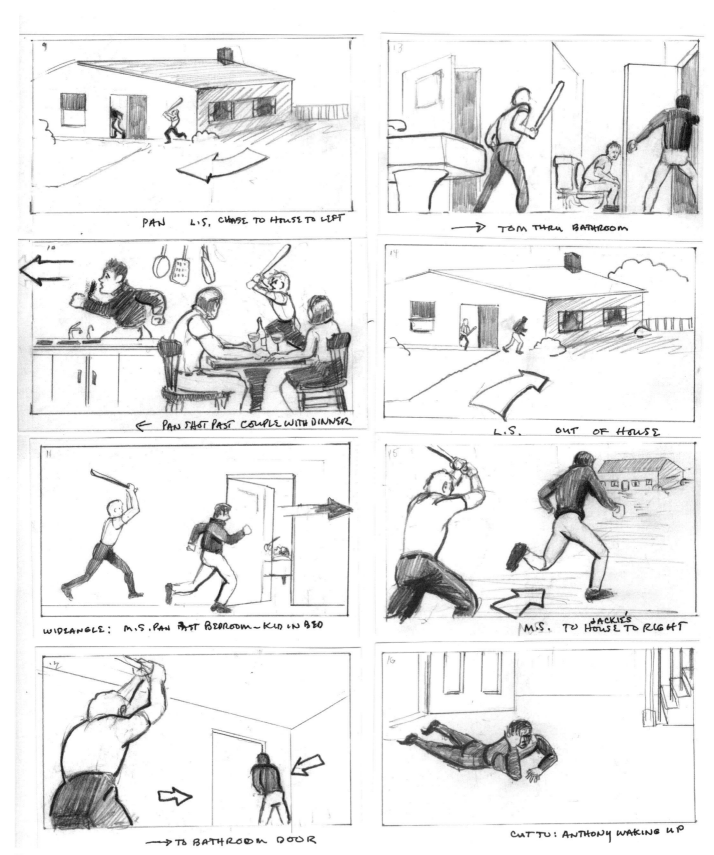

Figure 6–12 *Continued*

Figure 6-12 *Continued*

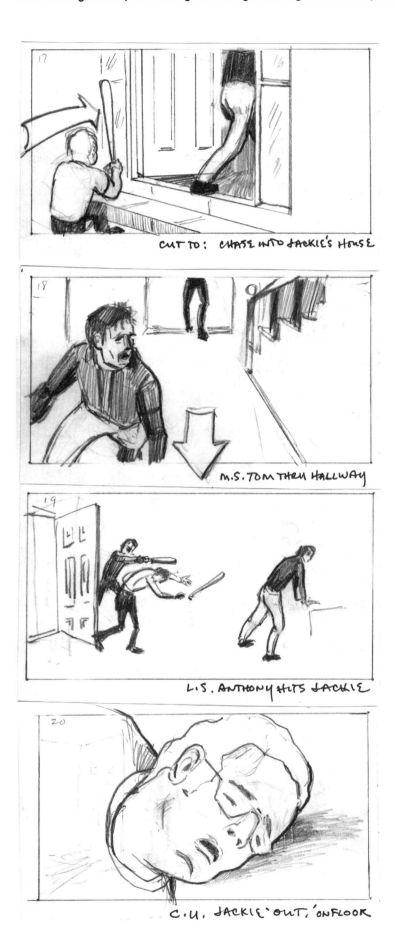

CUT TO: CHASE INTO JACKIE'S HOUSE

M.S. TOM THRU HALLWAY

L.S. ANTHONY HITS JACKIE

C.U. JACKIE 'OUT' ON FLOOR

STAGECOACH,
 FORD '39

SHOT SEQUENCE

INDIAN ATTACK

WILL WOMEN
HAVE TO BE SHOT
TO SAVE THEM FROM AN
INDIAN ATTACK?

Figure 6–13 *Stagecoach* (1939). Reprinted with permission.

Figure 6–13 *Continued*

Figure 6–13 *Continued*

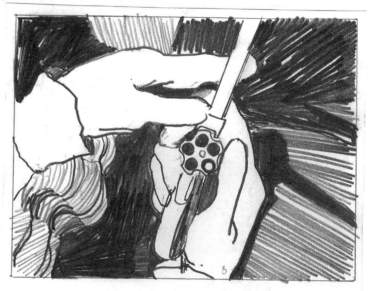

Figure 6–13 *Continued*

SAVED

the baby, the supposed assassin, and the terrified mother. Frames 10 and 11 continue in close-up, with the gambler raising the gun to firing position until the quick cut to the calvary trumpet. Saved! Strong images from a strong director, and a storyboard illustrated in a very strong style that compliments the intensity of the action and the raw emotions of characters who have been thrown into a desperate, shall we say, three-dimensional situation.

Exercise

Do a dozen quick, lightening sketches of figures in motion, starting with stick figures. Add dimension with light and shade, paying particular attention to light sources and the resulting motivated shadows, as with my runner continuity sketches.

7

Giving Order and Increased Reality to the Visuals within the Storyboard, by Using Perspective and Receding Planes

To the beginning artist, the word *perspective* can be intimidating. It shouldn't be. If you were to think of perspective in filmic terms, you might use the example of a cowboy film. Take almost any cowboy "horse opera," where the cowboy hero—that is, the protagonist—has the inevitable shoot-out with that mean hombre clothed deliberately by the wardrobe department in black—the antagonist.

One great example that comes to mind is Fred Zinneman's *High Noon* (1952), starring Gary Cooper as the lonely, abandoned sheriff who waits for his assassins while existing here in a one-point perspective world. You will notice in Figure 7–1 that all of the lines in the buildings go back to one vanishing point, here indicated by the dot just to the left of the church, which has been built in smaller scale for maximum depth.

It must be noted that the director has the perspective of the shot in mind, and that will dictate the camera placement and angles. This will be storyboarded for him or her to see before shooting it with the collaboration of the director of photography and art director or set designer, the scene as previsualized then will be shot.

You will notice that the climactic shoot-out always takes place in the middle of an abandoned main street smack dab in the center of town and usually right in front of the saloon.

With many of them shot at a low camera angle, the actors will appear taller and more imposing. Even the street itself will look more menacing if shot from that below eye-level angle—perhaps, we could call it the *below the ankle level*. Observe, too, in this shot, which could be taken from most any cowboy film, that the saloon in the left FGD, along with the general store on the right and the bank in the MDG, appears half the normal size.

And, going all the way back to the church on the right in the BKD, which, as we said before, appears smaller still because the set designer often will construct buildings in the BKD plane on an even smaller scale

117

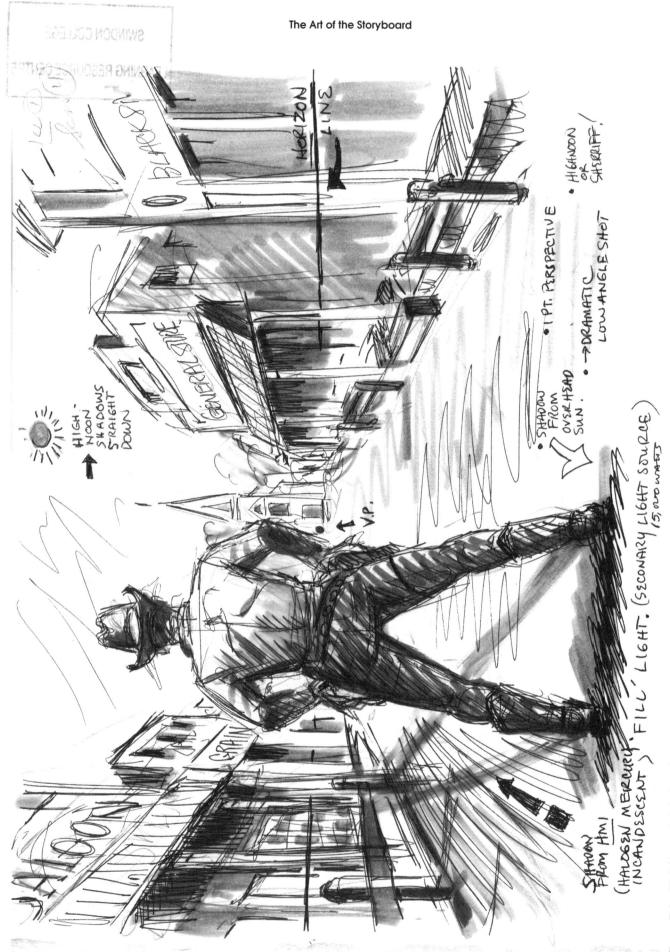

Figure 7–1 *High Noon*, sketch done from memory.

to give them that added depth, making the actors and buildings in the FGD appear that much larger.

In the storyboard in Figure 7–2, done for a new cowboy film, *Sheriff!*, you will notice, in frame 1, the use of the dramatic low angle view of the new sheriff. In this storyboard, he will be visiting the teacher after seeing his girlfriend in frame 2, an over-the-shoulder shot, and being observed in frame 3 by Mr. Evil in close-up.

Please note, in the following frames, the placement of the camera and its lens in order to set up each scene with an interesting design.

When drawing any storyboard, a variety of angles or viewpoints must be used to capture the scene. The placement of the actors by the director also is important.

The move from long shots (full figure) to medium shots (frame 7) to the close-up again in frame 8 makes for a variety of shot angles to keep the interest of the audience visually.

One-point perspective is used in frame 4, with lines converging to the vanishing point (VP) to the left of the teacher's desk. In frame 5, the VP is behind the sheriff's face as he frames the frontal "picture plane" in this shot.

Find the VPs in frames 6 and 7. Fill in your own ideas for the empty frame (9).

In the shot in Figure 7–3 from Humphrey Bogart's premiere detective story, we see another example of not only a very dramatic low angle, as Sam Spade looks down the embankment at his murdered partner's body, but also the use, behind him, of two-point perspective.

Picture an imaginary line running straight across the top of the FGD rocks (this will be your eye-level line). Out of our sight lines will be two vanishing points, one to the right of the frame and one to the left of the frame.

All the lines that make up the fence in the FGD and the flat walls facing us (receding planes) will converge to the VP on the eye-level or horizon line to the left of the frame. The angled wall directly behind Sam will be made up of lines that converge back to their own VP below the larger window with the two figures. All in all, this is an excellently designed scene by the director John Huston.

Figure 7–4 shows another example of one-point perspective in a generic design that fits umpteen movies and plays about the Great White Way. Its easy to make out all the lines that make up this set, and all of them converge back to the VP just below the arch under the sign glowing with JUDY. Can you tell where the horizon line or the eye-level line is? Remember that this is a low-angle shot.

I redesigned the Fox logo for the twenty-first century, and in Figure 7–5, you see it in two-point perspective. I have made it quite clear where the horizon line is and where both the right and left VPs are located. Whenever I look at a painting, photograph, or motion picture, the first thing that I ask is this: Does it project exceptional composition or design?

Classic films, many of which are used as examples in this text, along with Renaissance paintings by the great masters (all of which you should be familiar with), the best work of superb photographers like Ansel Adams, Alfred Steiglitz, and Margaret Bourke-White, to name a few, all contain great design and a brilliant sense of composition. Add to these visual elements an uncanny sense in the placement of figures, objects, and structures within a given picture frame or frontal picture plane.

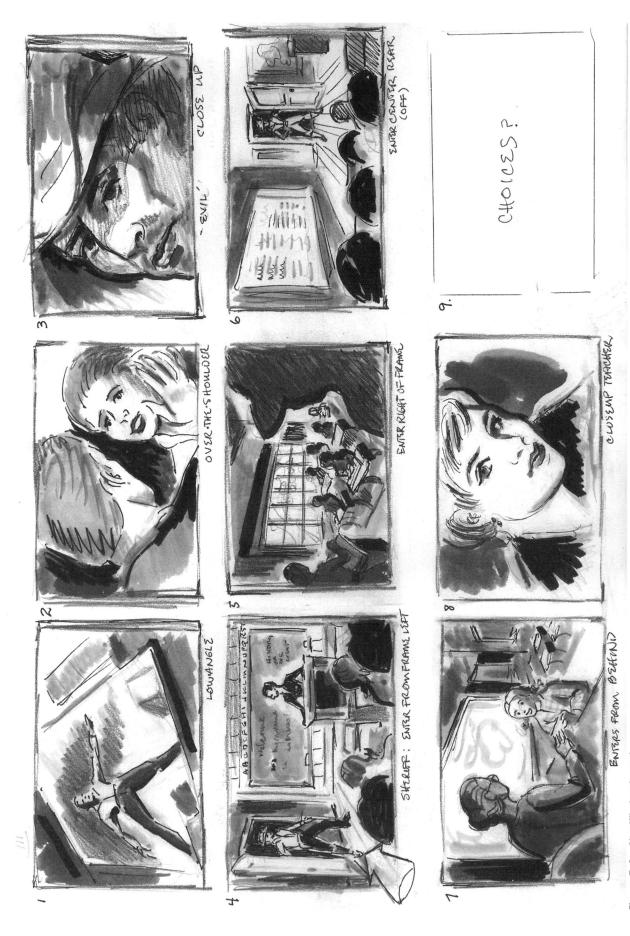

Figure 7-2 *Sheriff!* storyboard.

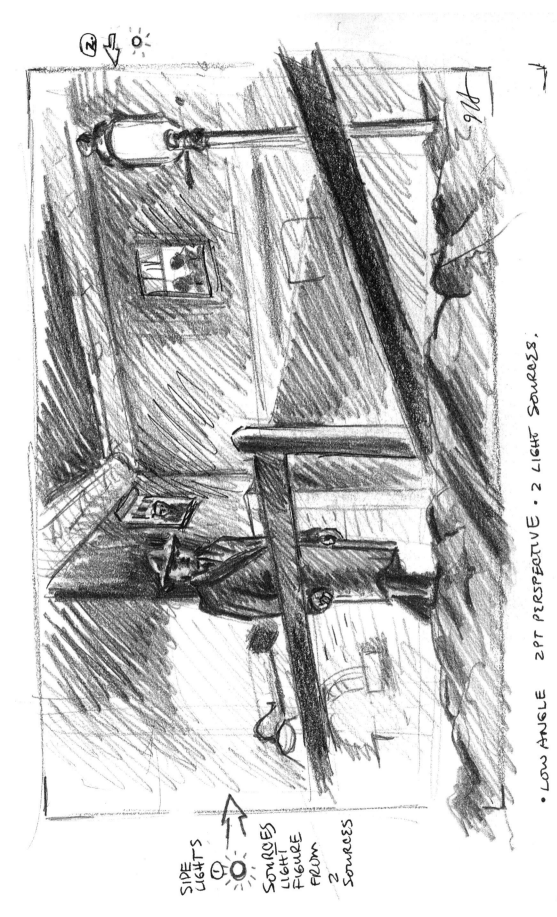

• LOW ANGLE 2PT PERSPECTIVE • 2 LIGHT SOURCES.

Figure 7-3 *Maltese Falcon* (1941).

Figure 7-4 Broadway.

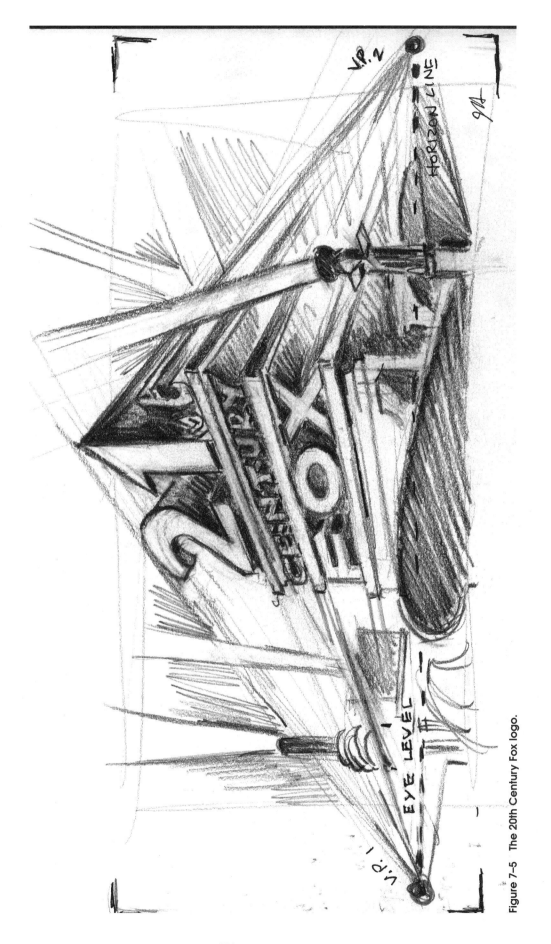

Figure 7–5 The 20th Century Fox logo.

The term *plane* is important to us because all that takes place does so within its preconceived boundaries. *Vertigo*, directed by Alfred Hitchcock in 1958, contains the shot in Figure 7–6 with the James Stewart figure and a seriously distorted one-point perspective at work, designed to intimidate the viewer.

It's easy to pick out the VP in the famous frame or shot shown in Figure 7–6. Jean Renoir, whose classic antiwar film *Le Grand Illusion* (1937) usually appears on most lists of the top-ten greatest films of all times, quotes his father, Impressionist painter Auguste Renoir: "One has to fill out, for a good painting, a good novel, or a good opera [or a good shot] makes its subject burst at the seams."

An illustration of that Renoir dictum is the shot in Figure 7–7 from a Howard Hawks western, telling us that perspective can consist simply of receding cattle and the cowboys who drive them to market. This shot is beautifully framed with the trees, the arrow indicates the line of action, and this mis-en-scène is certainly "bursting at the seams." Those so-called empty spaces that one observes in any "frame of reference" also should teem with life, even if its a cloudless sky, or an abandoned desert. Jean Renoir called it the *law of content*, and in any decently photographed western (like that in Figure 7–8), where the action might take place, as in, for instance, John Ford's favorite locale: Monument Valley, in Arizona and Utah, where it can be used to great pictorial effect.

In other words, what is placed in a shot in a film has to have a unity of space, a unity of composition, and a sense of pre-thought-out placement of people and objects who seem to want to "burst out of the seams of the surrounding frame."

Figure 7–6 *Vertigo* (1958).

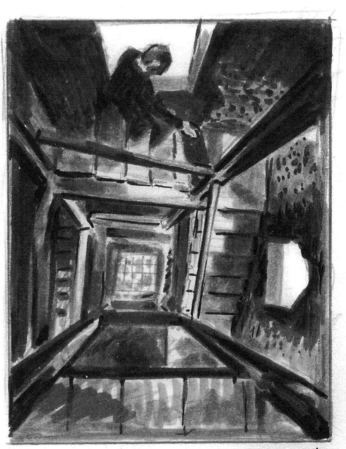

VERTIGO '58

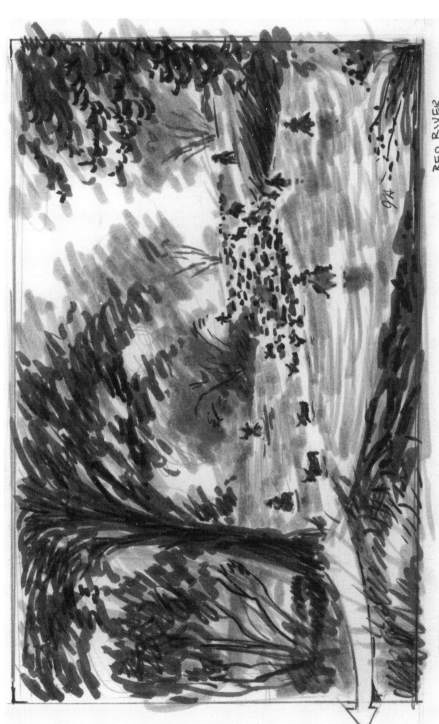

At FRAMING OF DYNAMIC MOVEMENT
RECESSION OF SPACE –

RED RIVER

Figure 7-7 *Red River* (1948).

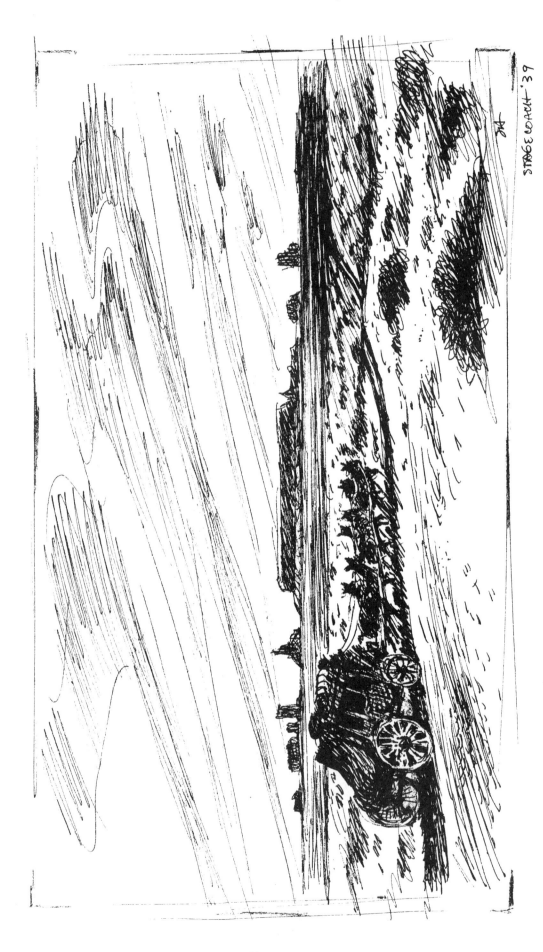

THREE DIMENSIONAL SPACE

STAGECOACH '39

Figure 7–8 *Stagecoach* (1939).

The *frame* (the four sides that contain the selected subject matter) is the picture's boundary of reality. Remember, we, as artists, choose from the millions of images that exist around us and then pinpoint, emphasize, and rearrange only a selected few of these images for public viewing.

These elements have been chosen to be designed in a very pleasing-to-the-eye manner and placed with great care within the picture frame, or frontal plane. In the shot from *West Side Story* (1961) shown in Figure 7–9, the overhead highway structure has been constructed in forced perspective and the two fighting figures, shot at a low angle, have been placed in the center of the set for maximum visual impact. Selected elements are designed to project in a dramatic way the story being told inside each frame of film.

A film script, then, is made up of a series of scenes denoting action. But what is contained within each scene or shot, and hence every projected frame, has to be designed by a creative team; that is, the production designer, the art director, the director of photography, and of course the director, who will give the storyboard artist the job of visualizing their concepts.

It's quite a challenge, working one-on-one with a director, often having to come up with on-the-spot rough idea sketches that help to visualize the various key scenes in the script. However, a practiced, trained eye in three-dimensional composition will aid the artist to meet that challenge with more facility.

A fine example of throwing diverse elements together in an interesting way is the very obvious one-point perspective composition in Figure 7–10 from *The Gang's All Here*, starring Carmen Miranda, bananas, and strawberries (in forced perspective).

Incidentally, a basic composition faux pas that I often see comes about because the artist is not aware of the *golden mean*. To put it simply, be aware that any image that exists behind that frontal plane should be divided into thirds, as in the shot in Figure 7–11 from Ingmar Bergman's *The Virgin Spring*.

Working horizontally, if there is a rendering of a sky or landscape, as in this shot, either the sky consumes the upper two-thirds of the rendering, leaving one-third for the land area, or the land consumes the bottom two-thirds of the picture, leaving the top third for the sky. Unless for obvious reasons, the division never should be half and half. The Greeks figured it out a long time ago, cutting any composition in two is boring to the eye.

Another example is the shot in Figure 7–12 from John Ford's *The Fugitive*, where the placement of the crosses, the figures to the right of the frame, and the space given to the sky in proportion to the land mass obey the *golden mean*.

Any sequence of shots or frames, then, will contain images that will illustrate all the visual talents of the director, the director of photography, and the production designer, and the storyboard artist combined—and that's collaboration.

Good design is about developing a sense of proportion, a feeling for what "works" behind the framing device, as in Figure 7–13 in a shot from *Gone with the Wind* (1939), where we see the large oak framing Scarlett as she looks back at Tara. This is a "pull back" shot for the camera, as indicated by the arrows.

This famous shot is about receding planes of FGD, MDG, and Tara in the BKD, imparting a three-dimensional feeling to this composition. Notice the division of thirds and the use of off-center placement and the

WEST SIDE STORY '61

FORGED 1 PT. PERSPECTIVE

Figure 7-9 *West Side Story* (1961).

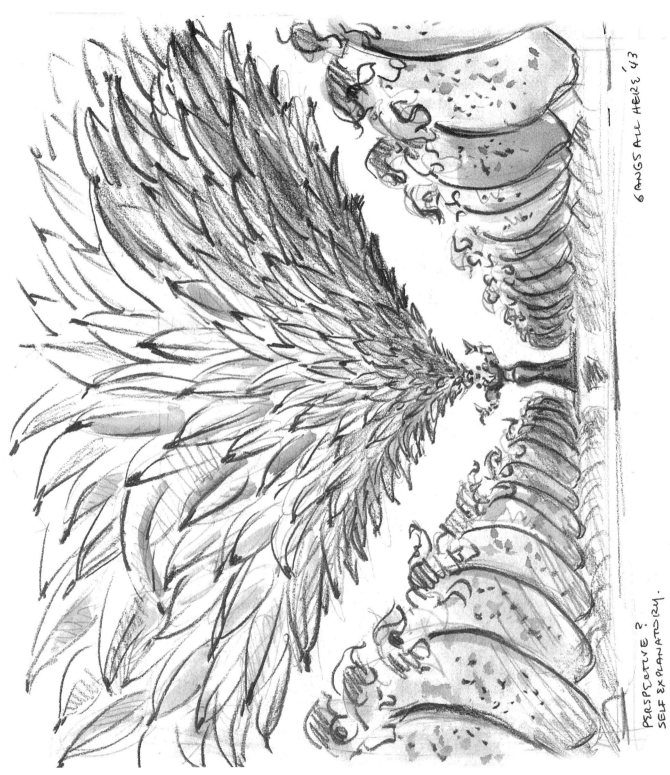

PERSPECTIVE ?
SELF EXPLANATORY.

6 GANGS ALL HERE '43

Figure 7-10 *The Gang's All Here* (1943).

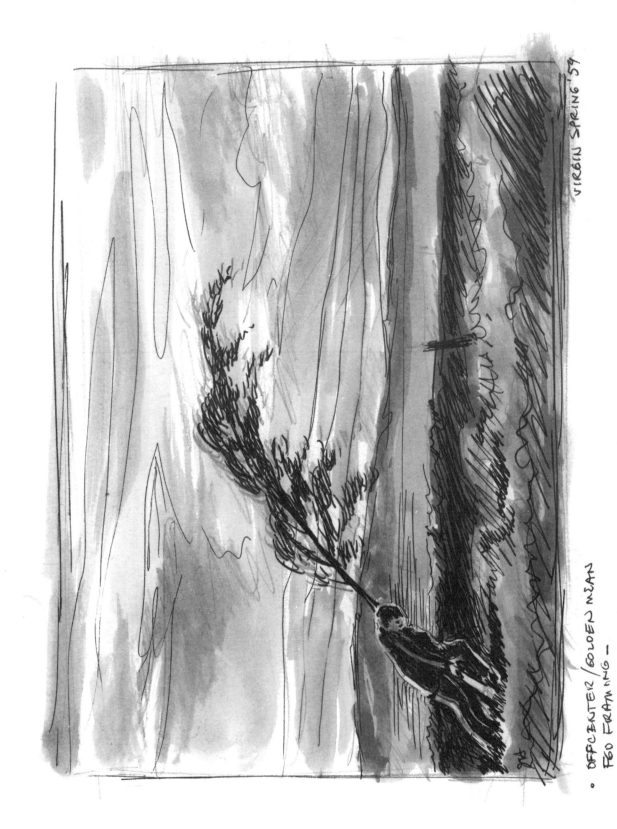

OFF-CENTER / GOLDEN MEAN
FRAMING —

VIRGIN SPRING '59

Figure 7-11 *The Virgin Spring* (1959).

Figure 7–12 *The Fugitive* (1947).

depth of field at play with the sharpness of the FGD plane against the softening of the MDG and BKD. It's perspective without lines. NOTE: In reality, life as we observe it consists of a series of receding planes.

In the storyboard shown in Figure 7–14, done from *In the Line of Fire*, starring Clint Eastwood, and rendered with a pen and ink technique, notice the variety of angles, MSs, CUs, LSs, and over -the-shoulder shots utilized by the director, Wolfgang Petersen. One-point perspective is seen in frames 2, 4, and in particular 10. Regard the foreshortening of Clint in frame 3 and 5 and note the FGD framing in frames 1 and 10.

Figure 7–15 shows one last example of angles, the "tilt" shot from *Taxi Driver*, showing Robert De Niro lining up a practice shot. This distorted angle imparts an off-balance quality to this shot, reflecting the tilted mind of the would-be assassin. This shot is a prime example of one-point perspective with all lines converging to the VP just at De Niro's mouth.

Exercise

Borrow a 35 mm still or movie camera (if available). Find an in-depth street locale. Note one-point perspective, horizon line, and vanishing point. Focus on figures or objects in the FGD, MGD, and BGD. Don't forget the establishing shot.

Figure 7–13 *Gone with the Wind* (1939).

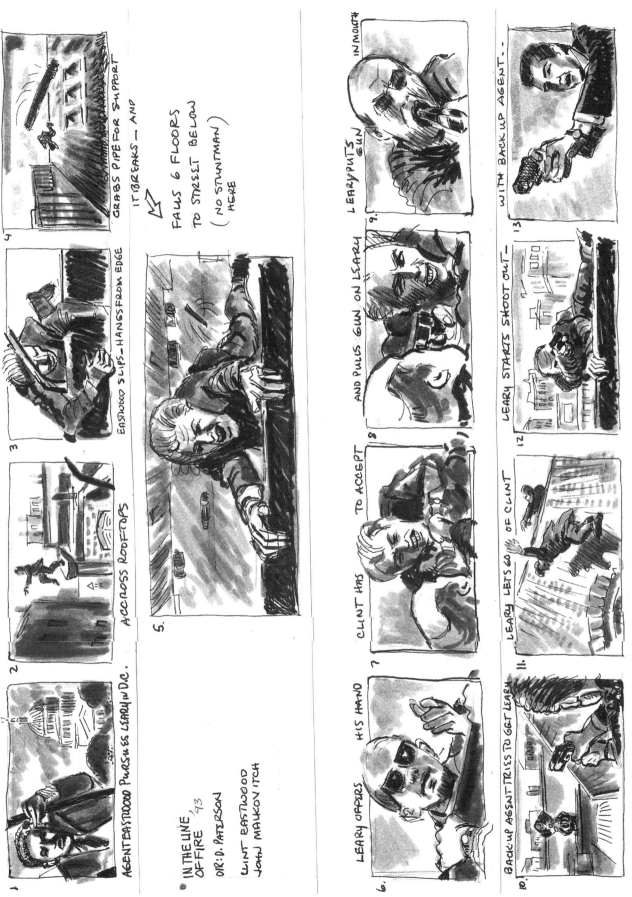

Figure 7–14 Interpretive sketches from stills of *In the Line of Fire* (1993).

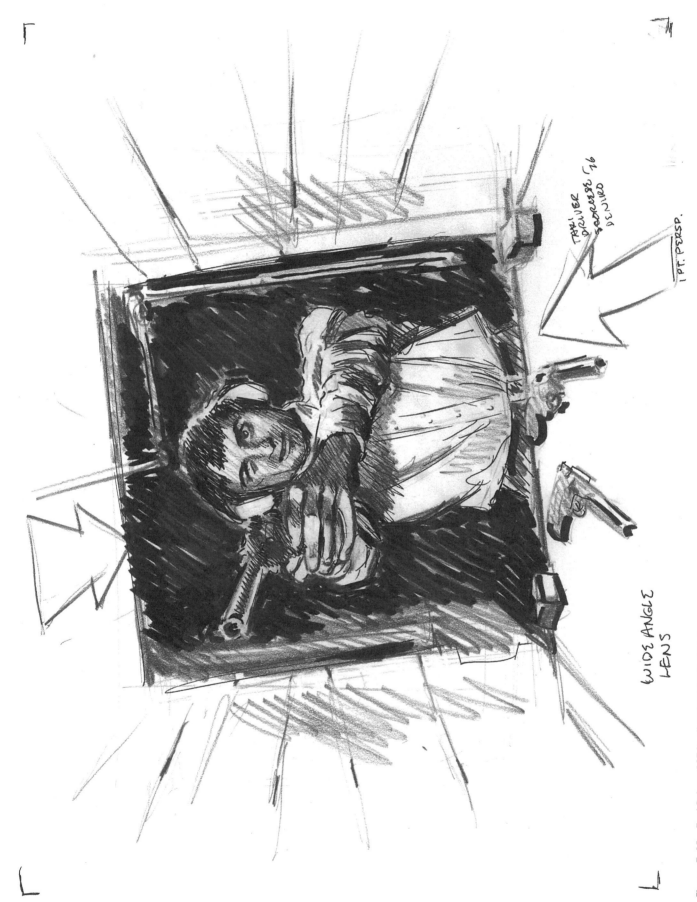

Figure 7–15 *Taxi Driver* (1976), director Martin Scorcese.

8

Depth of Field and Manipulating Light

For many lay persons, the concept of depth of field, which answers the question of where within the foreground (FGD), middle ground (MGD), or background (BGD) the focal sharpness will fall, is difficult to visualize. With the diagram in Figure 8–1, it should become simpler. Here we are dealing with filmic terms, like the FGD, MGD, and BGD, to indicate where it is *behind* the frontal plane (like the piece of glass covering a painting or photo), also, whether and where we will want the lens of our camera to focus within any of these three planes.

Do we want to focus our lens on Ricky the Raccoon in the MGD, on the trees in the BGD, or in the shrubs in the FGD? Naturally, if Ricky is the center of interest in the storyboard sequence, we want to focus only on him. We do this simply by focusing our lens directly on him. Now, what lens we use also will determine how much of Ricky and his immediate surroundings within the MGD will be in focus.

If you focus on Ricky in the MGD with what is called a *normal* 50 mm lens, he will be in sharp focus and as will the several feet of ground in front and behind him, because they exist within the focal plane selected for him on the focus ring of the lens attached to the camera. Now, the FGD and the BGD will be in softer focal planes because you didn't focus on them. If you were to use a wide angle lens (a short lens like 28 mm) to photograph Ricky from the same position, the distance in front and behind him will be increased. By choosing a long lens, say, 75 mm, to focus on him, you will cause the distance around him to be more out of focus.

Disney invented the multiplane camera, which fused the FGD, MGD, and BGD together to be photographed. Ricky will now be moving about in focus in the MGD plane, with the FGD plane in front of him and the BGD plane behind him slightly out of focus. This gives the scene a three-dimensionality.

Another analogy would be to see a football player on the field running toward the camera from the far 30 yard line over the 50 yard line to the FGD 30 yard line. In Figure 8–2, I, as the cinematographer, have focused my long lens on the 50 yard line. I know that when he passes the 50 yard line, the player will be running through my preestablished focal plane, and unless my focus puller continues to focus on him as he runs toward my camera position, he will be out of focus as soon as he runs beyond the 50.

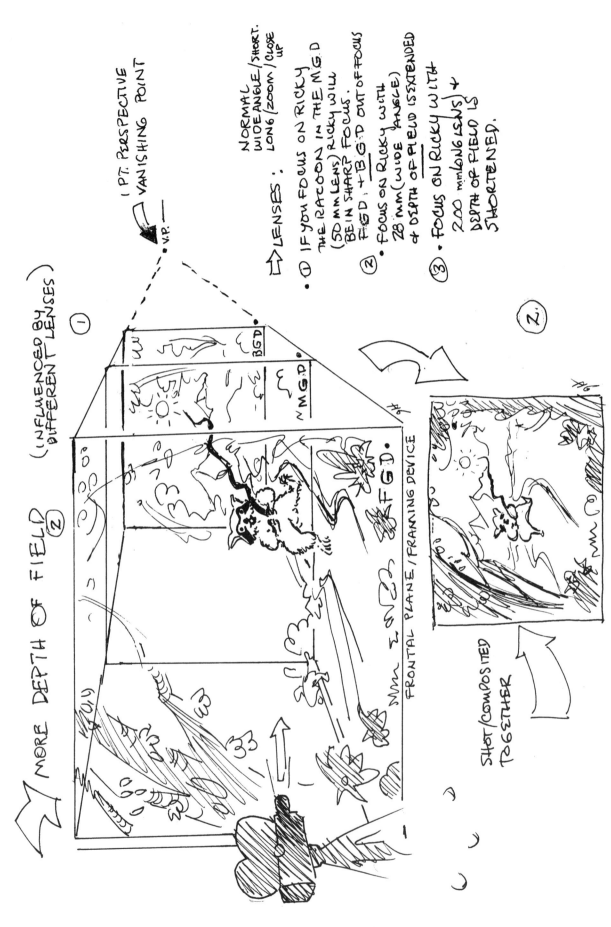

MORE DEPTH OF FIELD ②
(INFLUENCED BY DIFFERENT LENSES)

1 PT. PERSPECTIVE VANISHING POINT

↑ LENSES:
 NORMAL
 WIDE ANGLE / SHORT.
 LONG / ZOOM / CLOSE UP

① • IF YOU FOCUS ON RICKY THE RACOON IN THE M.G.D (50 MM LENS) RICKY WILL BE IN SHARP FOCUS. F.G.D. + B.G.D OUT OF FOCUS.

② • FOCUS ON RICKY WITH 28 MM (WIDE ANGLE) + DEPTH OF FIELD (EXTENDED)

③ • FOCUS ON RICKY WITH 200 MM LONG LENS) + DEPTH OF FIELD IS SHORTENED.

FRONTAL PLANE / FRAMING DEVICE

SHOT / COMPOSITED TOGETHER

Figure 8–1 Ricky the Raccoon.

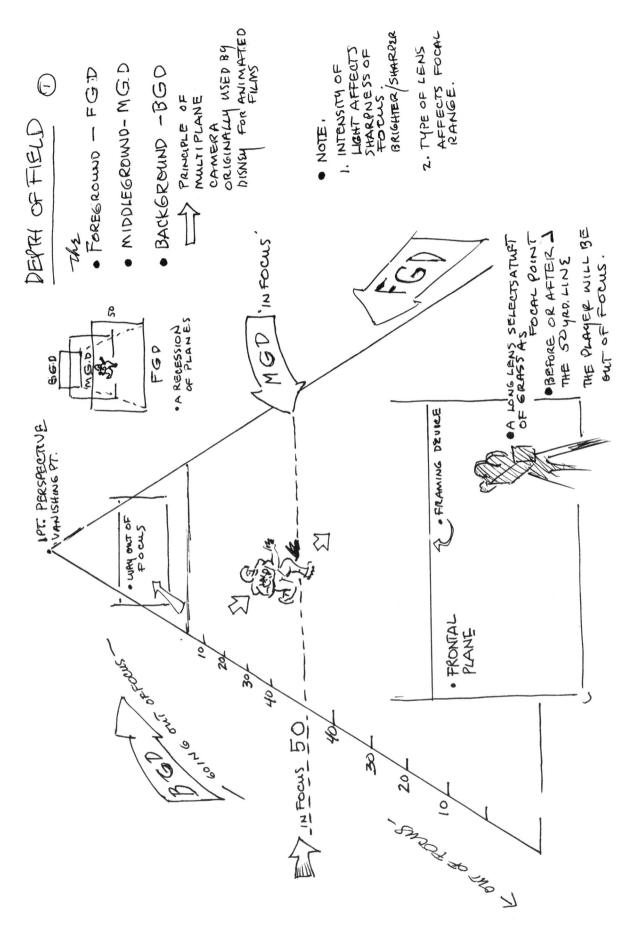

Figure 8-2 Football field.

Continuing with the same theme in Figure 8–3, notice the two photographs of brothers running toward my 35 mm Nikon camera, which was sporting a 105 mm lens (long lens, telephoto, or zoom lens). I already had focused on a bright yellow leaf on the ground that they were going to run past. I knew that if I focused carefully on that leaf, then I could click and would get them in focus when they ran over my "mark."

Fact: On an overcast day, you will not get the same depth of field or sharpness on the boys as on a bright, sunny day. Why? Because the more light is on an object, the more you are forced to increase the speed of the shutter. These sunny shots were taken at 250th of a second at an $f8$ opening. This increased the depth of field, even with the use of a long lens. On a day with cloud cover or if you are in a shaded area on a sunny day, you have to open the lens to admit more light. Doing this decreases the depth of field, resulting in softer images. Slower shutter speeds and larger lens openings make it more difficult to achieve sharp focus.

Figure 8–3 Boys running. Reprinted with permission.

Figure 8–4 shows an example of both of the boys in a shaded situation, up on a tree limb away from the strong backlighting that we saw before.

For this shot, I had to play with that focus ring on the 105 mm lens very quickly and still be exact as I tried to "follow focus" on those restless eyes. The depth of field was shortened, with less light falling on the subjects, forcing me to open my lens. Exposure here was slowed down from 250th of a second down to 60th of a second. While the lens opening was down from *f*8 to *f*5.6.

In the family group in Figure 8–5, I wanted backlighting from the sun to give them a dimensional quality. I had enough bounce light from the surrounding stone to fill in the shaded faces. If I were videotaping or filming this, I would want exactly the same effect. Notice that the BGD is very soft, very out of focus, because, here again, my lens opening was only *f*5.6.

In the shot in Figure 8–6, you can see the boy holding a reflector for me. The sun is behind him, backlighting his hair while it also bounces off the white reflector (cropped out later), filling his face with light—soft, natural light, at 250th of a second and at *f*5.6. This same backlighting effect is transferred to the studio with the use of artificial lights (see Figure 8–7).

Depth of field sharpness, then, is increased or decreased based on the amount of light falling on an object or person and the type of lens used to focus on the subject.

These are some of the lens basics with which the storyboard artist should be familiar when working with the director and the director of photography, if only in the sense that you must be familiar with the lighting and compositional tools that they will be discussing with you. They also will expect you to be familiar with most of the basic terms that pertain to lighting, lenses, and camera angles. The following illustrations help to clarify these concepts.

Figure 8–8 shows a sketch taken from *The Birth of a Nation* (1915) D. W. Griffith's landmark film about the Civil War, which made the movies into an art form and was the most famous film in the world until Selznick's *Gone with the Wind* in 1939.

Photographed by his indispensable cinematographer, Billy Bitzer, it is a scene taken from the Southern point of view. It is a tableaux permeated with natural, overhead sunlight that, of course, is the main light source. Normally, this is not the time of day during which one normally shoots people, because of the harsh overhead shadows. But here it works to realistic advantage, raw and in vastly sharp detail and focus. Also, because of the strong lighting, the depth of field not only is very sharp but extended beyond the soldiers in the frontal plane or FGD. The lenses weren't very sophisticated then, and here it looks like the normal 50 mm lens with its iris closed down to at least *f*16, putting all of the soldiers into sharp clarity while the depth of field on the fence behind is stretched back many years.

The portrait from *Sophie's Choice* in Figure 8–9 is an example of a "group shot." It also is an illustration of one-point perspective. Note the light source coming from their left and shot at our eye level, which also is the horizon line.

Figure 8–10 is a sketch I made of Griffith and Bitzer shooting *Way Down East* (1920), starring the resilient Lillian Gish, who actually clung to a real chunk of ice as she moved fatefully toward the big waterfall. The source of light was a bright, winter cloud cover permitting a decent

Figure 8–4 Two boys in a tree. Reprinted with permission.

Figure 8–5 Family group. Reprinted with permission.

Figure 8–6 Boy with reflector. Reprinted with permission.

sharp focus on Gish as they panned her floating by. In any artificial light situation, when the shots of actors are taken inside an enclosed space, like a studio, a variety of lights or lumieres are needed as the main light sources.

Without going into major detail about the hundreds of lights available to rent, suffice it to say that most of them use halogen quartz or tungsten quartz bulbs recessed in a variety of metal housings that focus or diffuse their effect as they illuminate actors or objects on a studio set. In terms of special lighting effects, the *key light* most often is used in reference to the close-up and is the main source of light that falls on the actor. This type of light can be either harsh, when it isn't diffused, or soft, when it is diffused via some material falling on the light source, on the camera lens itself, or with some video or movie cameras, behind the lens.

Figure 8–7 Backlit photo of Ryan Gibson, outside and inside. Reprinted with permission.

To determine the intensity of the light, think about how close to the performers you want it to go. You don't want to make actors uncomfortable due to the heat; in most cases, the minimum distance is five or six feet. A key light can be a scooped light, in which the quartz or tungsten light is deep inside the circular reflector, or in a more focused spotlight, in which the light source is closed to the outer rim of the circular reflector. In either case, the key light can be hard or soft.

Outside, the sun itself can be the key light. But, because it is a very harsh light, you should use it only infrequently (mostly for sports or Westerns) and almost always on men, not women. To estimate the best subject-to-key light distance, continually test the image on the video monitor or camera viewing screen when you experiment. Incidentally, using two key lights for a *crosslighting effect* can be a little awkward. Here, two lights play off each other. One light is positioned at a 45-degree angle in front of the model on the left side and another is placed in the same spot on the right side. As a result you get two separate shadows on the performer's nose. Furthermore, when the actor moves, so do the shadows. You'll find that just one key light is neater.

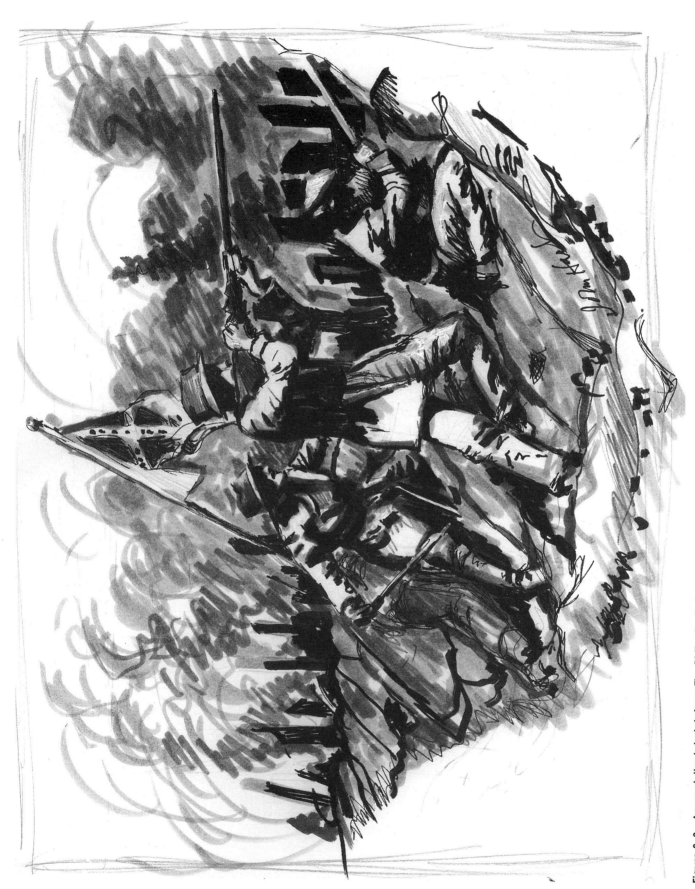

Figure 8–8 An analytical sketch from *The Birth of a Nation*.

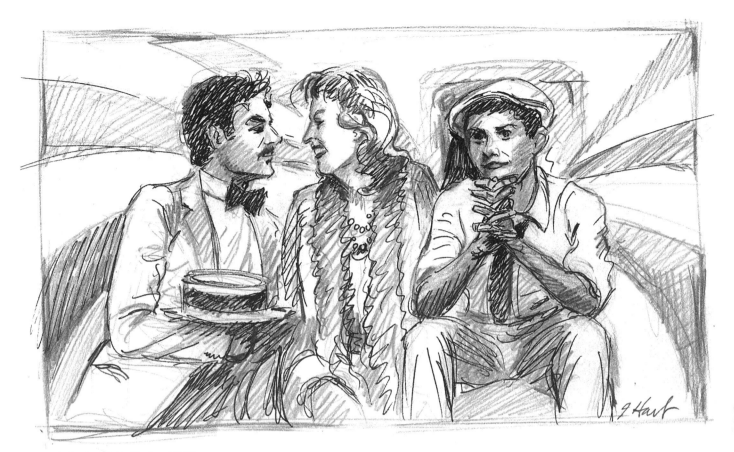

Figure 8–9 *Sophie's Choice* (1982).

Most video and film images are diffused to some degree, but the use of a *fill light* softens facial shadows a bit. This can be a reflector or another small light positioned just below the performer's face and the camera lens. Next, you'll probably want to add one or two *hair lights*. You can angle them down from behind with a boom light to illuminate the back of the head or the background; with this arrangement, the stand won't be visible. The main functions of a hair light are to enhance the hair, especially that of a woman, and to separate the performer from the background. The hair light can be as soft or as intense as you prefer and usually is between one third as strong as the key light and equal to it. Vary the intensity until you get the effect you want.

For the storyboard artist collaborating especially with the cinematographer or director of photography, who will be in charge of creating the lighting moods and atmosphere that reflect the director's intent, it again is stressed that you should be familiar with basic lighting terminology so that you know exactly what he or she is talking about and can render the effects on your storyboard for the lighting situations to be illustrated.

In the photographs in Figure 8–11, we see the key light illuminating the faces, the backlight highlighting their hair, and a fill light bounding into the shadows of their face to soften the shadow caused by the key light (here a large scoop light, softened with diffusion material). Also, an eye light is placed directly in front of Janet Rosenow's face to give a lively highlight to her eyes. This is "star" lighting that the extras don't get—they are lit with area lighting, a general expanded light that lets them be

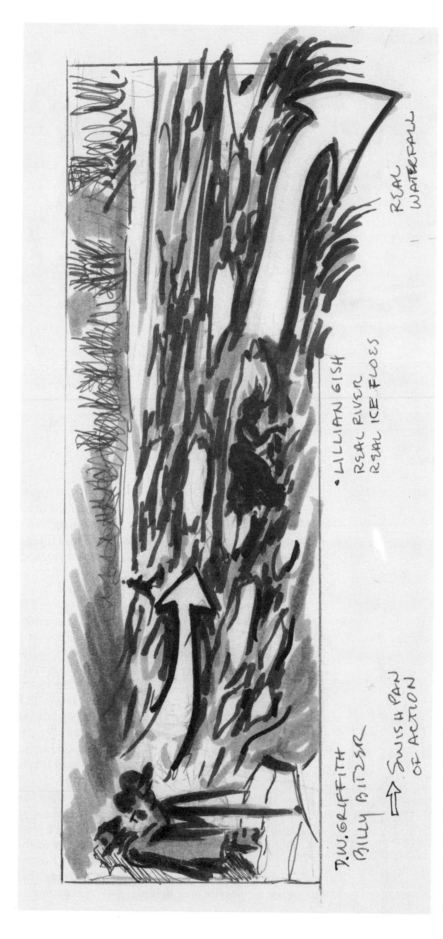

Figure 8–10 *Way Down East* (1920).

(a)

Figure 8–11 (a) Jack Brent, (b) Janet Rosenow, and (c) lighting diagram or light plot for Janet Rosenow. Reprinted with permission.

Janet Rosenow

Figure 8–11 *Continued*

(b)

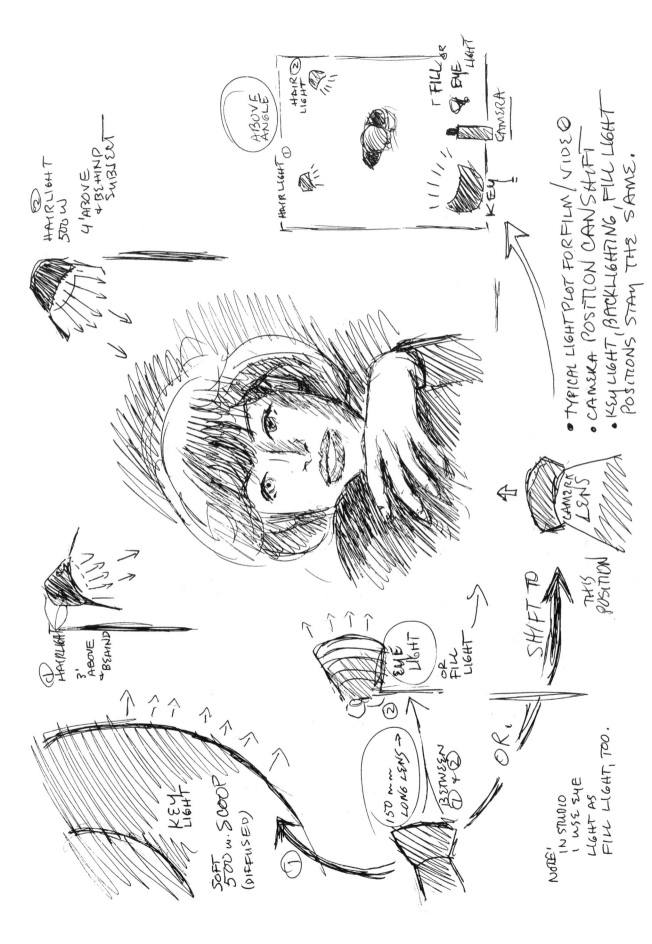

Figure 8–11 Continued

149

seen, but not in the lighting that the star gets. A few examples follow, using analytical sketches taken from certain shots from classic films, which will expand these lighting and compositional concepts further.

William Daniels, the cinematographer that Greta Garbo demanded on all of her films, backlit Garbo a lot, giving her hair a halo of luminosity, then lit her famous bone structure with a soft, diffused, "romantic" key light, adding another soft fill light to soften shadows (see Figure 8–12). This "glamour" lighting set a standard that is still used today.

Figure 8–13 shows a shot from *Citizen Kane* (1941), directed by Orson Welles and photographed by Gregg Toland, whose close collaboration with Welles produced a film that is invariably at the top of the list on everyone's ten best films of all time. It was just listed as number one in the American Film Institute's 1998 100 Best Films of the Last 100 Years. Here, Kane's key light is hitting him from a 45 degree angle, but it has been manipulated to shade his face from the eyes up to the top of the head, creating the emotional mood of a man whose life is spent, who is being blocked out, shaded, and pressed in upon.

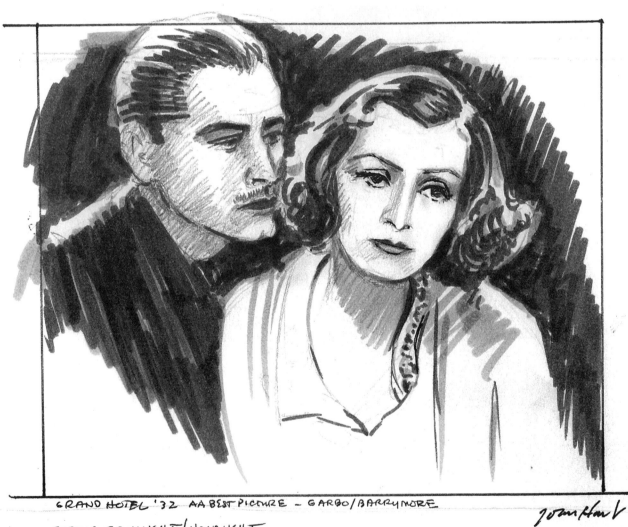

GRAND HOTEL '32 AA BEST PICTURE – GARBO/BARRYMORE

STRONG BACKLIGHT/HAIRLIGHT

SOFTER KEY LIGHT (DIFFUSED) ON FACES

Figure 8–12 An analytical sketch from *Grand Hotel*.

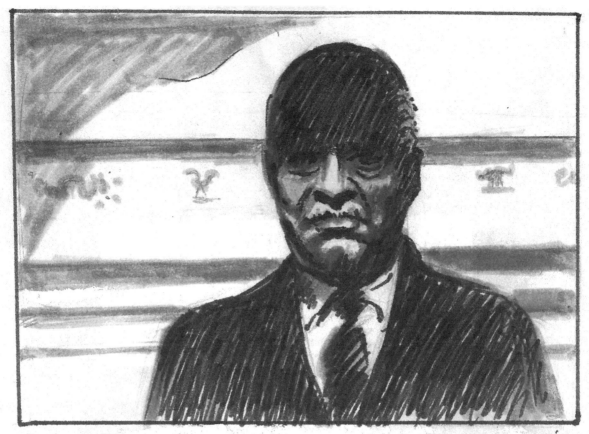

RECEDING HORIZONTALS OF BGD CEILING
STRONG OVERHEAD LIGHTING SOURCE

CITIZEN KANE '41

Figure 8–13　An analytical sketch from *Citizen Kane*.

The focus is specifically on Kane, using a normal lens in a medium CU shot, causing the shadows from the beams in the ceiling behind him to eventually soften as they recede in perspective. Shot from an unnervingly low angle, it photographs him almost silhouetted against those receding rafters, in turn reflecting his diminishing power.

High drama exudes from this analytical sketch in Figure 8–14 from *Ivan The Terrible, Part II*, directed by Sergei Eisenstein and photographed by his artistic partner, André Tisse, in 1946 and finally released in 1958. A strong chiaroscuro effect is caused by the intense key light emanating from the left. It is an original composition that is strong from the FGD figures all the way back to the MGD, with its imposing shadow of Ivan, to the tapestried BGD. The great depth of field comes from the brilliant key lighting along with supplemental lighting in the rear throne area.

Figure 8–15 shows a quickly sketched shot from *On the Waterfront* (1954) directed by Elia Kazan and starring the innovative Marlon Brando. The powerful backlighting from the headlights of the truck trying to kill the two protagonists gives this one-point perspective setup its visceral impact. The depth of field runs from the frontal plane right back to the truck headlights. The two figures are the subject of the pri-

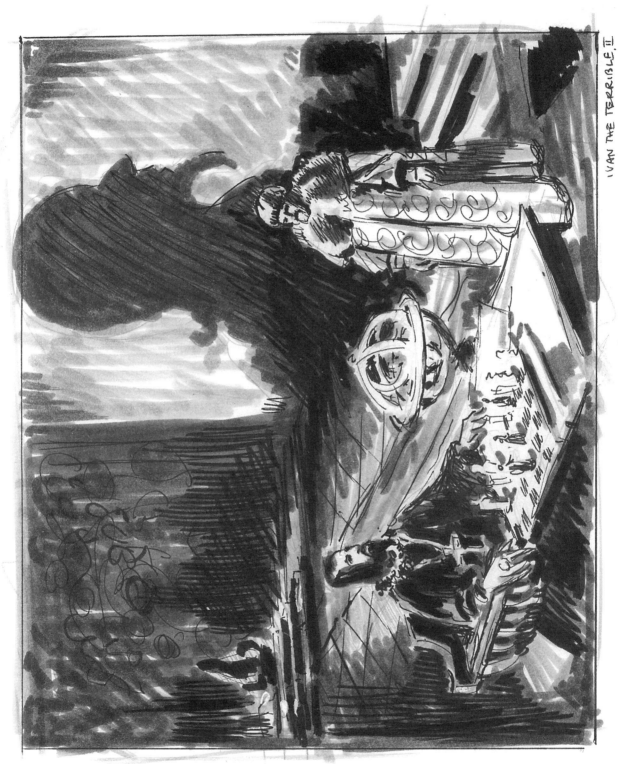

ARCHITECTONIC FRAMING

IVAN THE TERRIBLE, II
EISENSTEIN.
TISSE

Figure 8-14 An analytical sketch from *Ivan the Terrible, Part II.*

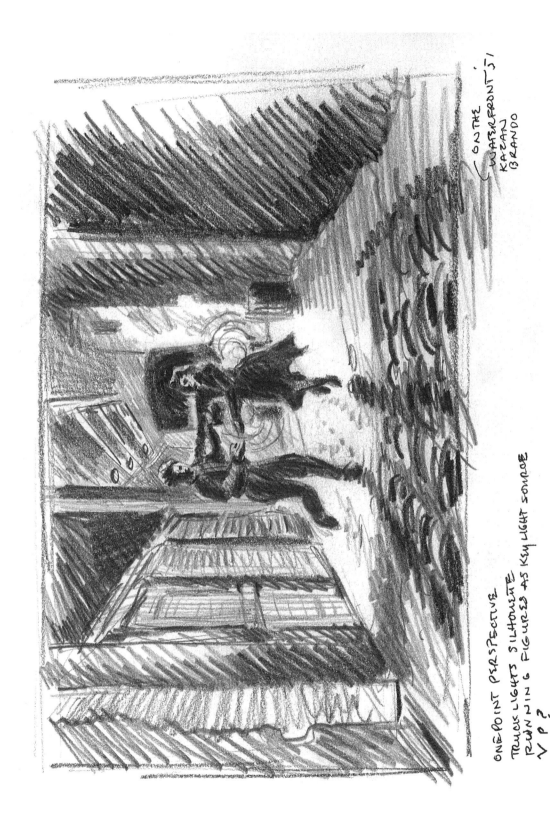

ONE POINT PERSPECTIVE
TRUCK LIGHTS SILHOUETTE
RUNNING FIGURES AS KEY LIGHT SOURCE
V P ?

ON THE
WATERFRONT'S!
KAZAN
BRANDO

Figure 8–15 An analytical sketch from *On the Waterfront*.

mary focus in this normal lens shot taken from a low ground level for extra drama—not that the camera operator and focus puller were kept busy following the focus on them as they run toward the foreground.

In Figure 8–16, you are looking at a scene (compositionally analyzed here in my water color rendering—the standing figure is my insert) that helped Freddie Young, director of photography for *Doctor Zhivago* (1965), and production designer John Box win Academy Awards for their visual contributions to this stunning film.

This is a night scene, permeated with an ethereal blue that inundates the cupola-dominated residence. Compositionally, the horizontal shadows in the FGD contrast with the vertical trees within the same plane. The strongest light source is from the left, with a strong overhead sky light descending on the snow-covered house and grounds. Probably, it was very strongly lit for great depth of field with a slightly wide angle Panavision lens, then softened by blue-gray gels to give it its late evening mood.

Having the superb production values of any David Lean film, *Lawrence Of Arabia* (1962), projects "hot" tonal values or "high key" lighting compared to the "cold" colors used. In Figure 8–17, Lawrence (Peter O'Toole) is about to advance on the enemy. This still is an excellent example of reflected light, bouncing in on Lawrence, who is "blocked" into the shadow of the flag. The scene probably was shot with a Panavision 75 mm lens at a pretty straight on level. Depth of field is not a major consideration here, and it would be lessened or opened up a bit because he is in shaded light and the lens is not "closed down" to accommodate the intense light of an open desert. Notice that the actor is slightly off-center in the design of the frame. This shot demonstrates a great manipulation of light, actors, and props.

Shot mostly out of doors in available light, *Apocalypse Now* was directed by Francis Ford Copolla, with photography by Academy Award-winner Vittorio Storaro and production design by Dean Tavoularis (who also garnered an Oscar for his stunning work). The tight CU of Martin Sheen in Figure 8–18 is a dynamic instance of sidelighting, as the telephoto lens moves into his unbelieving eyes witnessing the horror of war. The BGD was kept dark to emphasize the sidelighting.

In 1982, Stephen Spielberg gave the movie world *E.T.*, a groundbreaking venture in fantasy science fiction and the use of animated figures with humans. This film was an advance in the realistic portrayal of an alien being dealing with a human boy. E.T.'s movements were natural and more believable than anything before it, from *King Kong* on.

Even in the still from the film in Figure 8–19, you can see why he looked so natural, and that's because the same "glamour" lighting was used on E.T. as on Garbo. The lighting was intense, E.T. was backlit, just like the boy, and a soft flattering key light was taken from the glow emanating from his index finger. A general fill light surrounds the alien, too, so that in this lighting E.T. and the boy indeed are equals.

Exercise

Select 12 examples of photos from magazines, film stills, or newspapers that indicate various depths of field and light sources. Make a simple sketch of each, noting the FGD, MGD, and BGD focusing utilized by the photographer.

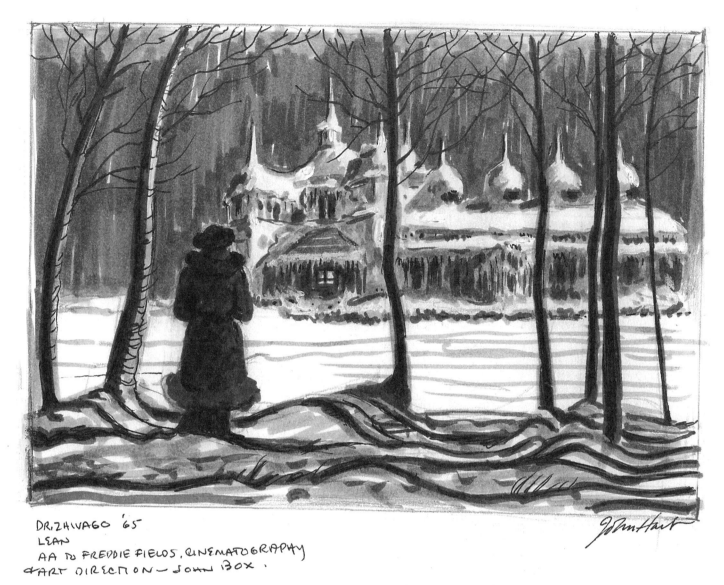

DR. ZHIVAGO '65
LEAN
AA TO FREDDIE FIELDS. CINEMATOGRAPHY
& ART DIRECTION — JOHN BOX.

Figure 8–16 An analytical sketch from *Doctor Zhivago.*

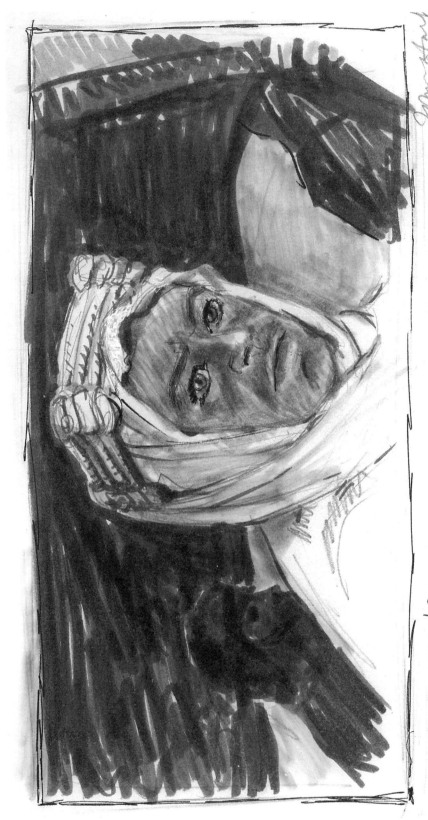

LAWRENCE OF ARABIA / LEAN

• REFLECTED LIGHT — WIDE SCREEN FORMAT FRAMING

AA FREDDIE YOUNG — COLOR CINEMATOGRAPHY

Figure 8-17 An analytical sketch from *Lawrence of Arabia*.

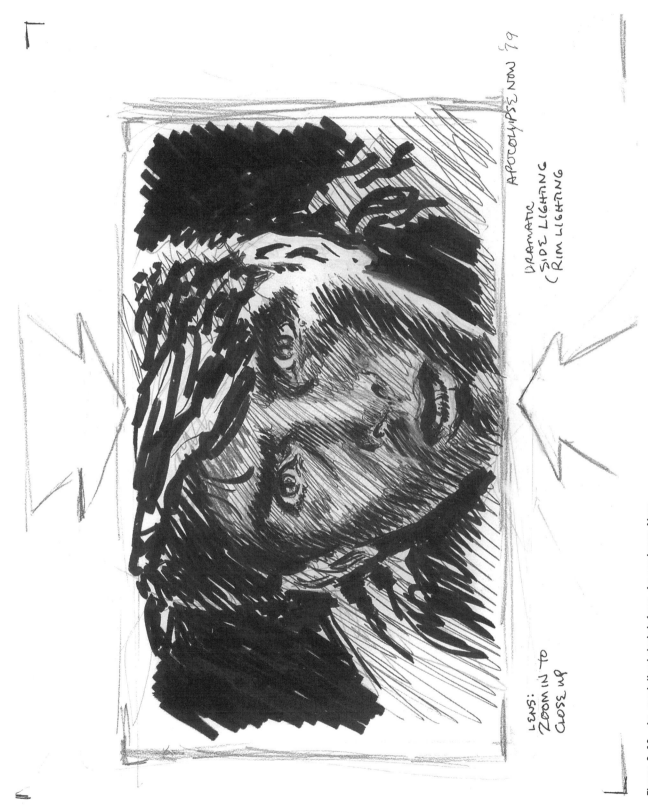

Figure 8–18 An analytical sketch from *Apocalypse Now*.

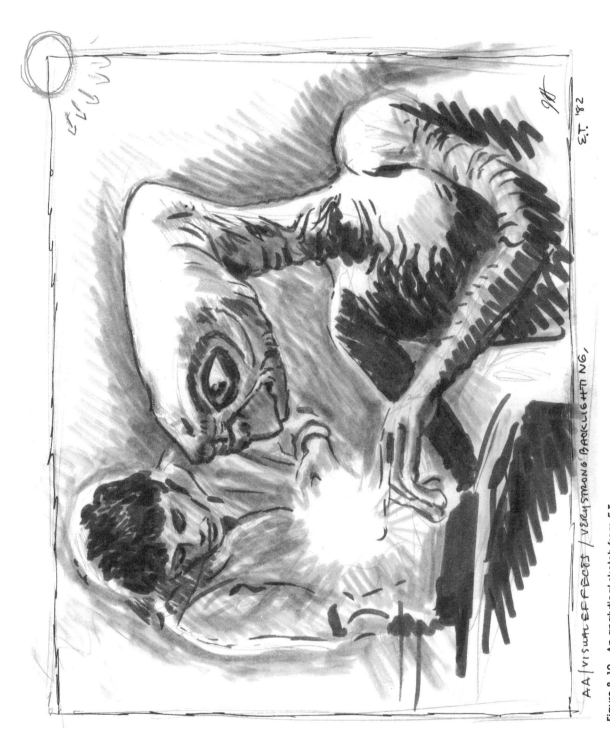

Figure 8–19 An analytical sketch from *E.T.*

9

Perspective and
Depth of Field:
Designing and
Composing the Frame

Recently, I made the sketch of the Brooklyn Bridge in Figure 9–1. I must admit that even I was fooled by the location of the vanishing point (VP) for what primarily is a one-point perspective study.

At first, I thought that it was in the center of the picture just under the midway point of the suspension, where the East River bends around to the left. The horizon line is easy, it is the river's edge that cuts across the center of the frame. But the VP itself actually is way over to the left of what could be an establishing shot for a film, just above the tug with the smoke stack. The small sailboat to the right of the left pylon of the bridge and the seagulls also are pointing to the VP (black dot).

The day was brilliantly lit; and so the depth of field was quite sharp, extending all the way from the vase of flowers on the FGD table to the bridge itself in the MGD to the buildings that line the river in the BGD. Naturally, the birds, the boats, and the bridge itself are sharper in focus than those buildings in the center of the frame, and the vase of flowers, table, chair, and railing that frame the FGD are the sharpest.

This scene is made up of receding planes: the frontal plane (actually the pane of glass in front of me in the restaurant), the river itself as a base plane that extends to the BGD, and the bridge itself consists of its own frontal plane and the planes that make up the sides of the arched supports in the MGD. Can you figure out the rest?

Normally, it's best to avoid shots with water sources that look like they are dripping off the bottom of the frame, so I have framed the base of the scene with the railing of the restaurant and the table and chair.

Remember, the brighter lit the scene, the sharper will be the depth of field; the "shorter" the lens, the sharper the depth of field; the "longer" the lens, the shorter the depth of field.

Being brightly lit on such a clear day, the sun itself, of course, was the key lighting element here, and its actually was positioned way out of frame to the right, indicated by the arrow.

Notice, in this quickly sketched shot, the dark shading of the bridge's gothic arch supports on the inside facing us, the shading of the underside of the suspension and the shading of the buildings receding from FGD to BGD. This shot might call for a wide angle lens, possibly

Figure 9–1 Brooklyn Bridge.

an anamorphic lens (originally designed for the very wide Cinemascope screen) to pull in the full panoramic vista of the possible scene.

To design this "frame," the support pylons themselves act as opposite framing devices, as do the seagulls and the two boats (which also serve to lead out eye into the shot). Again, the FGD railing, flowers, and the like frame the lower part of the sketch, with even the smoke from the tug moving forward in the lower left of the frame as a framing device that keeps our eyes focused on the scene being shot.

NOTE: It is the job of a good storyboard artist to design each frame so that the center of interest in each scene is maintained, using strong compositional devices such as the preceding ones that keep the eye only on what you want it to focus on. Extraneous elements that distract are to be avoided. Note, too, that the basic composition of the "shot" has been divided into two thirds that take up the lower section of the scene and the one third that takes up the sky.

Figure 9–2 is an example of a quick idea sketch, made on the spot, that I might be able to use later in storyboard as a reference. In addition, it is an exercise in one-point perspective (where are the VP and the horizon line?), comprising as it does, a crowd in the FGD plane, a receding highway going from the FGD through the MGD to the BGD, and framing the shot on the left the prow of an old ship.

It is recommended again that you carry a small sketchbook with you to record quickly images that you find interesting. Also, these "quickies" (this one took, maybe, three minutes) help you to think quickly and come up with fast concept sketches when you might have a script session with the director. These sketches, along with others that you have seen earlier in this text, are simple examples of what the storyboard artist-to-be should be doing in his or her spare time—constantly. These rough sketches always can be rendered in a more finished way later, if you like, but in the meantime they assist you to become a more facile

Figure 9–2 East River Drive and piers.

artist, one who is more adept at proportion, composition, lighting, and the placement of figures in the mis-en-scène of the shot. Most important, you learn how to think and draw three-dimensionally, and that is exactly what my stress on perspective and the recession of visual planes is all about.

In the shot in Figure 9–3 (sketched in 10 minutes), Mount St. Helen has erupted and the freeway already has been broken in two as everyone in their cars is trying to escape the fury of the volcano. First, this shot is obviously a one-point perspective project, but can you locate the VP and the horizon line?

The framing of the shot with the sign and the crumbling freeway on the left balanced on the right by the falling building is excellently designed, along with placing the center of interest (the cars falling off the collapsing freeway) to the left middle ground of the composition.

Incidentally, the railing of the FGD road on the left acts as a "fifth" line (the other four being the four sides of the frame) that leads our eye to the center of interest (like that tugboat in Figure 9–1) along with the inward direction of the cars themselves moving from FGD to MGD to BGD.

This is a composite shot made up of disparate SFX elements: "A collapsible miniature of the ramp and freeway—built by Grant McCune Design and filmed against a green screen by Digital Domain—was combined with live-action stunt footage shot in Wallace, Oregon on a full-size set piece" ("*Dante's Peak*, . . .," 1997).

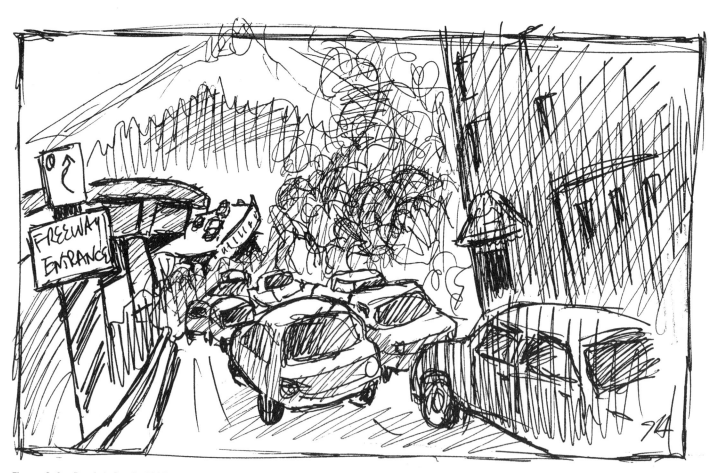

Figure 9–3 *Dante's Peak* (1997).

Certainly, this shot from *Dante's Peak* is visually dynamic, not just due to the aforementioned SFX elements but because principles of great production design were considered first. In particular, the mass of the cars and freeway (in the lower two thirds of the frame) were played off against the solid but falling building to the right. The smoke and fire taking up the center or MGD plane contrasts with the pyramidal volcano in the BGD. Note, too, that the cars themselves along with the road constitute the shape of another pyramidal mass that repeats the triangle of the volcano.

All these compositional devices recall Eisenstein's use of conflict of forms or masses: larger volumes against smaller volumes, the volcano against humankind; horizontals against verticals, the cars and freeway against the sign, the pylons of the freeway and the lines of the building on the right. Three-dimensionality is served beautifully by the combination of sound design techniques used by the director, the production designer, the director of photography, and the storyboard artist.

NOTE: When doing quick sketches, keep basic shapes and forms in mind first, like the triangular shapes mentioned earlier, the rounded rhomboidal shapes of the cars, and the rectangular shapes contained in the building, and the circular billowing of the smoke and fire in the center. Remember Cezanne?

Considering the overcast qualities of light caused by the volcanic dust, light and shade are soft, but the use of a sharp wide angle lens helps give it enough depth of field so that the viewer can certainly experience the visceral emotions of this disaster—all brought about by the collaboration of the artists involved.

In Figure 9–4, a dynamic shot from *Titanic*, the John Cameron blockbuster hit, several components are at play. First of all, about 60 shots using computer graphic imaging (CGI) are used in this miracle of imagination film. The digital *Titanic* (rendered in Lightwave) even uses what are called *synthespians*; that is, extras and stunt people, even "stand-ins" for the leads, completely rendered using CGI animation techniques, employing Softimage software, with the shadows cast by the synthespians rendered in Mental Ray (Mallory, Jan. 1998).

Even though we don't see any of the falling synthespians in this particular shot (you'll observe plenty of them doing their thing when you see the film), the dynamic composition seen here is worth analyzing. The huge bulk of the boat takes up most of the frame in this major use of the golden mean dictum.

The FGD tugboat (sharp focus) is played off against a smaller one (softer focus) in the right MGD, and we can see, very faintly in the BGD, a slightly out-of-focus shoreline. Even with CGI technology (by Digital Domain), the reality of depth of field is adhered to.

While there is no linear perspective with an obvious VP, using either one or two points (although I have indicated the receding lines of the faintly seen plates on the starboard side of the ship), the three-dimensional appearance of this shot is obvious with the contrasting volumes consisting of tugboat, *Titanic*, smaller tugboat, and the shoreline. The dynamic of large forms playing against smaller masses gives us in this frame an impressive observation of the gargantuan size of the doomed ship.

In the shot from *Forrest Gump* in Figure 9–5, the use of one-point perspective is obvious. Do you think that you can place the horizon line and the VP?

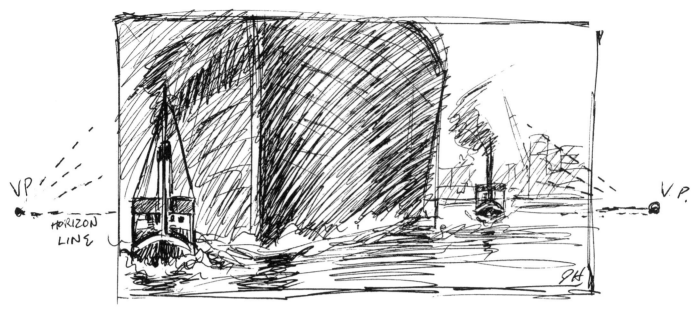

Figure 9–4 *Titanic* (1997).

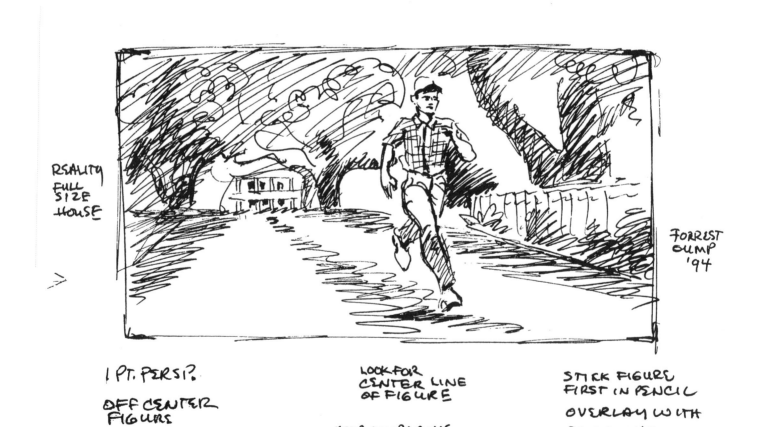

Figure 9–5 *Forrest Gump* (1994).

I'd like to say a word here about distorted or *forced perspective*. You already have seen examples of this in previous illustrations, particularly in *James and the Giant Peach*, Chapter 2, Figure 2–12, where the wall to the right is made larger in the FGD and forced to appear smaller by the time it reaches the MGD because it was constructed to start, perhaps, at 5 feet tall and recedes to 2 feet tall. Add that factor to constructing the house in the BGD so that it is one tenth the size of a real house and you have compressed the scene from FGD to BGD. You have used 20 feet in depth instead of 200, and in addition it adds to the fairy tale feel of the setting.

Figure 9–6 has added a sense of surrealism or unreality to the scene. We also could make it look more exotic. This should be used only when such surreal elements or dreamlike storybook settings are called for.

Giant (1955) featured, along with Elizabeth Taylor and Rock Hudson, one of the great film icons of the twentieth century—James Dean. Dean's impassioned approach to his role of the outsider who strikes an "oil rich" is memorable, along with the superb visual interpretation of *Giant*'s color art direction by Boris Leven, who was nominated for an Academy Award in 1956.

As far as the use of color is concerned, we've already indicated the use of FGD framing and perspective as devices that aid in imparting a spatial quality to a scene. Another technique is the use of tonality of color, or tonal progressions, to add depth to a shot. Remember, an extreme wide angle lens also could add distortion and a long lens will help throw the BGD into softer outlines.

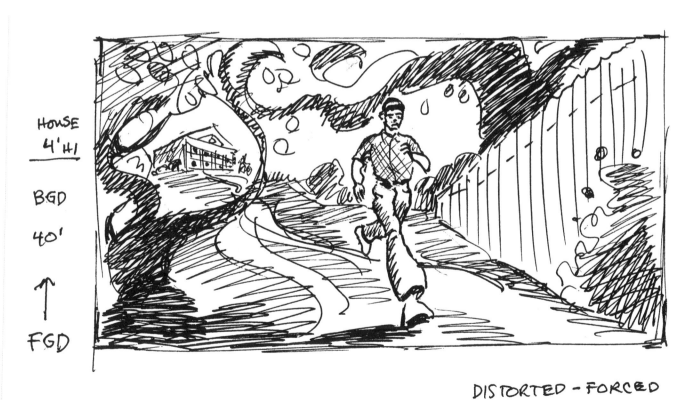

Figure 9–6 *Forrest Gump* (1994).

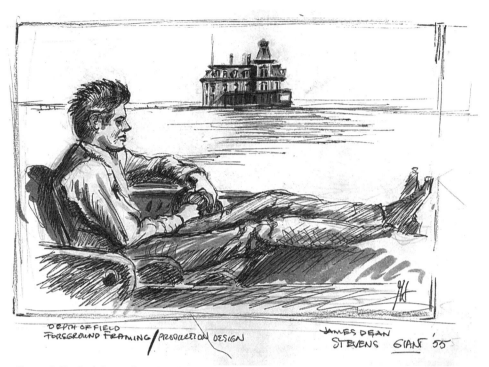

DEPTH OF FIELD
FORSGROUND FRAMING / PRODUCTION DESIGN

JAMES DEAN
STEVENS GIANT 55

Figure 9–7 An interpretive sketch for *Giant* (1955).

Tonality is added by painting or lighting forms and objects to be photographed with such gradations of color or shades that would go from dark tones in the FGD to more subtle shares in the MGD to bluer, softer shades or tones in the BGD. Red, for instance, reads FGD, terra cotta tones read MGD, while softer blue-pinks would read BGD.

Exercise

Study Eisenstein's *film form*. Look for one- and two-point perspective in shots from his films. Sketch at least six of each. Render one local street in two-point perspective. Indicate figures in action in the FGD, MGD, and BGD. Find a light source (position of the sun) and indicate appropriate shadows.

10

The Shot, Part I:
The Shot's Function as
Part of the Narrative Flow

Even in everyday parlance, you hear people with cameras saying, "I want to get a shot of you and your fiancee over there near the arbor" or "let me get a shot of the Parthenon from this angle before we go back to the hotel" or "a shot of that group of kids waiting to get on the carousel would be terrific."

This is the shot, then: focusing in on a particular scene with your camera in order to capture it on film. The difference in making films is that a series of shots of a particular scene is taken, motivated by dramatic events taken from a written screenplay or script.

You'll recall the schematic in Figure 10–1 from Chapter 2. It shows a series of shots, photographed in sequence, in order to follow the continuity of the script.

Illustrating this series of shots (images, frames) in a logical, structural rhythm, of course, is the job of the storyboard artist. These shots will have a unity of action to them, and they must obey a certain "principle of order." In *The Film Experience* (1968), Ron Huss and Norman Silverstein state: "The storyboard artist, guided by the director, captures the action and passions that will be translated into film (varying throughout the camera distances and angles that will evoke surprise or pathos). Even though his series of drawings is accompanied by written actions and dialogue, the continuity, reminiscent of action comic strips, remains primarily pictorial."

There is, in the storyboard, then, a rendered visual progression of shots. When the director and the director of photography have filmed a particular shot, say, of a man and a woman being chased by a lethal truck, as you observed in the alley shot from *On the Waterfront* (Chapter 8), the director will call "Cut!" and move on to the next setup for the next shot that will fall into the continuity of the script. The director and director of photography know that they have framed their action well, as you know from your new knowledge of perspective, receding planes, light and shade, and composition. Elia Kazan has used these concepts plus shifts in volume and mass within the pictorial space, to compose shots that reinforce his theme attitude and create his intended visceral action.

Notice that in Figure 10–2, an effective shot from *Duel in the Sun*, there is no obvious linear perspective, only a long shot (LS) of the figures silhouetted against a setting sun, with the earth in a darker FGD

THE FUNCTION OF THE STORYBOARD

☆ INDIVIDUAL FRAMES INDICATE AND ILLUSTRATE THE GOOD SHOTS THAT MAKE UP AVERAGE FILM.

☆ FLOWING ARROW REPRESENTS THE NARRATIVE FLOW OF THE STORYLINE (SCENARIO) I.E., THE CONTINUITY OF THE FINAL SHOOTING SCRIPT

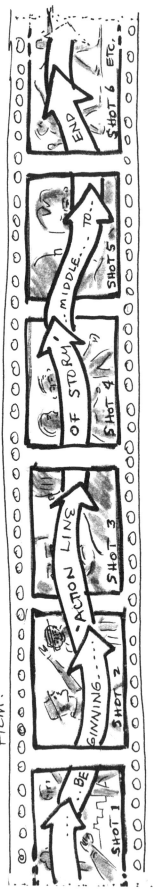

★ THE STORYBOARD IS THE VISUALIZATION OF THE WRITTEN WORD (SCREENPLAY) AND ITS STRUCTURE.

★ IT SERVES THE VISUAL NEEDS OF THE DIRECTOR, THE DIRECTOR OF PHOTOGRAPHY, THE PRODUCER AND THE SPECIAL EFFECTS TEAM.

Figure 10-1 The storyboard.

DUEL IN THE SUN '46

GOLDEN MEAN AT WORK
CIRCLES/DESIGN
SETTING SUN AS LIGHT SOURCE

Figure 10–2 *Duel in the Sun* (1946; David O. Selznick, producer).

plane and the night sky acting as the BGD plane. The use of circles here make for a strong design element. Observe one third/two thirds division of earth and sky. In the memorable series of shots from Alfred Hitchcock's infamous *Psycho* (1960) shown in Figure 10–3, you will note how he filmed this action in a very original way with the use of a stunning variety of angles.

Reading from left to right, we will use the terminology pertaining to use of angles.

Frame 1. A close-up (CU) of the back of Anthony Perkins's head. Since it starts a new locale in the script, the shower room, frame 1 also could be described as an establishing shot (EST SHOT) that lets the viewers know where they are before the action begins.

Frame 2. *Cut to* CU back of Perkins's head as he looks through a "peep hole."

Frame 3. *Cut to* medium shot (MS) of Janet Leigh.

Frame 4. *Cut to* extreme CU (EXT CU) of Perkins's eye, staring.

Frame 5. *Cut to* MS of Leigh undressing

Frame 6. *Cut to* low angle, MS Leigh under showerhead.

Frame 7. *Cut to* low angle shot of showerhead.

Frame 8. *Cut to* MS of Leigh, profile.

Figure 10–3 *Psycho* (1960).

Frame 9. *Cut to* MS Leigh, three-quarter shot, right of frame.
Frame 10. *Cut to* MS of Perkins, through shower with knife.
Frame 11. *Cut to* CU, Perkins's hand with knife.
Frame 12. *Cut to* CU, Leigh screaming.
Frame 13. *Cut to* EXT CU, Leigh's mouth.
Frame 14. *Cut to* MS, Leigh grabs Perkins's arm.
Frame 15. *Cut to* EXT CU, knife at her midsection.
Frame 16. *Cut to* tight CU, Leigh's face.

These graphic shots from one of the best suspense films of any generation illustrate the brilliant use of diverse camera angles combined with an eerie Bernard Herman score and Hitchcock's incisive editing.

Going from the sublime to the commercial, the storyboard in Figure 10–4 illustrates its function as part of this particular narrative action and flow coming from a test commercial for a toothpaste product.

There are indications of one- and two-point perspective plus the idea of drawing from a stick figure representation and then fleshing out the walking figures beginning with frame 4.

As you can see, the storyboard starts with an EST SHOT, or master shot, with lines drawn for a review of two-point perspective. A wide angle lens is used in the helicopter shot (or bird's-eye view).

Frame 1. EST SHOT.
Frame 2. Extreme long shot (EXT LS), drawn in one-point perspective.
Frame 3. LS.
Frame 4. MS.
Frame 5. CU, with some minimal shading drawn in.
Frame 6. Tight CU, BGD out of focus, with long lens.
Frame 7. MS, two shot, at an overhead angle.
Frame 8. MS, over-the-shoulder shot, at a low angle.

The storyboard from *Sheriff!* (Figure 10–5) demonstrates the use of a variety of angles, compositions, and perspectives.

Follow the action from the EST SHOT in frame 1, to the zoom in to MS of the saloon in frame 2, to the high angle MS in frame 3 with the steadicam camera following him into the bar (before steadicam this would entail a dolly shot) within frame 4, to the medium CU (MCU) of the bar rats in 5, to the EXT CU in 6, to the tight CU (TCU) of the sheriff in 7, to the zoom in to an MS of Mr. Evil, to finish at the tight two-shot of the bartender and the sheriff in the FGD as Mr. Evil watches from the balcony in the BGD, over the heads of the bar rats in MGD.

It has become obvious that *cut to* does not necessarily have to be indicated on each shot of the storyboard because it usually is referred to in the dialogue beneath each frame of the storyboard. Figure 10–6 shows two storyboards in rough sketch form done on the spot from the script with the screenwriter to help visualize each of these scenes.

I made quickie rough sketches right on the margin of this page and scene from *Venus Mountain.* As you can see, they are concept sketches that even in their small state help to visualize the written action in each shot.

I expanded the mini sketches, using pencil to sketch in the basic movements of the figures and their office environment with each shot, then added pen and ink lines to further delineate the action. At this stage, I kept the drawings as simple as possible. In a later stage, I could apply more shading to give them a more three-dimensional feeling, if I

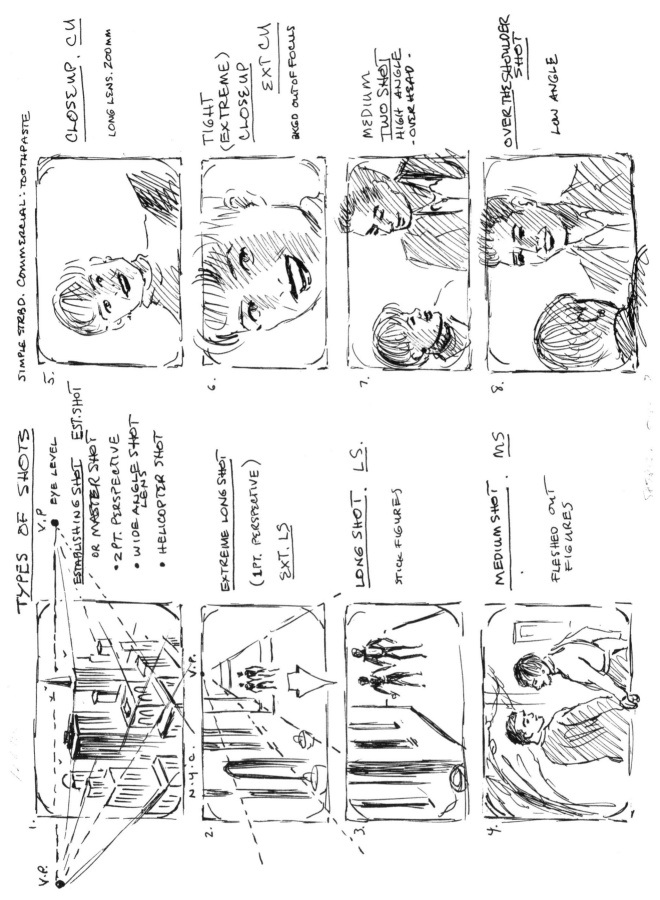

Figure 10–4 Test toothpaste commercial.

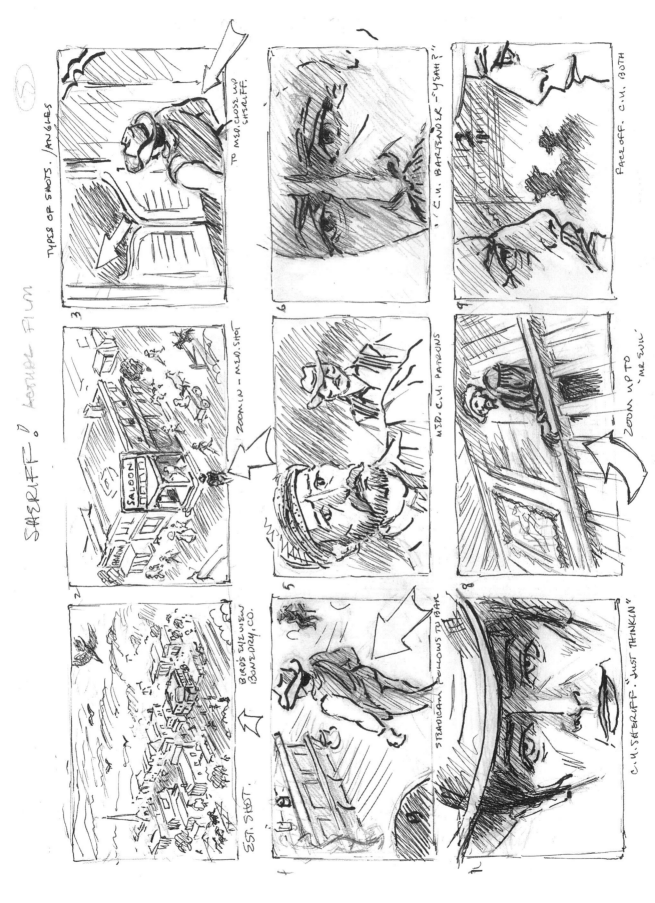

Figure 10-5 Analytical sketches from *Sheriff!*

29

JUSTIN CARDIFF turns the corner and comes down the cor-
ridor toward us. He continues by, FOOTSTEPS FADING.

It's DARK inside CARDIFF'S OFFICE. The DOOR opens,
rheostated LIGHTS come up, and

CARDIFF strides in. He tosses his jacket on a COUCH,
goes to a BAR, pours himself a BRANDY, then strolls over
to the WINDOW, where he stands for a moment, looking out.

Turning back to his DESK, he sits, flips on a TAPE DECK,
pulls out some STATIONERY, and begins to SCRIBBLE. As
the opening chord of VESTI LA GIUBBA (vintage CARUSO)
sounds,

CARDIFF IS FRAMED IN THE DOORWAY OF THE DARK, ADJOINING
ROOM. Then,

A GUN hanging straight down fills one half of the screen,
dwarfing CARDIFF (BG). The GUN begins to move—— slowly
—— TOWARD him. We follow THROUGH THE DOOR, as CARDIFF
grows LARGER.

MARY, still advancing.

CARDIFF, head down, engrossed in what he's writing——
but still growing LARGER. Then, he SENSES another pres-
ence and

CARDIFF LOOKS UP.

MARY STANDS THERE, STOPPED.

THE GUN, CLOSE UP.

CARDIFF AND MARY FACING EACH OTHER.

In the UNOCCUPIED OFFICE, BENNY and MOON are by the WINDOW:
BENNY with BINOCULARS, MOON crouched over a high-powered
RIFLE with SCOPE; SAL is by the RADIO.

 BENNY
 What the hell is that?!

 SAL
 (eyes lighting up)
 Vesti La Giubba! My old man
 used to sing it all the time.
 What a set o' pipes my old man
 had—— ya shoulda heard 'im, Benny.

Figure 10–6 *Venus Mountain* by Lanny Foster, page 29 of the script and storyboards for the page.

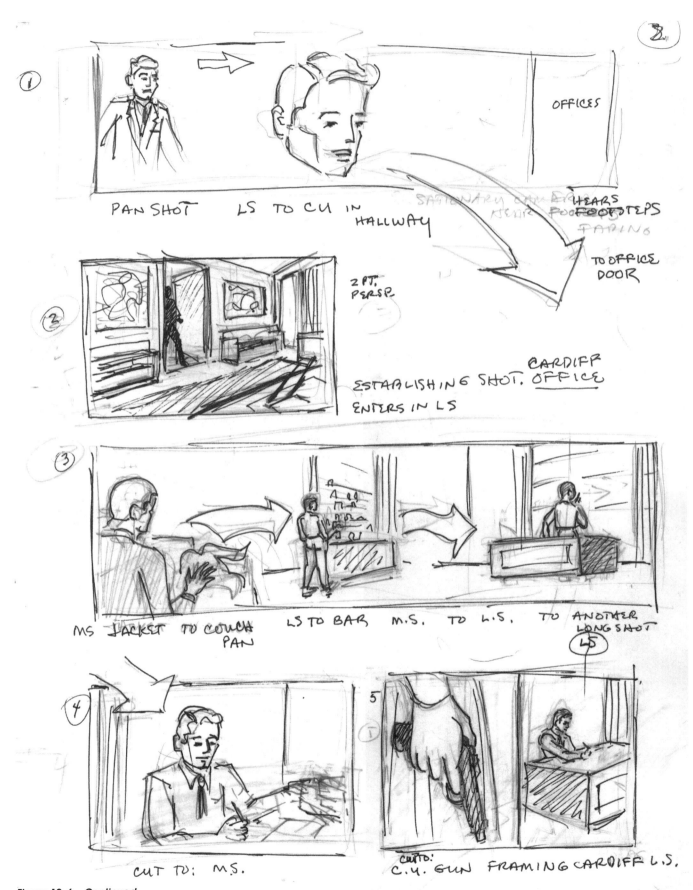

Figure 10–6 *Continued*

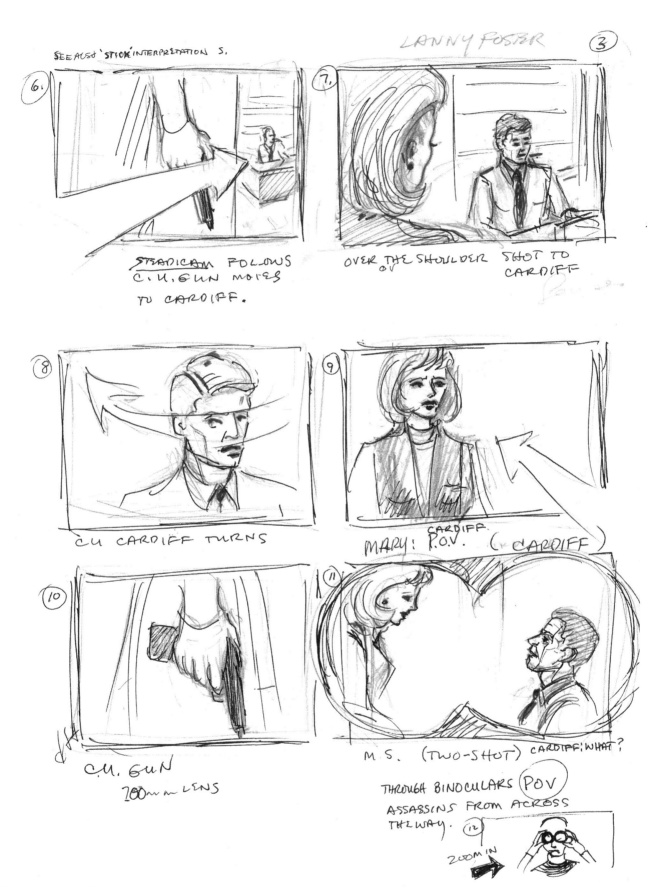

Figure 10–6 *Continued*

feel that is needed. There are arrow indications for possible camera movements.

Frame 1 is a pan shot, which occurs when a stationery camera (here with a wide angle lens) pans or follows the character in the scene. In this case, the camera follows Cardiff down the hallway outside of his office. A pan shot is also used in shot 4, where the camera follows Cardiff from an MS FGD shot to a LS as he goes to the bar, then moves to behind his desk. Note the variety of shots and angles as Mary and her gun are followed as she enters Cardiff's office in 7. Cardiff notices her in 8 and turns in her direction. In 9, the low angle MS of Mary is from his POV (point of view), from his lower angle looking up at her.

From the CU of her gun to the medium two shot of them, POV of the assassins in the opposite building, in frame 11 (frame 12 will zoom in on one of the assassin's faces), a variety of angles and movements is used to project the tension and emotionality of this conflict.

So, as you can detect by now, the director looking through a viewfinder has many options at his or her disposal.

As Gene Phillips says in *The Movie Makers* (1973): "The whole filmmaking process indicates the vast technical economic and artistic problems that must be coped with in the making of a film." Charlie Chaplin himself said: "Complexity isn't truth, we get things so cluttered up, get so damn clever that it hides the simple truth in a situation." Eric Sherman in *Directing the Film* (1976) quotes Vincente Minnelli (Academy Award for *Gigi*, 1958): "I think the visual is very important. I think that the story and the actors are most important, of course, but the surroundings, their place and time in space is very important." Perhaps, as storyboard artists, we should keep these dictums in mind.

We often see photos of directors looking through either a handheld viewfinder or the chosen lens on the camera (assuming that the collaborative efforts between the producer, director, director of photography, and the storyboard artist already have been accomplished), "lining up the shot."

Figure 10–7 shows a high angle shot of Orson Welles doing the final lining up of as shot with legendary cinematographer Gregg Toland while working on *Citizen Kane* (1941), a film that is required viewing for any film student. See it just for its superb handling of a fluid camera, its extremely sharp depth of field, its SFX compositing (putting several separately photographed shots into one frame), its very original use of camera angles, and last but not least, its legendary story line.

Basically, the three most frequently used lenses are the normal lens (what the human eye sees) for medium shots or normal framing, a long lens or telephoto for close-ups, and a wide angle lens to bring more of the scene into the shot. Telephoto lenses are long lenses, used to focus on a given figure or object from a distance. A zoom lens will go from the FGD to the MGD to focus on a CU in the BGD.

With the kind of rough sketch in Figure 10–8, an "on the spot" storyboard done for writer-director Ron Massaro and sketched in outline form in pencil during a story conference, you designate the type of shot you think each frame requires, as they have not been done by me. Only the dialogue has been indicated.

EST SHOT, CU, MS, LS, pan shot, zoom shot, two shot, and the like are your choices. What angels are indicated— high, low, straight on? Also, indicate what lenses you would suggest for each shot—normal, wide angle, zoom, or long lens?

177

Figure 10–7 *Citizen Kane* (1941).

SHOOTING CITIZEN KANE '41

A tornado sequence is illustrated in another segment of the screenplay *Sheriff!* (see Figure 10–9). The use of a more finished rendering has been done here, yet the outlines of the figures and their environment has been kept simple. Enough pen lines and simple shading were used to indicate the sequence and tempo of the ensuing action. Does this storyboard fulfill the emotional requirements of the scene? Could you do better? Terrific!

The school children and the teacher see the approaching tornado (frame 2) after its EST SHOT in frame 1. The tornado and its destructive path will require a lot of SFX from that department: making the tornado look real, handling the broken glass and its cuts in shot 4, the schoolhouse being carried away in shot 5, the flood in shot 6, the school afloat in frames 7, 8, and 9.

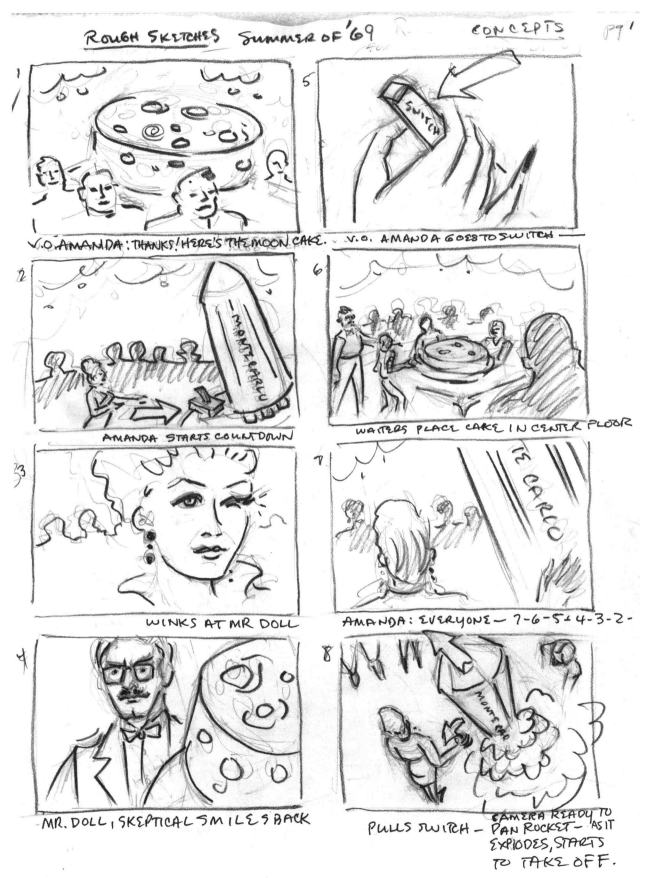

Figure 10–8 *The Summer of '69.*

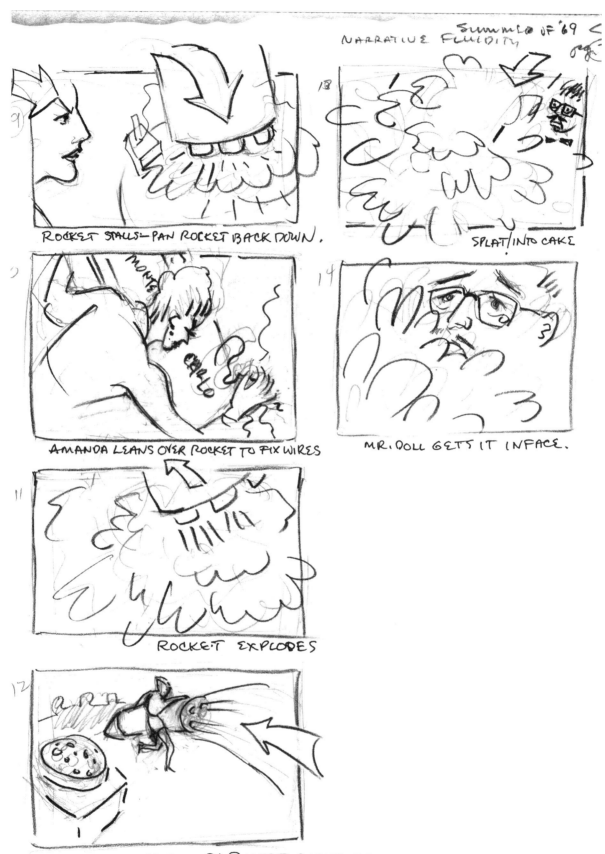

ROCKET STALLS—PAN ROCKET BACK DOWN.

SPLAT/INTO CAKE

AMANDA LEANS OVER ROCKET TO FIX WIRES

MR. DOLL GETS IT IN FACE.

ROCKET EXPLODES

AMANDA FLIES WITH ROCKET ACROSS BALLROOM

Figure 10–8 *Continued*

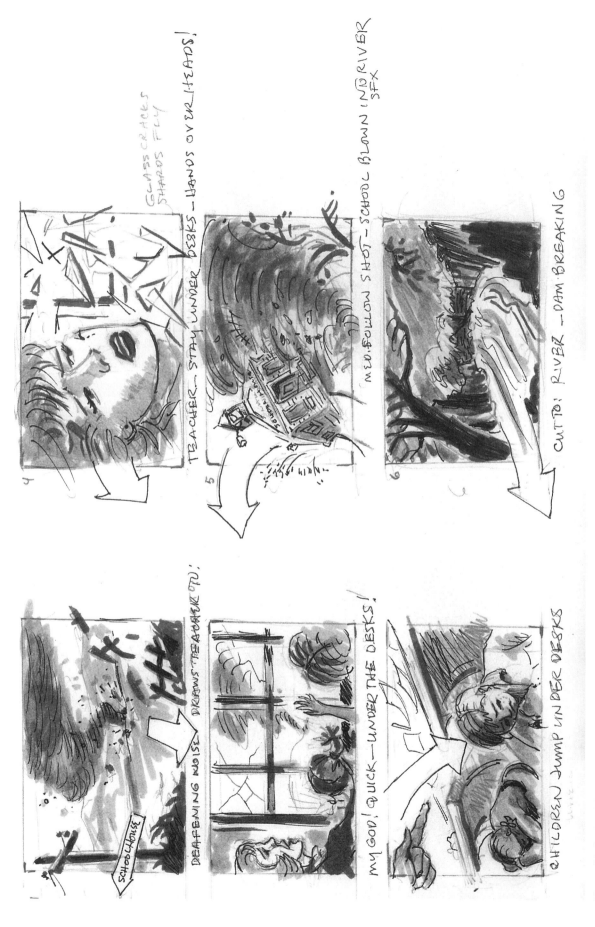

Figure 10–9 Analytical sketch of tornado scene in *Sheriff!*

Figure 10–9 *Continued*

SHERIFF: THERE THEY ARE!

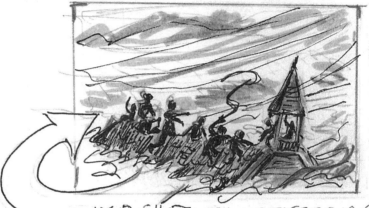

MED. SHOT. SCHOOLS TUSSED ABOUT

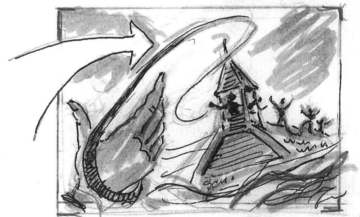

SHERIFF TUSSES ROPE TO TEACHER

Here again, for another exercise, indicate the types of shots, the angles used, and suggested lenses.

Exercises

1. Make up the copy or dialogue for the storyboard represented in Figure 10–4.
2. Write two pages of original script. Break it into shots, and design a basic storyboard for it. Create two characters in a crisis situation in a storyboard (24 frames) and resolve the crisis.

I want to say a word about aspect ratios. Although I have used several different storyboard formats, basically keep frame size at approximately $2\frac{1}{2}$ to 1 proportions for current wide screens. Draw your own.

11

The Shot, Part II: The Visual Language of Cinema

The visual language of cinema is a language of story structure, whose grammar is made up of the shot. To paraphrase Gertrude Stein, "a shot is a shot is a shot." Like Stein's poetry, the shot has its own simplicity and its own complexities, its hard realities and its emotional or intellectual side. The director has to figure out exactly what he or she wants the shot to say to the audience.

By way of introduction to the variables and components of the shot and why it is the visual heart of the movie making process, let's go back to the audience itself. The shot or a succession of shots is what must grab the audience's attention, whether in a movie theater or while viewing a commercial or film on TV.

For storyboard consideration, let's try to keep it first to its simpler side. Film is foremost an artistic medium that desires an emotional response from its audience. This audience even has its own group psychology. It sits there in the dark waiting to become involved in the sequence of shots projected before it, willing to be affected by the director's interpretation of reality. Having others sitting next to them helps the audience accept a bloody murder on screen because "those others" tell them it really isn't a grisly event they just might be imagining.

It is a primary fact that this audience must be treated with respect. At the heart of preparing the audience for the presentation of the drama, comedy, or the current sci-fi thriller is a film that contains a strong story line, one that will visually interpret the written words of the screenwriter. The shooting of each of the individual shots or scenes that make up the story structure, utilizing preproduction storyboarding, is what creates the finished movie that the eager audience will enjoy or be thrilled by.

B. P. Schulberg, production head of Paramount Pictures in the golden age of Hollywood, told his production team, during a story conference held over the screen adaptation of *Dr. Jekyll and Mr. Hyde* (1932; see Figure 11–1), originally written by Robert Lewis Stevenson, "Remember, *Jekyll and Hyde* already has a continuity. We don't have to waste time hammering out a story line. What you have to do is visualize it, think of every scene [or shot] as the camera will see it, not as you—or Stevenson—would describe it in prose."

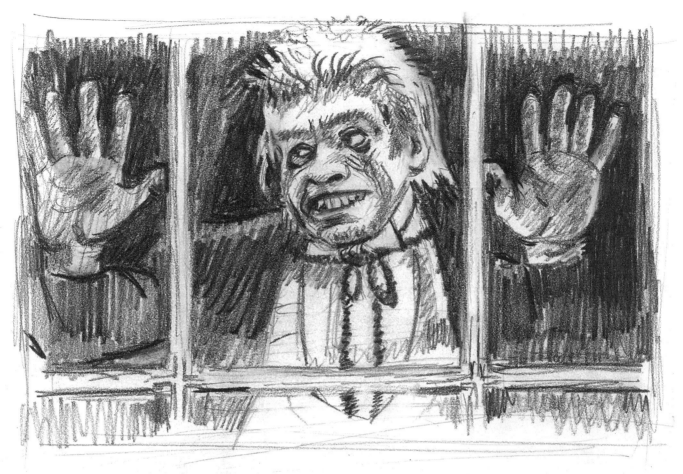

Figure 11–1 *Dr. Jekyll and Mr. Hyde* (1932).

"We've got the makings of a great picture. A great story, a great director [Rouben Mamoulian], a great cast [Fredric March and Miriam Hopkins], and a great cameraman [Karl Struss]."

NOTE: Eisenstein compressed the essence of the entire Russian Revolution into the 75 shots (1,500 meters) that constitute the Odessa Steps sequence from *Battleship Potemkin*. (See the Odessa Steps sequence from *Battleship Potemkin* in Chapter 5: cossacks firing on the populace.)

Suffice it to say here that, in reference to any series of shots, no matter what source these individual takes might come from, they have to be part of the story structure and, like Mr. Schulberg mentioned earlier, they have to make up the "entertainment package." Eisenstein, "worked at a phenomenal pace in order to get the film ready on December 12th. Yet, only at this stage did Eisenstein's compositional ideas finally crystallize and, despite the rush, he was continually experimenting with difference combinations of shots in his striving for artistic perfection" (Barna, 1973). He is also quoted saying that, "the words of the scenario became visual images—the genuine emotion with which they were charged was contained not in these brief indications but in our own feelings. As we strove to evoke the events, these feelings gave birth to characters that became living beings" (Barna, 1973).

It must be said too that, with all of Eisenstein's brilliant innovations in the framing of compositions and his use of metaphoric montage, he

always was conscious that his work had to be viewed as entertainment, just like those often maligned Hollywood moguls who actually knew a good story and a good shot when they saw one.

Again, no matter if the director is a beginning documentarian trying to expose corruption in Wall Street or Steven Spielberg returning for inspiration once again in *Jurassic Park*, all the images, the shots, the takes have to have substantial content within them. First of all, the story must have content and structure; second, when it comes time to visualize the setups in the script, the shots themselves have to have stunning, eye-pleasing content.

Since the shot itself is the smallest element that makes up the scenario, it dictates its own psychological, artistic, and intellectual demands. The primary questions that one has to ask in reference to the content of the shot are these: What are the demands of the script? Who is involved in the scene? In what locale do these characters exist? Why are they there? What mood will enhance the setup of this particular shot? What colors will augment the emotions involved in the conflict? Where will the camera be placed to best advantage? What lenses will be used for establishing the shot? Refer the illustration of the toothpaste commercial and the *Sheriff!* storyboard in Chapter 10 and Figure 11–5 later in this chapter.

Many variables indeed are involved in the content of the shot, and the storyboard artist's familiarity with them certainly will be of inestimable use to the entire creative team. The sequence of shots cannot be static. The story line has to move. The individual shots have to flow like music. They need a rhythm of their own. They must be paced so as to follow one another with appropriate speed.

For instance, how long should the camera hold on any one shot? Assuming that the art director or production designer composed the shot (three-dimensionally) and gave it a dynamic visual punch, you can't hold on to the scene as though it were a painting, because the scene has to keep moving so the audience is glued to the screen and will have its share of kinetic thrills, experiencing the planned unity of action, emotion, and environment of each shot as it continues to flow along with the continuity of the script.

Although the shot might have within it changing perspective, angles, or changes of camera or lens focus (like changing the focus on the villain's gun in the foreground to the figure of the crusading marshal in the middle ground), the shot should result in an onward force of cumulative action imparting a totality to the film itself.

Whether the scene takes place in a saloon, a Las Vegas gambling casino, or a two-shot of a couple in the honeymoon suite at the Plaza Hotel in New York City, betting on who opens the champagne first, it is important that each shot contains certain details that have been selected for use within the previously designed frame of reference. No extraneous details need apply, only those that pertain to the here and now of the story to be told. To be professional, these selections have to be made ahead of time. That again is where the storyboard artist will be on hand, helping to translate the director's vision in deciding which elements of the scene will be selected and designed with camera placement, choice of lenses, and compositional framing in mind, so that they can be illustrated in the panels that make up a successful storyboard.

Often producers or directors like a scene to be shot from many different angles, with lots of retakes, so that the editor will have lots of choices when putting together the final footage. Since Ford did not like his work

messed with too much, he shot his scenes with economy and dispatch, leaving the editor little or no extra footage from which to choose. The "final cut" was in the hands of the director not the producers.

Current directors like Steven Spielberg, John Cameron, and Martin Scorcese have the last word on the "final cut," but a director has to have made mucho bucks at the box office for that privilege. John Ford, for instance, wanted his work to be his creation and his alone. Even while he was working on *The Grapes of Wrath* (1940), Darryl F. Zanuck, the intimidating production chief at 20th Century Fox, was looking over his shoulder, to no avail. *The Grapes of Wrath* turned out to be a classic work, filmed with the mutual respect of all of the creative teams involved.

David O. Selznick, Hollywood's most famous producer, had to have his hands into every department; and you only have to read *Memo from David O. Selznick* (Behlmer, 1972) and look at his thousands of memos to the various creative departments to be convinced of his involvement, which extended, of course, to the editing department.

Montage, as in our current usage, was probably not present in Selznick's film techniques, but in his and his editor's hands, the technique of having one scene flow smoothly into the next, as in the opening shots of *Gone with the Wind*, which introduce the audience to the culture of the Old South that existed around Tara (the O'Hara plantation in Georgia), consist visually of an intoxicating color tableaux that flows effortlessly from one shot into another, creating a stunning montage. Refer to the *Gone with the Wind* illustrations in Chapters 2 and 9.

In the beginning of the second half of the film, there is a very effective but brief montage of the continuing Civil War that blends hot flames with silhouettes of marching soldiers at arms and cannon, accompanied by an appropriate soundtrack of narration and orchestral variations on the melody "Dixie."

The definition of *montage* in *The Film Encyclopedia* (Katz, 1994) as it is applied to motion pictures is "a sequence made up of a quick succession of brief shots blending and dissolving into one another, created to compress action and convey the passage of time." Refer to Figure 11–3 (John Wayne), Figure 11–5, (*Sheriff* conference), Figure 11–7 (*Godfather*), and Figure 11–10 (*Rules*)—all in this chapter.

Eisenstein seems to have made montage the chic symbol that it has become, and as demonstrated in the illustrations of *Potemkin* in this book, we see how he employed it to stunning effect. But he was influences to a great extent by our own D. W. Griffith, especially as Griffith manipulated his footage in *Intolerance* to achieve the sympathetic emotional response he wanted from the audience.

If we think of montage as the assemblage of different footage shot by the director to give a sequence a new meaning or a special clarity or to make a dramatic or metaphorical point, then it can be used as just such a device to satisfy the demands of the script and certainly to be created at the discretion of the director. The director has to consider plot points like these: Will using a montage in this particular spot advance the story line? Will it have the pace, metric precision, and rhythm that are needed? Does the script necessitate a metaphorical or intellectual message here? Might it not, if used, wind up attracting attention to itself?

In some instances, the editing itself will deliver the montage effect when it is cut from the footage that has already been shot. In some cases, judicious editing has actually saved a film. Tony Bill, one of the producers of *The Sting* and the director of *Untamed Heart* (1994), told me that, on his first directorial effort, *My Bodyguard*, he found out that he

hadn't shot enough coverage to make a certain climactic fight scene occurring toward the end of the picture really work. No retakes could be taken as it was already "a wrap" and who could afford to rehire actors and crew?

This pivotal scene was saved in the editing process by juxtaposing certain shots that already had been taken. Working with the editor, Bill did a quick cutting of various unused close-ups and medium shots of the two actors who were "pulling punches" and thus brought it all together.

Griffith used montage and editing for dramatic and emotional response to construct a story. Eisenstein used them for metaphorical, intellectual, or even political emphasis. And both had to admit that the techniques of crosscutting from one locale to another, close shots, flash-backs, dissolves or fades, even "panning" as the eye moves from one character to the next can be observed in authors like Charles Dickens, Tolstoy, and Dostoyevski. One can even imagine *Crime and Punishment* shot in nothing more than an edited series of introspective close-ups.

In watching again the famous chase in *The French Connection* (see Figure 11–2), one is impressed with the sheet bravado of it all. In this particular sequence the audience experiences the zenith of brilliant editing in the film.

It is all there in this film—every selected shot is held on screen for just the right length of time and then has been cut to the next shot. The use of too long a shot or too short a shot would break the pace, the momentum, and the rhythm of its dramatic construction. With break-neck speed, the car careens along under the elevated trains while the pace is accelerated as the shots intercut between the good guys and the bad guys they are pursuing. As in music, a great tempo is orchestrated in this dizzying chase with each cut being visually motivated. We constantly are aware, in this dynamic, kinetic sequence of fluid shots, exactly where we are, who is involved, what the individual motivations are, and where the suspense might be taking us—because of judicious cutting.

Any final sequence of a "shooting script" will work because the collaborative efforts of the director, cinematographer, storyboard artist, sound effect technicians, the composer of the musical score with its ensuing soundtrack, and finally the editor have been realized. From the rough cut or director's cut (the final cut as agreed upon by the director and the editor), a final negative or answer print is arrived at, culminating in a release print that will go out to the theaters, where the rapt audiences will be thrilled with the film's dynamic continuities.

Although editing is an integral part of the filmmaking process, it comes at the end of that progression, almost opposite the creation of the storyboards. In this sense, I feel that at least a cursory knowledge of it is important to the training of the storyboard artist, but this does not necessitates an in-depth discussion, as we have done with the inherent qualities of the shot.

Ira Koenigsberg, in the definitive *The Complete Film Dictionary* (1987), said that "it is the editor/cutter who, by shaping and arranging shots, scenes, and sequences, while also modulating and integrating sound, has considerable influence in the development, rhythm, emphasis, and final impact of the film." That he or she would do this as a completely collaborative effort with the director, along with the John Fords, Howard Hawkses, and Stephen Spielbergs is "a consummation devoutly to be wished." Incidentally, Lawrence Olivier was in on the final editing of his filmed interpretation of *Hamlet*.

Figure 11-2 *The French Connection* (1971).

To reiterate, the following terms are definitions by illustration; that is, defined in the descriptions accompanying selected illustrations—continuity, montage, the image, unity of action, number of shots, pacing, rhythm, and so forth:

Establishing shot (EST SHOT): Tells us where we are.
Long shot (LS): We see the character involved in the action at a distance.
Medium shot (MS): We view the character moving past the middle ground toward us.
Close-up (CU): Almost face-to-face with the audience.

All of the abbreviations for the various shots are designed to indicate the placement of the characters inside the various pictorial planes contained in this storyboard sequence taken from John Ford's *Stagecoach* (see Figure 11–3). NOTE: No zoom shots were available at the time this film was shot, but tracking shots (a camera on tracks or a vehicle that parallels the action) and pan shots (following the action with the camera from one designated position) were being used.

To start, frame 1 is in EST SHOT and LS, which builds to a MS in frame 4. Wayne is actually falling toward a CU shot in frame 8. In so doing, he has moved from the background(BGD) through the middle ground (MGD) to the foreground (FGD). NOTE: In this sequence, obviously, there is no over-the-shoulder shot but recall the use of several over-the-shoulder shots in *The Seventh Seal* (Chapter 6), and also illustrated in *Sheriff!*

The group shot of John Wayne with two antagonists in Figure 11–4, taken from *True Grit* (1969), is an example of an over-the-shoulder shot, only with two shoulders instead of one. Naturally, if only two people are talking, there only one shoulder will be within the "line of action"—only camera angles consistent with the scene being shot are allowed and those angles should take place inside an arc that is normally 180 degrees from actor to actor.

More examples of the preceding shots will be found in the continuity contained in the storyboard in Figure 11–5, rendered for the screenplay *Sheriff!*

Reading left to right, its easy to distinguish the EST SHOT, in frame 1, the over-the-shoulder shots in frames 4, 8 (in MCU, or medium close-up), 11, and 12; Medium shots in frames 4, 7, 14, and 15; CUs in frames 2 (actually an ECU, extreme close-up), 5, 6, and 10.

There are no long shots, per se, except in frame 14, with an extreme long shot of the boat, framed in the BGD, by a curtain and Blake (placed way off center in a profile shot). Notice the zoom in on the EST SHOT action and the zoom back in frame 13. Frame 15 also could be considered a wide shot (with wide angle lens, probably 28 mm). Observe that a logical line of action stays consistent with the placement of the characters in each frame. There is no jumping in and out of the *established sight lines*. This storyboard was rendered with minimal pen and ink lines (uni-ball micro) shaded with a gray felt tip (Le Plume, 11).

Remember the illustration of *Dr. Jekyll and Mr. Hyde* (Figure 11–1). In the MCU (medium close-up) shot, the image of Hyde has been placed slightly off-center in the central panel of the window, giving it a pleasing "balance." The other window panels also serve to break up the frontal pictorial plane of this impact shot. Hyde's hands themselves act as a

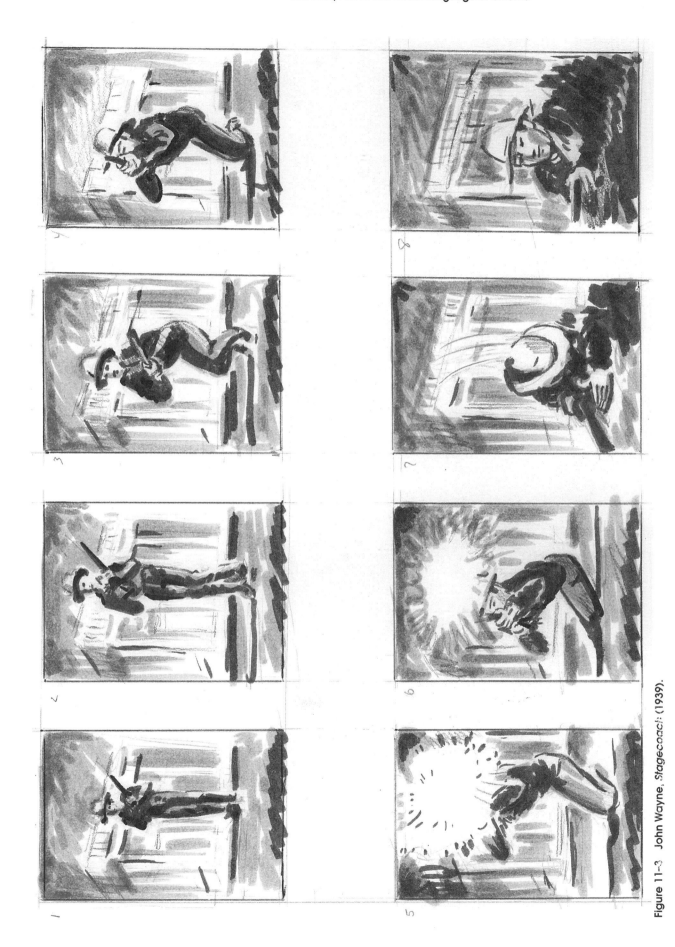

Figure 11–3 John Wayne, *Stagecoach*: (1939).

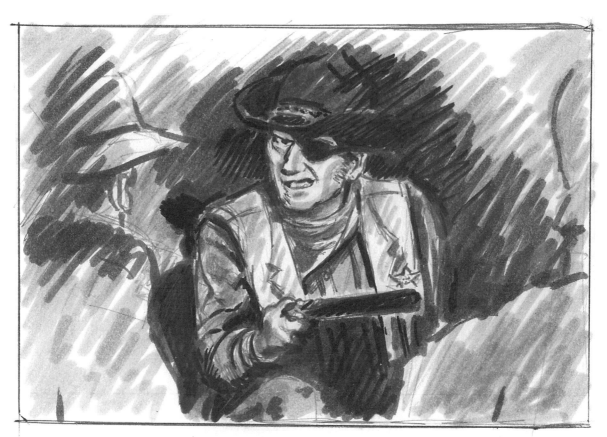

Figure 11–4 *True Grit* (1969).

framing device for his face and they add to the strength of an already scary shot.

The three lions (actually shot at three different locations) in the dynamic shot in Figure 11–6 become a metaphor for the awakening masses responding to the mutiny on the battleship *Potemkin*.

Frame 1 is a MCU, 2 is a CU, and 3 is an MS. Separately, each shot could be referred to as mimetic (a static imitation of life), but combined by Eisenstein, they project a kinetic vitality. In the hands of a major talent, inanimate stone suddenly springs to life. NOTE: As with any shot, the length of time that it is allowed to stay on screen is up to the director, who will be aware that his or her timing of the shot will affect the pace and rhythm of the scene. If held too long, a given shot might slow down the pace; if too short, the audience might not get it.

In the sequence of the three lions here, the director left each image on screen for a matter of a few seconds. Any longer would have inhibited the continuity and the pace of the other sequences involved, like the massing of the populace on the Odessa Steps. Even the few seconds that the three lions sequence is visible in *Potemkin*, they become part of the montage of images that Eisenstein was building to in the structure of his narrative. *Montage* can refer to several images overlapping each other, dissolving into each other, or in the case of Potemkin, it can denote a series of separate images or shots that edited in continuity can convey something quite different in meaning, instigating an emotional or intellectual response.

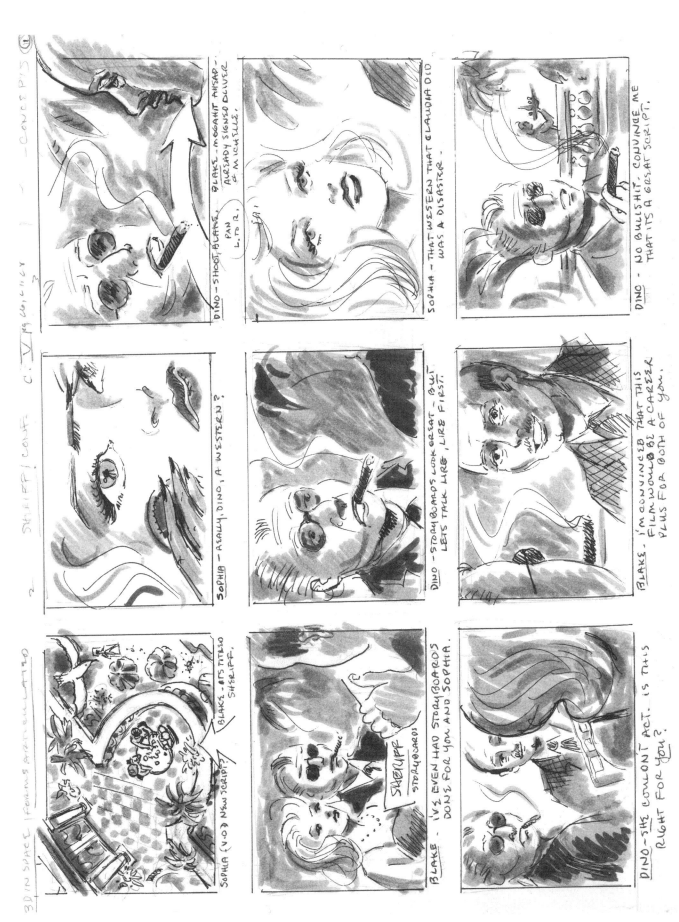

Figure 11-5 An analytical sketch of conference storyboard for *Sheriff!*

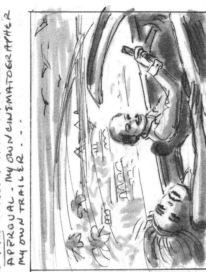

SOPHIA – AND I WANT SHOOTING SCRIPT APPROVAL – MY OWN CINEMATOGRAPHER – MY OWN TRAILER – –

DINO – O.K. I WANT FULL DISTRIBUTION RIGHTS FOR ITALY & FRANCE – YOU GET 10,000,000 – DEAL?

CUT TO: ITALIAN RIVIERA BLAKE: I KNEW YOU'D BE HAPPY, MARIA.

BLAKE DINO – SOPHIA – SCRIPT'S BEEN IN DEVELOPMENT FOR THREE YEARS, A SIX TIME RE-WRITE – ALLEN'S FINAL DRAFT'S – –

CUT TO: (BLAKE'S HOTEL ROOM) BLAKE – WE DID IT, BABY!

(REVERSE ZOOM AS SOPHIA V.O.'S) – – MY PERSONAL WARDROBE DESIGNER – – –

Figure 11-5 Continued

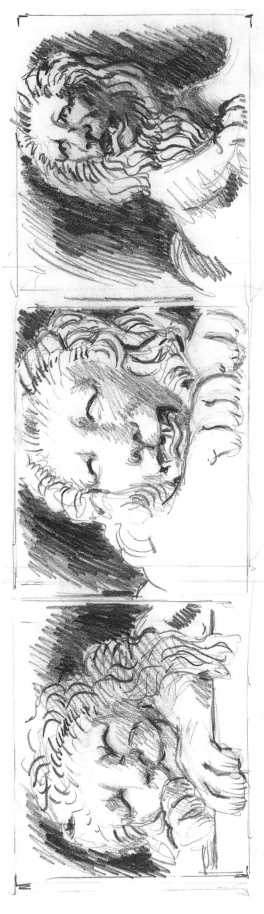

Figure 11–6 *The Battleship Potemkin,* three lions shots.

In the series of shots in Figure 11–7, taken from *The Godfather, Part II*, Francis Ford Coppola uses several difference techniques to convey the meaning of this sequence. Michael Corleone is attending his son's baptism, and frame 1 already speaks of the beginnings of life in the MC of the priest's hand and the baby's head. Hands will be a continuing motif in this montage as there is a cut to a CU of a barber's hands taking up lather, which in frame 3 is applied to character who will later be murdered in the chair. Frame 4 is a cut back to the baptism again with the hand of the priest.

Witnessing the beginning of life, but also having given the order to "wipe out" his competitors, is Michael, paced over to the right of the frame and balanced on the left with the innocent faces of the other witnesses. Frame 6 is a cut of a hand holding open an elevator door in an over-the-shoulder shot of the assassin. In frame 7, in a MS, the gunman kicks open the elevator and fires. Then there is a quick cut to frame 8 with Michael still etching the ceremony. The camera cuts to frame 9, with another over-the-shoulder shot, this time from an opposite angle, where we can see a man on a table through the door of a massage parlor. The next cut is to a MCU, in frame 10, where in suspense we fear what is going to happen when there is a cut to frame 11, when we have heard the muffled shot and now see the results in a graphic CU. The camera cuts back to Michael in a tighter CU, still a witness. He starts, but his mind is you know where.

This Coppola montage holds great visceral action, with its dual story line, graphic compositions, strong framing, and imaginative choice of camera angles. All held together, too, with the soundtrack playing organ music right through the killings.

In Figure 11–8, as volcanic lava burns its way down Hollywood near Vine, we observe it as a prime example of kinetic action. Add to that the helicopters trying to drop water on the primordial flow, and the shot makes for action all right. The fire trucks waiting to confront the scorching advance could be considered the mimetic part of this mis-en-scène that is a compendium of SFX imagined by digital wizardry.

This kinetic shot also demonstrates one-point perspective in action, with the vanishing point just above the body of the helicopter. All the lines in the buildings, the lava flow, and the trucks converge back to that one point. Note the use of an arrow again to indicate thrust and movement.

The shot in Figure 11–9, taken from a very funny chase comedy, could be a metaphor for the continuity for which the director is always striving. Continuity in the narrative shot means that the audience follows a logical sequence of events—the visualization of which is exactly what the storyboard has been created to do. The storyboard has continuity in the style of the film, its location, its decor, its lighting and its costuming, the choice of lenses, and the proper angles chosen for each shot.

In this breathtaking MS, the actors involved are desperately trying to achieve what they have been motivated to do, as they cling to a speeding train that is going in only one direction and on one specified track. This particular shot is but one of many others that, strung together, give the film is continuum, its forward motion, while maintaining the pace and tempo one should expect from any well-directed (and storyboarded) film.

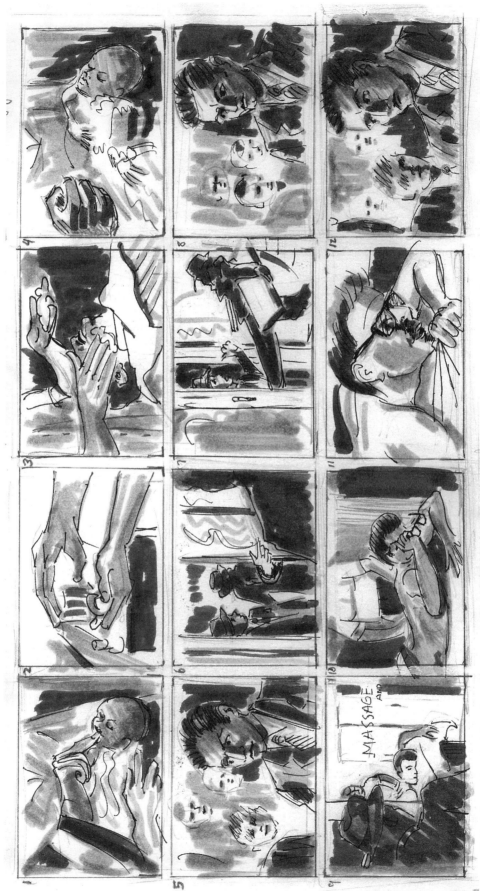

Figure 11-7 Interpretive sketches from *The Godfather, Part II*, montage.

Figure 11–8 *Volcano* (1997).

To top off this chapter, Figure 11–10 shows a storyboard for a new film by Robert Capelli, *Rules*. This sequence from the script comes at the end of the film and it consists of 11 frames.

I rendered this sequence on a rather quick deadline, as the director and writer had changed the ending of the film and needed this storyboard quickly. The script was faxed to me and any suggestions from the producer or screenwriter came over the phone. NOTE: Although I have shown the need for "fleshing out" one's basic drawings previously, you will notice here with these original concept sketches and with the final storyboard submitted, I am demonstrating how simple line drawings (these done with black Rolling Ball No. 7) can be effective in telling the story visually and getting the continuity across to the director or director of photography. If I had the time, I might have added more halftone shading, which is after all, my favorite way to illustrate a storyboard.

Figure 11–9 *Silver Streak* (1976).

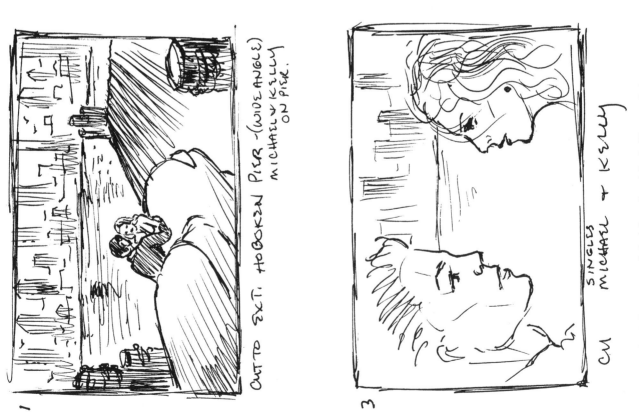

Figure 11–10 *Rules*, concept sketches. Reprinted with permission.

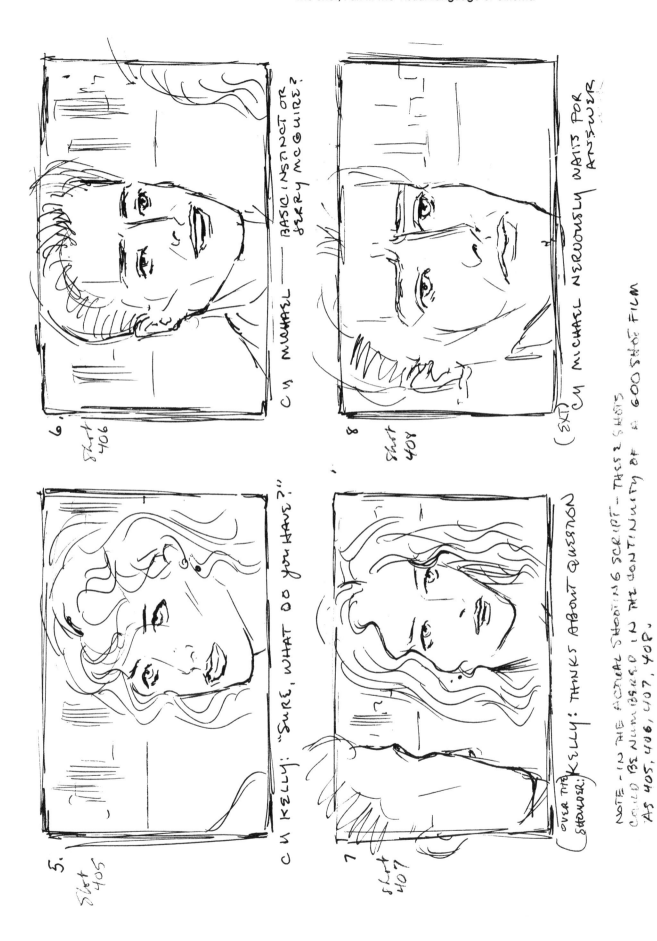

6.
Shot 406

5.
Shot 405

8.
Shot 408

7.
Shot 407

CU MICHAEL — BASIC INSTINCT OR JERRY MCGUIRE?

CU KELLY: "SURE, WHAT DO YOU HAVE?"

(EXIT) CU MICHAEL NERVOUSLY WAITS FOR ANSWER

(OVER THE SHOULDER:) KELLY: THINKS ABOUT QUESTION

NOTE — IN THE ACTUAL SHOOTING SCRIPT — THESE 2 SHOTS
COULD BE NUMBERED IN THE CONTINUITY OF A 600 SHOT FILM
AS 405, 406, 407, 408.

Figure 11–10 Continued

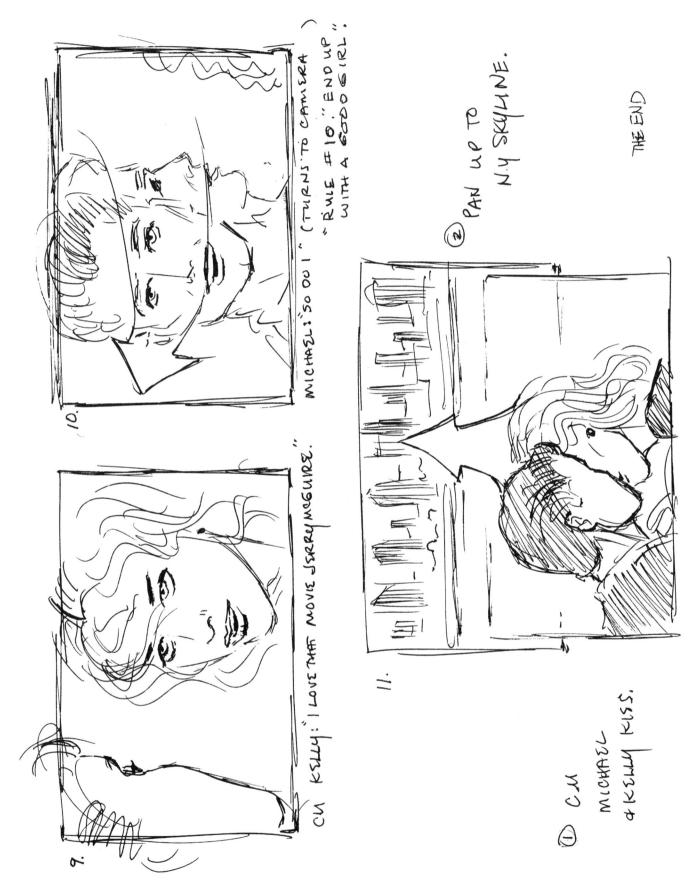

9.

CU KELLY: "I LOVE THAT MOVIE JERREY MCGUIRE."

10.

MICHAEL: "SO DO I" (TURNS TO CAMERA)
"RULE #10. "END UP
WITH A GOOD GIRL".

11.

① CU
MICHAEL
& KELLY KISS.

② PAN UP TO
NY SKYLINE.

THE END

Figure 11–10 *Continued*

Exercises

1. Storyboard a selected sequence from a current film composed of 24 frames (make quick thumbnail sketches).
2. Storyboard a 15 or 30 second commercial. Watch a commercial on TV and count the number of shots employed in making the commercial.

Continue to contribute your best storyboards to your portfolio.

NOTE: Check out the advice from directors, art directors, and storyboard artists on how to get work in the Interview section of the book.

Appendix A

A Word about Cartoons, Commercials, and Multimedia

Storyboarding for Commercials and Cartoons

There's no question that computer-generated imagery is the current buzzword, as we have seen in the animated film genre and also will see in the commercial field and in multimedia.

If you were to watch the kiddie shows on Saturday morning, you would certainly get a sampling of what is out there now, CGI-wise—not only in the cartoon area of visual interest but in the production of commercials as well. The essential use of storyboarding in the preproduction of the following, at this point, is obvious. Here is a sampling of some of what I "screened" recently:

- Computer animated action heroes, *X-Men*, listed as Animatics. Credits given for storyboard directors, artists, and clean-up specialists. Dynamic, three-dimensionally rendered BGDs.
- *Warner Bros. Kids!* Current characters introduce the Golden Oldies like Looney Tunes' Bugs Bunny, Daffy Duck and Elmer Fudd, *Tiny Toons Adventures* with cartoon characters played against lavishly rendered BGDs.
- *Teddy Bears* is a beautifully executed cartoon series rendered in a nice old-fashioned comic book style, with simple plot lines that make a moral point like Hanna Barbara's *Flintstones* or an animated version of *I Love Lucy*.

Naturally, interspersed among this cartoon fare, are commercials, mostly for milk, cereal, candy, cookies, and potato chips—all of which, like the cartoons themselves, had to be extensively storyboarded, using all of the drawing and rendering techniques that you have learned up to this point. Only in the case of commercials will the storyboard involve only enough frames to make up a 15, 30, or 60 second spot on TV.

The shots that make up these commercials must be dynamic and eye catching, full of very interesting images that will grab the attention of the viewer—keeping in mind that you have only, say, 30 seconds to sell the product.

Illustrated in Figures A–1 and A–2 are two storyboards for commercials for two different products, one for milk and one for a car (the names have been altered). In both renderings, note the flow of the copy

(15) SEC. SPOT VIDEO/LOGO	2	3 SINGER: MILK IS AWESOME.	4	5 2ND COW: SOMETHING TO MOO ABOUT!	6	7
MUSIC UP OVER CURTAIN ANNC: MILK'S COOL!	ANNC: MUSIC IT'S A BLAST!		COW: V.O. MOO, TOO!		FARMER: PLUS QUALITY CONTROL.	ANNC: ALWAYS TIME FOR MILK.
8 BABY: RIGHT, MAN. IT'S GREAT.	9 MOTHER: DON'T KNOW IT.	10 KIDBROTHER: IT'S COOL!	11 GRAMPS: AWESOME!	12 COW: WE GIVE OUR BEST FOR YOU.	13 JUDGE: (HITTING GAVEL) HONEST!	14 LOGO ANNC: THE CHEERING CONTINUES! FOR MILK.

Figure A-1 Milk commercial.

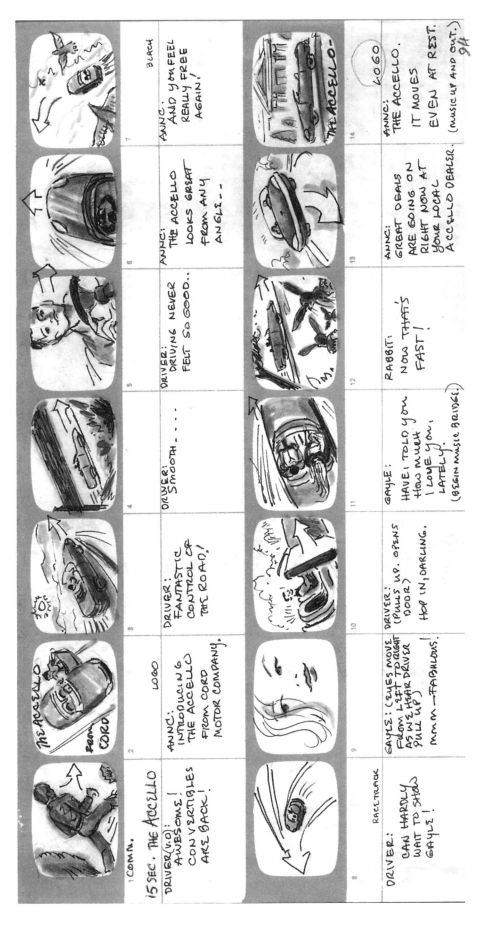

Figure A–2 Car commercial.

(placed in the frame below the shot to match the illustrated action); the liberal use of LS, MS, and CUs; and the variety of camera angles used to attract and hold the viewers' interest and to make them want to go out and buy the advertised product.

NOTE: The storyboard layout pads can be purchased at most commercial art supply stores. Obviously, the top panel is for the drawn action continuity and the bottom panel contains the copy; that is, the narration for a recorded voice-over or for words spoken by an actor directly to the camera.

On Multimedia

If you are interested in career opportunities in multimedia productions, you could be using your newly acquired storyboarding techniques by working somewhere in what has been described as the "hottest, fastest growing field anywhere." Either on the Internet, in the computer-based entertainment industry (video games have continuity), or in marketing sales presentations (industrial films), the job market is there for you to explore.

Interactive multimedia is here to stay, along with its specific need for imaginative computer artists (already trained in the art of the storyboard). We are all searching for the ultimate image, whether it be found in the traditional film and animation techniques of rendering or in the creation of the digital image. The choice is up to you and, as I've said before, the concept is what counts.

Of more specific interest to those who want to stick with narrative imagery, this new art of manipulation offers many possibilities in content creation for the entertainment industry, and you certainly could get a better grip on it by studying at a training center that features silicon graphics.

I suggest, too, that you attend the various trade shows that feature interactive multimedia, which frequently are being offered in many large cities—so, as they say, check your local listings and perhaps get an introduction to various multimedia learning systems, designing multimedia programs, digital technology design and development, and learning on the Internet.

Check out a group called Bridges: The AnimAction Training Program, located in Santa Monica, California. This group is "looking for artistically talented individuals who are seeking careers in the booming Animation, Multimedia, and Comic Book Industries." Here, you could do further studying in life drawing, 3D studio/design (digital modeling), rendering, perspective, background, and Adobe Workshop.

I want to say a word here about the software available to you if you want to render your storyboards digitally on a computer. Look into Storyboard Artist, available for Windows and Macintosh. It's a great software tool for "assisting the creative professional in producing dazzling animatics and interactive boards to show ideas." Software applications come with ready-to-use graphic renderings of characters, locations, and props. "You don't have to know how to draw, but you can, if you want to" (Writers' Computer Story, http://www.writerscomputer.com).

An example of computer-aided storyboarding follows in Figure A–3, rendered by Ly Bolia. Notice that the figures are drawn with simple, forceful lines, as they move from BGD to MGD to a CU in the FGD. Observe, too, how the artist has softened the BGDs to increase the

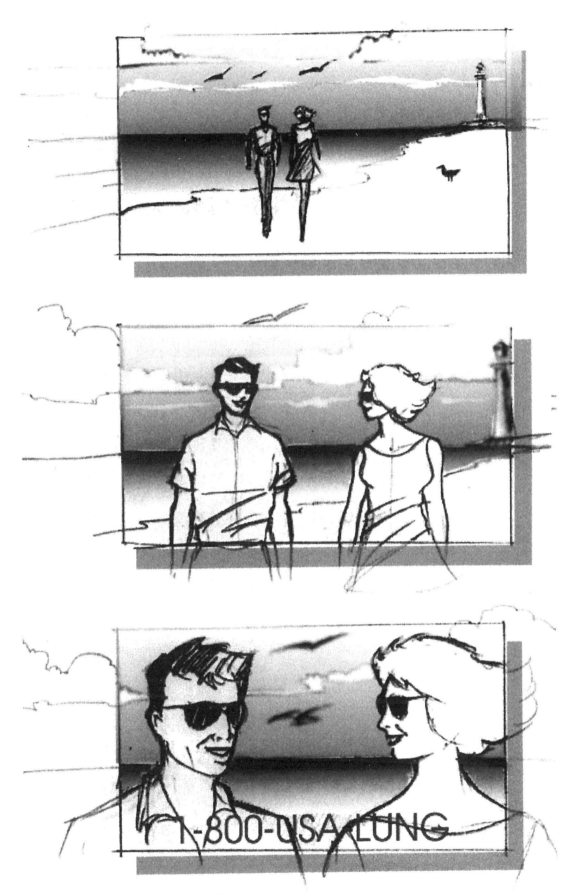

Figure A–3 Storyboard for Lung. Reprinted with permission.

impression of depth behind the walking couple. To accomplish this, Bolia used a Power Mac 7100, then scanned the drawings into Adobe Photoshop. His goal was to "mimic the camera and its ability to shorten focal lengths and depth of field."

Appendix B

Interviews

Joe Bevelaqua, Producer and Director

Joe Bevelaqua recently finished production on a full-length feature, *Shark Skin,* which he described as a film-noir thriller (distribution, Fall 1998). The film was directed by Assan Ildari, the script was 120 pages long, 140 scenes were shot (key action scenes were storyboarded).

Q Joe, what do you expect form the storyboard artist?

A I'll describe every scene to be shot with him or her and expect them to come up with a visual interpretation for me. Storyboard artists are another item in a tight budget for an independent filmmaker and I expect them to not only be extremely talented, but to work fast in interpreting the visual narrative for me.

Q What does your cinematographer expect from the storyboard artist?

A Most basic ramifications of the setups are worked out in production meetings, but normally the director of photography wants a clean, fluid storyboard to work from, but not so detailed that he has to stick to it slavishly. The storyboard might have to be modified if there is a conflict in camera angles or setups, or if the production team gets to a certain location and sees that changes have to be made. The storyboard is a foundation, but not the whole structure.

Q How about the use of storyboards when you shoot commercials?

A Storyboards here, especially, cannot be too tight, but loose—allowing for interpretation. For instance, if a storyboard artist has indicated a polka dot dress and on the shoot the client doesn't see a polka dot dress, there's trouble. Or, if a certain prop is indicated in the storyboard and it's not there, more trouble. Repeat: The storyboard should be fluent and fluid and not too tight.

Ly Bolia, Storyboard Artist and Cinematographer

Ly Bolia's comments about using storyboards were very succinct: "They are an excellent visual device for the director to communicate with the cinematographer, especially in setting up for camera shots." Ly also mentioned that, when he is working on his own films, he draws two storyboards. The first is for continuity, followed by some changes; the second, for the production schedule itself. He found them useful, too, in helping him shoot transition shots, shots that can act as a visual bridge from one sudden cut to another.

Q Ly, you are a freelance artist in the film business. How do you get work?

A Don't expect any contacts from schools. After graduation, you are on your own. So, keep in touch with friends in the IFP [Independent Feature Projects]. Monitor lists of productions coming to New York, like the Mayor's Office publishes up-to-date lists of production companies that will be shooting in NYC. Also check out the Hollywood Reporter. Naturally, as a storyboard artist, you have to have a top notch portfolio to show directors.

Q How do you work with the director as a storyboard artist?

A During preproduction meetings you discuss with him or her the idea of each shot. Then, you visualize it—sometimes on the spot with quick thumbnail sketches—you get verbal input first (as far as camera angles, use of lenses, etc.) then you do your storyboards for his or her approval.

Q Do you work much with the production designer?

A I often discuss the sketches with him. He then establishes for me, how much of his designs will be seen in each shot—say, a given room. Then, allowances will be made for what lenses and what camera angles will augment his production designs.

Q What is your relationship with the director of photography?

A We rarely meet. The director has already had his or her meetings with the cinematographer and established their own communication.

Q What is you function with the set supervisor?

A Not much. His is not a creative role. His job is to make sure the sets are organized and in final shape for the shoot.

Q How about storyboarding for commercials?

A They are usually done in-house, so you have to call art directors and try to show them your portfolio if you want to work in-house with a particular ad agency.

Robert Capelli, Jr., Producer and Director

I just had an opportunity over lunch to ask Robert Capelli, Jr., the director of *Rules,* for which I did the storyboard for the last scene of his comedy (see Chapter 11, Figure 11–10), and with his cinematographer, Ly Bolia, a graduate of the NYU Film School, who also is a storyboard artist (see Figure A–3).

Q Did you use storyboards on your new film and how did you use them? Also, what do you expect from the storyboard artist?

A The storyboards were very useful for setting up the shots. We knew exactly what went before so we could subsequently match the previous shots. Preplanning with the storyboards was a real time saver and consequently a money saver for my independent film—you know, no big studio bankroll to back me up. Yes, I found the storyboards to be very useful in giving us a relative point to start from in a given shot, so that if we wanted to make any changes in camera position or angles, we had that starting point to work from. For instance, in shot 10 of John's storyboard for *Rules,* we decided to have him put his head on the girl's shoulder for the over-the-shoulder shot instead of looking bolt upright into the camera.

Elizabeth Perez, Storyboard Artist

Q Do you work much with producers?

A Once in a rare while.

Q What does a given director expect from you as a storyboard artist?

A Ability to draw, a sense of speed, familiarity with technical things—camera angles, etc.—use of stick figures is helpful, ability to read their mind, you be their eyes, be prepared to work long hours and not complain.

Q Do you work with a cinematographer?

A No. He usually works from our storyboards.

Q With a production designer?

A I have on occasion.

Q How do you get work as a storyboard artist?

A Advertising in a publication I'd rather not mention. Mailings. Word of mouth. Contacting art directors. Interview and try to show my portfolio.

Mark Simon, President of Animatics

Mark Simon states that, in contrast to live action storyboards, the animation storyboards have to be even more detailed, more exact in drawing details such as every movement of the characters facial expressions—as with the beginning of a smile with the mouth closed to a wider smile showing teeth to the lips closing again at the end of the smile, composing what is called *in-between drawings*, resulting in many more drawings for screen time. In the key frames, then, every major motion has to be indicated, conforming to the question, Where is the motion going to be?—as on a field chart, where the camera would pan three fields to the right.

In answer to my question: "How do you satisfy the requirements of a specific client?" Simon replied: "Each of my staff artists has a different style and that style will adapt itself to the 'look' that will best suit their clients special needs." This is the case with his current animation for Nickelodeon.

Simon also makes it emphatic that the storytelling is paramount with any animation project. "If the story doesn't work, the project doesn't work." "You might have terrific storyboards acting as the blueprint for a given story, but if the story is weak, the storyboards go for naught." (See Figure B–1.)

Jan Suzanne, Art Director

Jan Suzanne of the Commercial Arts Agency in New York City has had many years of experience in the commercial field. She was very terse and knowledgeable with her answer to two of my questions: "What do you expect from the storyboard artist?" and "How are storyboards helpful in delineating the needs of the client?"

First, she reiterated my oft repeated dictum, the concept is what counts, and then added, "not only the concept but how it is executed, and secondly, the way it is displayed and then how to market it." As for what she expects from the storyboard artist, she requires a crisp, simple approach that tells the essence of each sequence, pencil sketches or thumbnails that capture the key moment—that tell the story (see Figure B–2).

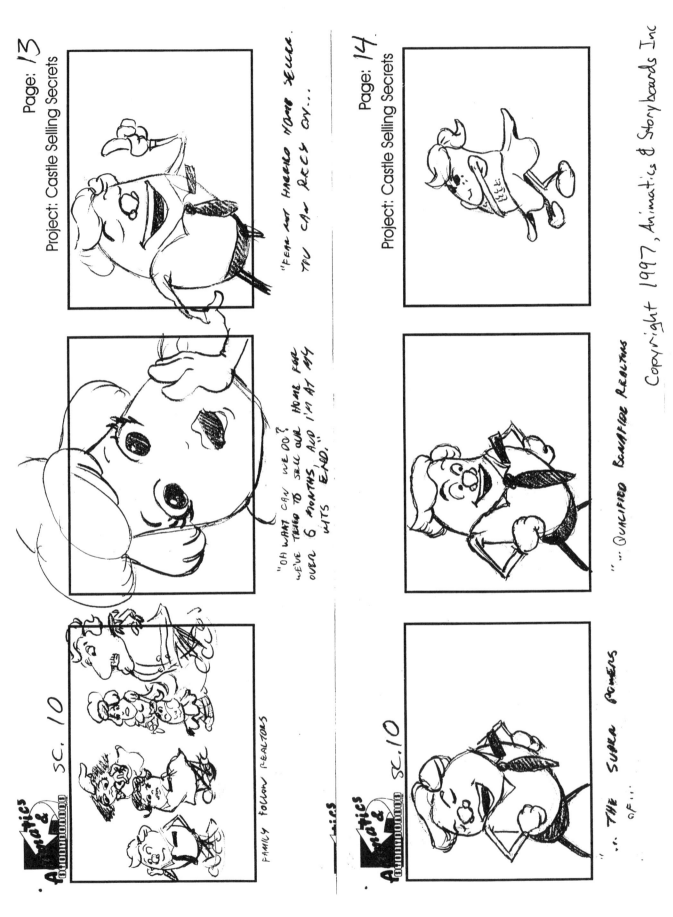

Figure B–1 Storyboards from *Castle Selling Secrets*, artist Mark Simon. Reprinted with permission from Animatics & Storyboards, Inc.
Copyright 1997 A&S, Inc., all rights reserved.

Project: Castle Selling Secrets

SC. 10

"A SUB-ATOMIC NEUTRALIZING QUANTUM LONG SWORD?"

"GOOD GUESS, BUT NO, SWEETIE"

HIS HAND MOVES B&F.

"A DAZZLING WHITE UPTURNING OF A SMILE?"

Project: Castle Selling Secrets

Page: 16

SC. 10

"I'M AFRAID NOT MY TOOTHSOME GAL."

FLOATING

"A MAGIC WAND?"

TOWERS GLASSES

"AH, A MAGIC WAND?"

Copyright 1997, Animatics & Story boards, Inc.

Figure B–1 Continued

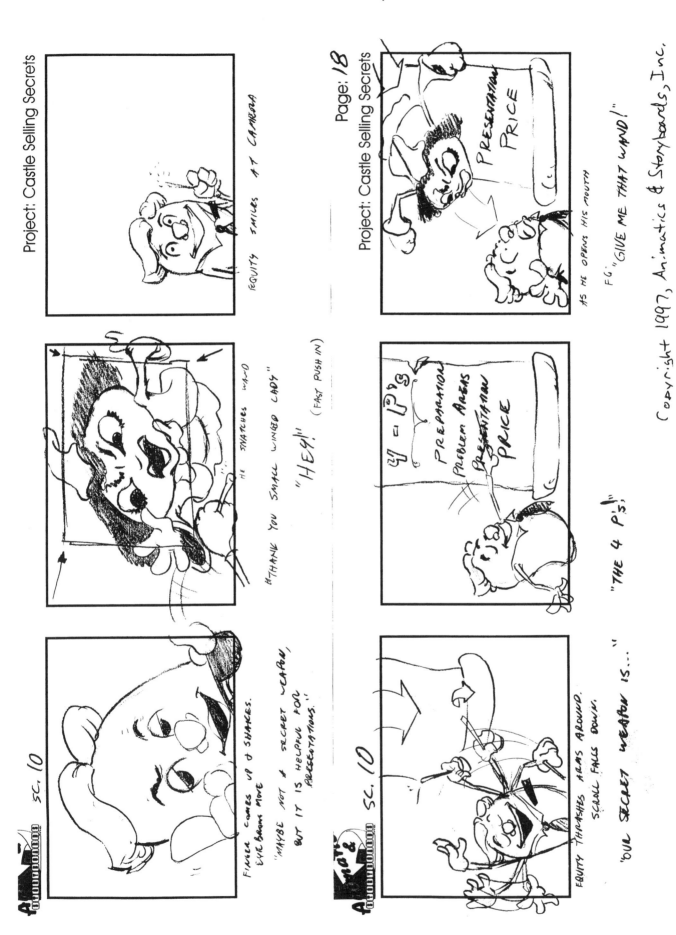

Project: Castle Selling Secrets

Project: Castle Selling Secrets

Page: 18

SC. 10

EQUITY SMILES AT CAMERA

HE SNATCHES WAND

"THANK YOU SMALL WINGED LADY"

"HEY!"

(FAST PUSH IN)

FINGER COMES UP & SHAKES.
EYEBROWS MOVE

"MAYBE NOT A SECRET WEAPON,
BUT IT IS HELPFUL FOR
PRESENTATIONS."

AS HE OPENS HIS MOUTH

FG: "GIVE ME THAT WAND!"

"THE 4 P's;

EQUITY THRASHES ARMS AROUND.
SCROLL FALLS DOWN.

"OUR SECRET WEAPON IS..."

SC. 10

4 = P's
PREPARATION
PROBLEM AREAS
PRESENTATION
PRICE

PRESENTATION
PRICE

COPYRIGHT 1997, Animatics & Storyboards, Inc.

Figure B-1 Continued

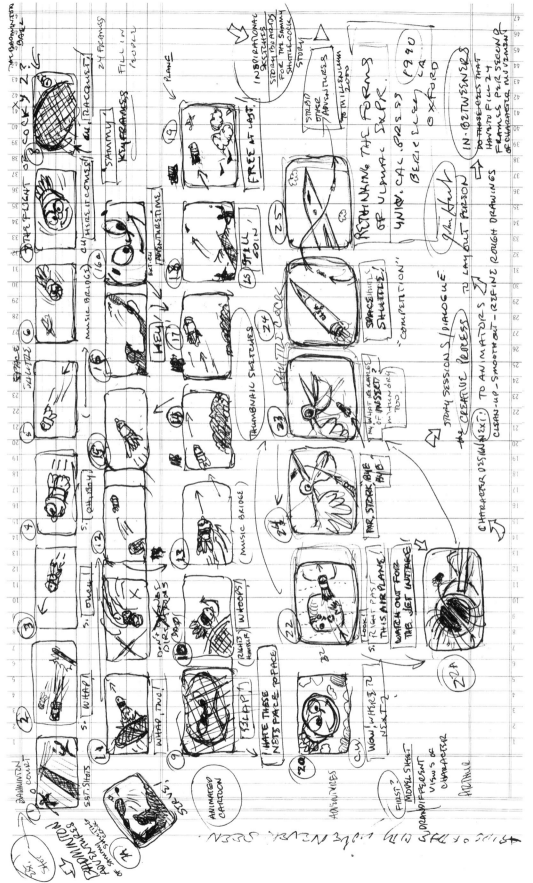

Figure B–2 Thumbnail sketches for "The Adventures of Sammy the Shuttlecock."

The storyboard has to communicate in order to accomplish its goals.

The voice of every artist is heard in the way they execute ideas.

The computer has changed the nature of graphics. We are using Web sites now, but thumbnail ideas that help the client to understand things quicker is the ideal—no matter what the medium.

Here is one last thought. At San Jose State University in California, Courtney Granner and Alice Carter teach a terrific animation course, working in conjunction with Warner Brothers Feature Animation (with critiquing via TV monitors). Granner informs us rightly that: "The narrative image as we have known it in the last 200 years is changing." With daily advances in special effects and computer software imaging and compositing, we can see what he means. So, storyboard artists, let's hone those creative skills and tools of drawing so that we can build up a personal momentum that will take us into the next visual millennium. Videos of several animated motion studies can be found on the Chronicle of Higher Education's Web site at http://www.Chronicle.com.

Bibliography

Books on Filmmaking and Drawing

American Cinema Manual. 1980. Hollywood, CA: ASC Holding Corp., 1980.

Anderson, Robert M. *D. W. Griffith: The Years at Biograph.* New York: Farrar, Straus, and Giroux, 1970.

Anobile, Richard J., ed. *Stagecoach.* New York: Avon Books, 1975.

Bare, Richard L. *The Film Director.* New York: Macmillan, 1971.

Barna, Yon. *Eisenstein.* Boston: Little, Brown, and Company, 1973.

Barsacq, Leon. *A History of Film Design.* New York: New Amsterdam Library, 1978.

Barson, Michael. *Illustrated Who's Who of Hollywood Directors: An Archive Photobook.* New York: Harper, 1995.

Bayer, William. *The Great Movies.* New York: Grosset and Dunlap, 1973.

Behlmer, Rudy. *Memo from David O. Selznick.* New York: Viking, 1972.

Behlmer, Rudy, and Tony Thomas. *Hollywood's Hollywood.* Seacaucus, NJ: Citadel Press, 1979.

Belazs, Bela. *Theory of the Film.* New York: Dover Publications, 1970.

Bergala, Alain. *Magnum Cinema, Intro.* London: Phaidon Press, 1995.

Boorstin, John. *The Hollywood Eye.* New York: HarperCollins, 1990.

Box, Harry C. *Set Lighting Technicians Handbook.* Boston, MA: Focal Press, 1993.

Bridges, Herb. *The Filming of* Gone with the Wind. Macon, GA: Mercer University Press, 1984.

Brownlow, Kevin. *David Lean.* New York: St. Martin's Press, 1996.

Byrge, Diane. *Private Screenings/American Film Institute.* Atlanta: Turner Publications, 1995.

Cameron, James, and William Wisher. *Terminator 2: Judgment Day.* New York: Applause Books, 1991.

Capra, Frank. *The Name Above the Title.* New York: Macmillan, 1971.

Castrell, David. *Hollywood, 1970's.* New York: Gallery Books, 1986.

Cawkwell, Tim, and John M. Smith, eds. *Encyclopedia of the Film.* New York: Galahad Books, 1972.

Clair, Rene. *Cinema, Yesterday and Today.* New York: Dover Publications, 1972.

Clarke, Charles G., ed. *American Cinematographer Manual.* Hollywood, CA: ASC Holding Corporation, 1980.

Crowther, Bosley. *Vintage Films.* New York: G. T. Putnam and Sons, 1977.

Dickenson, Thorold. *A Discovery of Cinema*. London: Oxford University Press, 1971.

Dolan, Edward F., Jr. *History of the Movies*. New York: Gallery Books, 1983.

Esso, G., and R. Lee. *DeMille*. New York: Castle Books, 1970.

Farris, Edmond J. *Art Student's Anatomy*. New York: Dover Books, 1961.

Field, Syd. *Four Screenplays*. New York: Dell Publications, 1994.

Geist, Kenneth, and Joseph L. Mankewitz. *Pictures Will Talk*. New York: Scribner and Sons, 1978.

Gussow, Mel. *Don't Say Yes Until I Finish Talking, ZANUCK*. New York: Pocket Books, 1972.

Harris, Robert A., and Michael S. Lasky. *Complete Films of Alfred Hitchcock*. New York: Carol Publishing, 1995.

Hart, John. *Lighting for Action*. New York: Amphoto/Watson-Guptill, 1992.

Hat, Peter. *MGM: When the Lion Roars*. Atlanta: Turner Publications, 1991.

Haver, Ronald. *David O. Selznick's Hollywood*. New York: Bonanza Books, Crown Publications, 1985.

Hirsh, Foster. *The Dark Side of the Screen/Film Noir*. New York: DaCapo Press, 1981.

Hirschorn, Clive. *The Warner Brothers Story*. New York: Crown Publications, 1979.

Hirschorn, Clive. *The Hollywood Musical*. New York: Crown Publications, 1981.

Hirshorn, Clive. *The Universal Story*. New York: Crown Publications, 1983.

Hogarth, Burne. *Dynamic Anatomy*. New York: Watson-Guptill, 1958.

Huss, Ron, and Norman Silverstein. *The Film Experience*. New York: Dell Publications, 1968.

International Encyclopedia of Film. New York: Crown Publications, 1972.

Katz, Ephraim. *The Film Encyclopedia*. New York: Harper Perennial, 1994.

Katz, Steven D. *Shot by Shot*. Boston, MA: Michael Wises Productions and Focal Press, 1991.

Kawin, Bruce F. *How Movies Work*. Berkeley: University of California Press, 1992.

Kerr, Bob. *Elements of Film*. New York: Harcourt, Brace and World, 1969.

Knoght, Arthur. *The Liveliest Art*. New York: New American Library, 1957.

Konisgsberg, Ira. *Complete Film Dictionary*. New York: New Amsterdam Library, Signet, 1987.

Lawton, Richard. *A World of Movies*. New York: Bonanza Books, 1974.

Leish, Kenneth N. *Cinema*. New York: Newsweek Books, 1974.

Maltin, Leonard. *The Art of the Cinematographer*. New York: Dover Publications, 1977.

Marsh, Edward W., and Douglas Kirkland. *James Cameron's* Titanic. New York: HarperCollins, 1997.

Marx, Arthur. *Goldwyn*. New York: Ballantine Books, 1976.

Marx, Samuel. *Mayer and Thalberg*. New York: Random House, 1975.

Mast, Gerald. *Film/Cinema/Movie*. New York: Harper/Colophon Books, Harper and Row, 1977.

Moran, Ethan. *The Hollywood Studios*. New York: Alfred A. Knopf, 1988.

Multimedia Sourcebook, vol. 3. WWW, Internet Directory, New York: Hi Tech Media, Inc., 1997.

Nelmes, Jill, ed. *An Introduction to Film Studies*. New York and London: Routledge, 1996.

Osborne, Robert. *Sixty-Five Years of the Oscar*. New York: Abbeville Press, 1994.

Perard, Victor. *Anatomy and Drawing*. New York: Random House, 1995.

Pfeiffer, Lee, and Michael Lewis. *The Films of Tom Hanks*. Seacaucus, NJ: Citadel Press, 1996.

Phillips, Gene D. *The Movie Makers*. Chicago: Nelson Hall Co., 1973.

Pirie, David, ed. *Anatomy of the Movies*. New York: Macmillan, 1981.

Place, L. A. *The Non-Western Films of John Ford*. Seacaucus, NJ: Citadel Press, 1979.

Reisz, Karel, and Gavin Millar. *Film Editing*. New York: Communication Arts Books, Hastings House Publications, 1968.

Renoir, Jean. *My Life and My Films*. New York: DaCapo Paperbacks, 1974.

Robinson, David. *History of World Cinema*. New York: Stein and Day, 1987.

Sackett, Susan, ed. *Box Office Hits*. New York: Billboard Publications, 1996.

Schulberg, Budd. *Moving Pictures: Memoirs of a Hollywood Prince*. London: Allison U. Busby, 1981.

Sherlie, V. and W. T. Leny. *Complete Films of Frank Capra*. New York: Citadel Press, 1992.

Sherman, Eric. *Directing the Film*. Boston and Toronto: Little Brown and Company, 1976.

Silver, Alain, and James Ursini. *David Lean and His Films*. London: Leslie Frewin Publications, 1974.

Sinclair, Andrew. *John Ford: A Biography*. New York: Lorimer, 1984.

Singer, Michael. Batman and Robin: *Making the Movie*. Nashville: Routledge Hill Press, 1997.

Smith, Thomas G. *Industrial Light and Magic: The Art of Special Effects*. A Del Rey Book. New York: Ballentine Books, 1986.

Sobchack, Thomas, and Vivian Sobchack. *An Introduction to Film*. Boston: Little Brown and Company, 1980.

Sowers, Robert. *Rethinking the Forms of Visual Expression*. Berkeley: University of California Press, 1990.

Spoto, Donald. *Art of Alfred Hitchcock: Fifty Years of His Motion Pictures*. Garden City, NY: Doubleday Books, 1976.

Spoto, Donald. *Rebel: James Dean*. New York: Harper Paperbacks, 1996.

Spottiswoods, Raymond. *Film and Its Techniques*. Los Angeles: University of California Press, 1957.

Stallings, Penny. *Flesh and Fantasy*. New York: St. Martin's Press, 1978.

Stephenson, Ralph, and J. R. Debrix. *The Cinema as Art*. New York: Penguin Books, 1969.

Talbot, Daniel, ed., *Film: An Anthology*. Berkeley: University of California Press, 1959.

Thomas, Bob. *Thalberg: Life and Legend*. Garden City, NY: Bantam Books, Doubleday and Co., 1970.

Titelman, Carol, ed. *The Art of* Star Wars, *Episode IV, A New Hope*. New York: Ballantine Books, 1997.

Truffaut, François. *Hitchcock, Truffaut*. New York: Simon and Shuster, 1983.

Vaz, Mark, and Shinji Hata. *From* Star Wars *to* Indiana Jones. San Francisco: Chronicle Books, 1994.

Vermilye, Jerry. *Great British Films*. Seacaucus, NJ: Citadel Press, 1978.

Vermilye, Jerry. *Great Italian Films*. Seacaucus, NJ: Citadel Press, 1994.

Webb, Michael, ed. *Hollywood: Legend and Reality*. Boston: Little Brown and Company, 1986.

Weinberg, Herman G. *The Lubitsch Touch*. New York: Dover Publications, 1977.

Yule, Andrew. *Losing the Light*. New York: Applause Books, 1991.

Books on Animation

Adamson, Joe. *Bugs Bunny: Fifty Years and Only One Gray Hare*. New York: Henry Holt, 1990.

Animation Art (catalogue). New York: Sotheby's, 1990.

Canemaker, John. *Tex Avery: The MGM Years '42–'55*. Atlanta: Turner Publications, 1996.

Culhane, John. *Walt Disney's* Fantasia. New York: Harry N. Abrams, 1983.

Culhane, Shamus. *Animation from Script to Screen*. New York: St. Martin's Press, 1988.

Finch, Christopher. *The Art of the* Lion King. New York: Hyperion, 1994.

Finch, Christopher, and Linda Rosenkrantz. *Sotheby's Guide to Animation Art*. New York: Henry Holt and Company, 1998.

Gray, Milton. *Cartoon Animation: Introduction to a Career*. Northridge, CA: Lions Den Publications, 1991.

Krause, Martin, and Linda Witkowski. *Walt Disney's* Snow White and the Seven Dwarfs: *An Art in Its Making*. New York: Hyperion, 1994.

Lassiter, John, and Steve Davy. Toy Story: *The Art and Making of the Animated Film*. New York: Hyperion, 1995

Maltin, Leonard. *The Disney Films*, 3d ed. New York: Hyperion, 1995.

McCloud, Scott. *Understanding Comics: The Invisible Art*. Northampton, MA: Kitchen Sink Press, 1993.

Solomon, Charles. *History of Animation*. New York: Wings Books, Random House, 1994.

Magazines

"Art of Lighting." *Film and Video* (June 1996).

"Building Blockbusters/*Godzilla*/*Deep Impact*/*Armageddon*/*Prince of Egypt* (animated pic.)." *Variety: On Production* (May 1998).

"CGI Artists/*Spawn*." *Variety: On Production* 6, no. 8 (August 1997).

"CGI Visual Effects/*Con Air*." *Variety: On Production* 6, no. 6 (June 1997).

Cheplic, Matt. "As Crappy As Possible—The Method Behind the Madness of *South Park*." *Millimeter* (May 1998).

"*Dante's Peak, Star Trek: First Contact, The Relic*." *Cineflex: The Journal of Cinematic Illusions*, no. 69 (March 1997).

"Digital Networking." *Film and Video* (May 1996).

"Emmerich/*Independence Day* Feature Animation." *Film and Video* (July 1996).

"Evolution of Production." *Variety: On Production* 5, no. 5 (June 1996).

Ferster, Bill. "Urge to Merge." *Video and Multimedia Producer* 20, no. 4 (April 1998).

Henry, Selick. "Iain Blair." *Film and Video* (June 1996).

"Holding Court in Cannes." *Variety: On Production* 6, no. 7 (July 1997).

"*Independence Day.*" *Entertainment* no. 335 (July 12, 1996).

"Invasion of Effects/*Independence Day.*" *Variety: On Production* 5, no. 6 (July 1996).

Katz, Steven D. "Siggraph: How to Find the Best Animation Job." *Millimeter* (July 1998).

Kaufman, Debra. "Colossal Pictures (Aeon Flux)." *Animation Magazine* (September 1995).

Magid, Ron. "Reanimating a Familiar Foe." *American Cinematographer* 78, no. 11 (November 1997).

Magid, Ron. "*Titanic:* A Rollercoaster Year for Visual Effects." *American Cinematographer* 78, no. 11 (November 1997).

Mallory, Michael. "*True Lies (Titanic).*" *Millimeter* (January 1998).

Marchant, Elizabeth Stevenson. "Mulitmedia Meets Madison Avenue." *Video and Multimedia Producer* 18, no. 4 (September 1996).

Masters, Todd. "How One Artist Went Digital." *Millimeter*, Supplement VIZ*f*X (November 1997).

"Maximum Web Power." *ZD Internet* 2, no. 6 (June 1997).

"Modeling Animation Multimedia, 2 D CAD Software/Affordable SFX." *CGW* (July 1996).

Plantec, Peter. "Beating Animators Block." *Video and Multimedia Producer* (September 1998).

Plantec, Peter. "Test Patterns." *Video and Multimedia Producer* 19, no. 10 (November 1997).

"Primetime '97, Tuning the Weds Channels." *Variety: On Production* 6, no. 9 (September 1997).

Rebello, Stephen. "Bringing Disney's *Pocahontas* to Life." *Animation Magazine* (July 1995).

"Special Report: Animation." *Video and Multimedia Producer* 19, no. 12 (December 1997).

Speier, Michael. "The Art of CGI" *Millimeter*, Supplement VIZ*f*X (November 1997).

Speier, Michael. "On the Spot (5 Commercial Directors)." *Millimeter* (October 1997).

"3 D Animation and Special Effects." *Millimeter* (July 1997).

Variety: On Production Special Edition, SFX and Animation, entire issue (December 1997).

Wiener, David. "Chasing the Wind." *American Cinematographer* 77, no. 5 (May 1996).

Wisehart, Cynthia. "Houses of Style: Animators Go Commercial." *Millimeter* (May 1998).

Wolff, Ellen. "ILM Does *Men in Black.*" *Millimeter*, Supplement VIZ*f*X (November 1997).

Wolff, Ellen. "Model Planes (*Air Force One*)." *Millimeter* (August 1997).